IMAGES
of America

PORT TOWNSEND

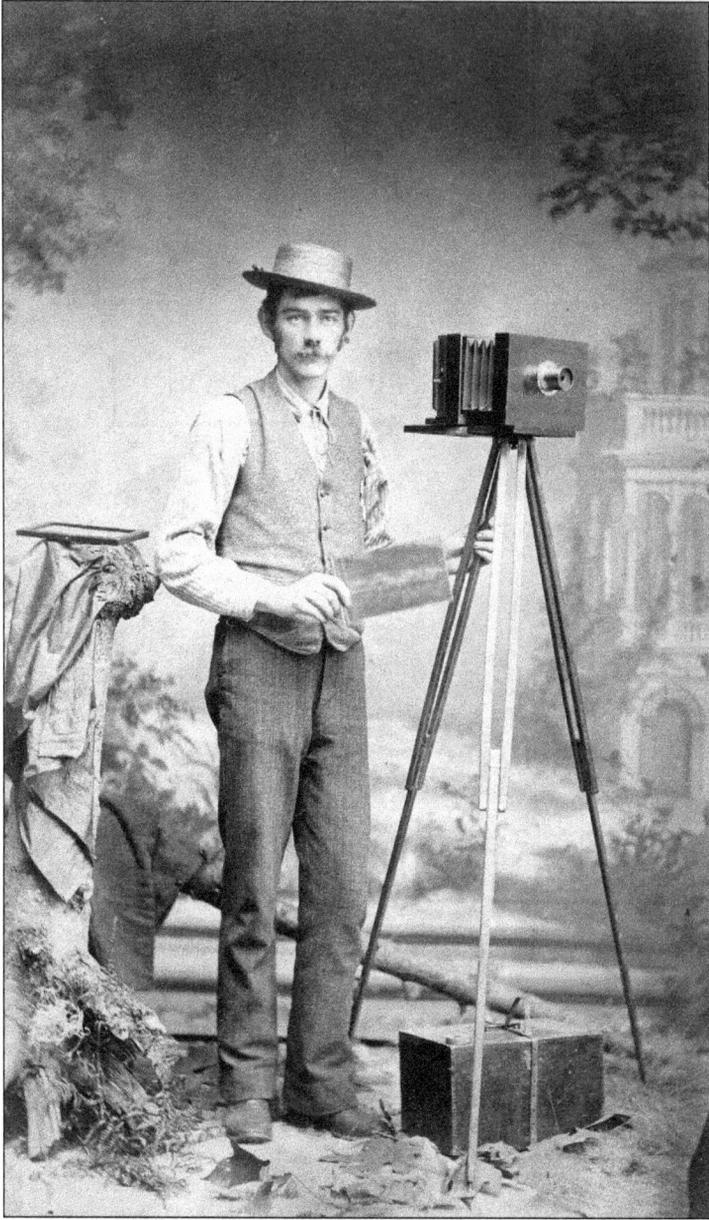

JAMES M. MCMURRY'S SELF-PORTRAIT, "THE AMATEUR." James McMurry's surviving work proves him to have been a modest man. He brilliantly chronicled the growth of the town and lives of its citizens. In 1887, he advertised a "first class gallery" in the *Port Townsend Call*, offering to take "negatives . . . in cloudy weather." Within 10 years, McMurry had sold his gallery to the Olson Brothers and became a druggist.

ON THE COVER: UNION WHARF. This is the Union Wharf, c. 1915, at the base of Taylor Street in downtown Port Townsend. The vessel on the left is the *Chippewa*, built on the Great Lakes in 1901 and sailed to Port Townsend via the Straits of Magellan. Smaller boats on the lower left were used as water taxis. Taylor Street was once lined with saloons; the building on the right with the skylight was the popular Patsy Lennin's Pacific Saloon.

IMAGES
of America

PORT TOWNSEND

Jefferson County Historical Society

ARCADIA
PUBLISHING

Published by Arcadia Publishing
Charleston, South Carolina

Library of Congress Catalog Card Number: 2007937760

For all general information contact Arcadia Publishing at:
Telephone 843-853-2070
Fax 843-853-0044
E-mail sales@arcadiapublishing.com
For customer service and orders:
Toll-Free 1-888-313-2665

Visit us on the Internet at www.arcadiapublishing.com

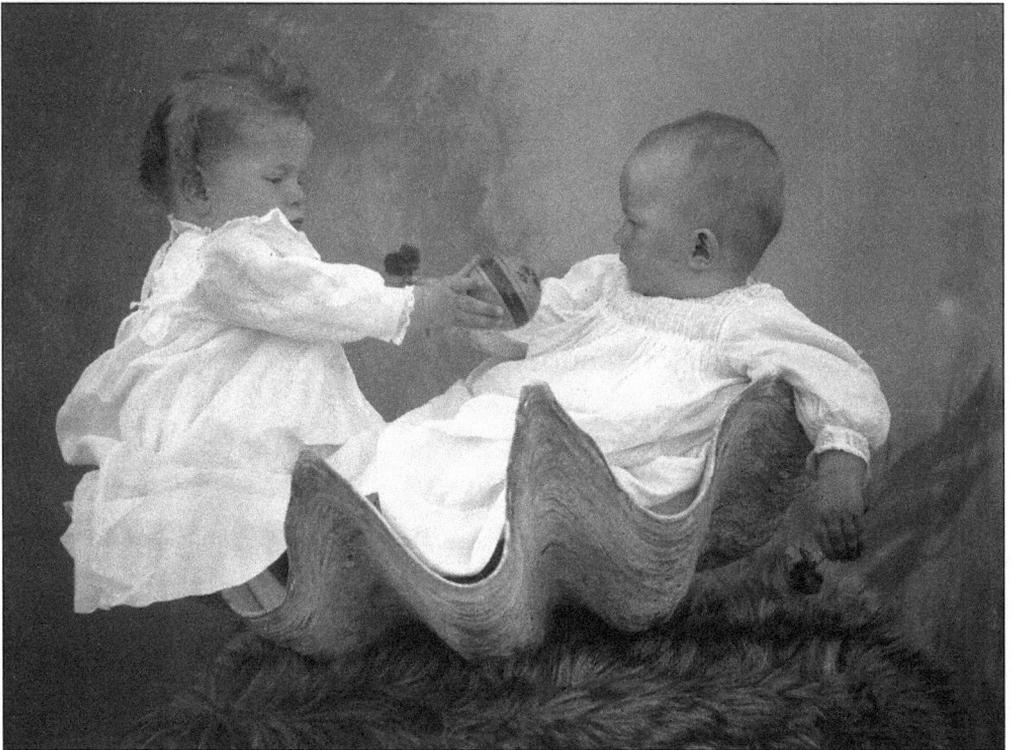

HORACE MCCURDY AND ROSETTA KLOCKER. This portrait by James G. McCurdy is of Horace McCurdy and Rosetta Klocker in a giant clamshell. This amazing shell from Indochina is part of the Bash Collection on exhibit at the Jefferson County Historical Society Museum in Port Townsend. When Henry Bash was the U.S. Shipping Commissioner in the 1880s, he asked captains to bring him samples of shells and coral from islands in the South Seas. The ship captains complied, dropping off the specimens the next time they came through Port Townsend. Eventually, the collection grew to over 75 different varieties.

CONTENTS

ACKNOWLEDGMENTS

The Jefferson County Historical Society (JCHS) maintains a fine collection of historic photographs. We sincerely thank all who have donated to this collection and encourage anyone with photographs that illustrate Port Townsend's history to add their images to this resource. We thank the *Peninsula Daily News* for a 2004 grant that made it possible for us to begin digitizing the collection. We appreciate the grant from the Institute of Museum and Library Services that made it possible for us to rehouse our glass-plate negatives.

Marge Samuelson, archivist at the Jefferson County Historical Society's Research Center, and the Jefferson County Genealogical Society volunteers conducted research and tapped into their own wealth of knowledge about Port Townsend's history; Bryan Shrader continues to add depth and detail to photograph descriptions; Bruce Freeland's work with the Historic Property Survey of Jefferson County structures provides an ever-growing wealth of information; Vicki Davis supervised scanning the photographs; Lillian Raines, Hal McCoy, and Alan Hughes have input vast amounts of historic information into the database; Jim Christenson keeps the computers updated and in working order; JCHS museum coordinator Marsha Moratti wrote and edited the text and formatted the photographs; Pam Clise checked our historical facts; Steve Ricketts provided historical information about his Port Townsend ancestors; and JCHS trustees Linda Maguire and Catherine Garrison provided excellent editing and proofreading skills.

INTRODUCTION

Early Settlers found a S'Klallam Indian community well established on the protected shores of Port Townsend Bay. The chief of the Port Townsend band of S'Klallams, known as Chetzemoka, was friendly to the growing community of newcomers and helped maintain peace between his people and the settlers.

Port Townsend was the first permanent American settlement on the Olympic Peninsula, founded on April 24, 1851, when Alfred A. Plummer selected a homestead and registered a claim with the surveyor general's office in Olympia. Puget Sound's protected bays were far friendlier to commerce than the northern Pacific Ocean and the entire region was covered in forest, right down to the water's edge. The California Gold Rush assured a booming market for lumber. Sawmills sprang up throughout the Puget Sound region. Fledgling communities farther into the sound (including Seattle) were a long, slow voyage in sailing vessels. They were often towed in and out by tugs from Port Townsend.

Port Townsend's designation in 1854 as a U.S. Customs Port assured its status as a seaport. At a time when the transportation of nearly all people and goods in the Pacific Northwest depended upon sea travel, Port Townsend was at the hub. Maritime-related enterprises fueled a booming economy, providing ready wealth and shaping the character of the ambitious town.

Like many young communities in the Puget Sound, Port Townsend aspired to greatness. Calling itself the "Key City" and the "New York of the West," Port Townsend quickly became a bustling seaport as the gateway to the Pacific Northwest. Wood-frame buildings came to be replaced with fine brick and stone structures. In 1880, a thousand ships from all over the world passed through Port Townsend. There were consulates from as far away as Germany, Peru, and the Sandwich Islands. County and city governments built grand municipal structures designed for a population of 20,000. In 1892, the U.S. Customs and Post Office, city hall, and county courthouse buildings were completed.

While sin and commerce flourished at sea level, the money from the bars and bordellos on the waterfront helped build fine homes, churches, schools, clubs, a shopping district, and parks uptown on the bluff. There were tennis and bicycle clubs. Fraternal organizations, such as the Odd Fellows, Masons, Red Men, and Good Templars, built large meeting halls that were used by the community for theatricals and dances.

Port Townsend went bust after the anticipated railroad failed to arrive and as steamships replaced wind-powered craft, eliminating its geographic advantage. Fortunes were reversed in the mid-1890s, and the town's population fell from 7,000 to 2,000 almost overnight, leaving its grand buildings empty and, in many cases, unfinished.

After tough years of belt-tightening following the collapse of the railroad bubble, the discovery of gold in 1897 along the Klondike River gave Port Townsend a flurry of prosperity. Prospective miners swarmed through the town as they hurried north. Steamships publicized weekly sailings from Union Dock. Soldiers and their families boosted the population when Fort Worden was completed in 1902 as one of the "Triangle of Fire" defenses to the entrance to Puget Sound.

No longer a viable seaport, the federal government moved the customs house to Seattle in 1911. The shine had worn off the grand buildings from the boom years. The people who remained logged,

fished, farmed, or worked in canneries. No one could afford to maintain, let alone replace, the old structures. There was little economic incentive for new construction. Some original buildings were adapted for reuse, others remained vacant; most fell into disrepair. Only Fort Worden and the welcome construction of a $7 million Crown Zellerbach paper mill in 1928 kept Port Townsend from becoming a ghost town.

The first settlers of Port Townsend had a strong sense of community pride and history-in-the-making when they organized the Jefferson County Historical Society of Washington Territory on May 3, 1879. The mission of the society today is virtually unchanged: ". . . to actively discover, collect, preserve, and promote the heritage of Jefferson County in the State of Washington."

In 1932, the mission of the Jefferson County Historical Society was reaffirmed, emphasizing the importance of collecting and preserving "papers, documents, photographs, pictures, and other objects . . . and the suitable arrangement and housing of such collections." Space was secured in the basement of the Carnegie Library to house the collections and conduct society business.

In the early 1950s, the society undertook its first effort in historic preservation when it mounted a campaign to raise $1,500 and organize volunteers to repair and repaint the historic Fire Bell Tower on the bluff—a proud symbol of Port Townsend's history. This project inspired the community and reinvigorated the society. In 1951, the year of Port Townsend's centennial, the Jefferson County Historical Society opened a museum in the old courtroom of the historic city hall. Membership in the society grew, collections expanded, and individuals began to restore the old Victorian buildings in the town. A research library was established in 1960 as part of the museum.

In 1971, the Fire Bell Tower was again in need of repair. This time, JCHS raised more than $9,500 to pay for the restoration effort. In gratitude, the community gave the Jefferson County Historical Society a 99-year lease for part of the old city hall for a museum and archive. Port Townsend's special historical landscape and efforts at preservation and restoration began to receive outside recognition.

In 1975, the National Trust for Historic Preservation undertook an architectural survey and inventory of the central business district, and the Washington Trust for Historic Preservation was established, with headquarters operating out of the Jefferson County Historical Society. Although the Washington Trust moved on to a permanent location in Olympia, Port Townsend and adjacent Fort Worden gained status as National Historic Landmark Districts, and the increased local consciousness of the town's special historical inheritance imbued the Jefferson County Historical Society with a greater sense of responsibility as a steward of this heritage.

Once again, proving that history does indeed repeat itself, JCHS mounted a campaign to raise funds for major restoration of the Fire Bell Tower. This time the cost was over $250,000. In March 2004, the Washington State Office of Archaeology and Historic Preservation (OAHP) named Port Townsend's Fire Bell Tower, restored by the Jefferson County Historical Society and the City of Port Townsend, as the recipient of the 2004 State Historic Preservation Officer's Award for Resource Stewardship.

At the same time, JCHS was deeply involved in raising funds for the restoration of Port Townsend's landmark city hall building. The 1891 building is a pivotal structure in the Port Townsend National Historic Landmark District. Its council chambers have served as the setting for democratic discourse for 125 years. As the fire and police departments, police court, and city offices moved on to more modern facilities over the years, the Jefferson County Historical Society's museum expanded into the spaces left behind.

The maritime environment and over 112 years had taken their toll and the building was dangerously deteriorated. Believing that the economic and cultural viability of downtown Port Townsend is greatly strengthened by the presence of city hall, the city partnered with JCHS to save the building. The Jefferson County Historical Society returned to its restored home in November 2006.

Such a spectacularly situated town could not remain obscure for long. Port Townsend booms again, thanks largely to retiring baby boomers and tourists visiting the town's increasingly restored historic district and the many events and attractions at Fort Worden.

One

REMOTE OUTPOST

In the 1850s, Port Townsend was a remote territorial outpost, a collection of damp wood buildings and piers on a sand spit at the entrance to Puget Sound's calm waters. The California Gold Rush brought settlers west and the U.S. government's passage of the Donation Land Claim Act of 1850—offering 320 acres to single men and 640 acres to married couples—brought more. Port Townsend's deep and protected harbor was easily accessible to sailing ships and there was ample level land for building a town. The entire region was covered in timber for which the California Gold Rush provided a ready market.

In August 1850, Henry C. Wilson made the first land claim at Port Townsend, but he didn't file on it until 1852. In April 1851, Alfred A. Plummer and Charles Bachelder arrived from the California gold fields. They were building a cabin when, a few months later, Francis W. Pettygrove and Loren B. Hastings arrived from Portland. In 1792, Captain Vancouver named the bay in honor of his friend, the Marquis de Townshend; the four newcomers named the town Port Townsend. They agreed to a partnership with the goal of developing the site to attract the settlers, trade, and business investments that would build a city. Pettygrove and Hastings returned to Portland to bring their families and other potential settlers back to Port Townsend.

By May 1852, three families and 15 bachelors made up the nonnative population of Port Townsend. They immediately set about building permanent homes and stores, and starting gardens and orchards. In September, they shipped out the first cargo of lumber.

By 1860, over 300 new settlers and 200 S'Klallam lived in Port Townsend and the waterfront sported at least 50 wooden structures, including docks, warehouses, stores, offices, hotels, and saloons. Some early houses were located in the valley nearby and on the bluff above the main town, but most people lived "on the flat."

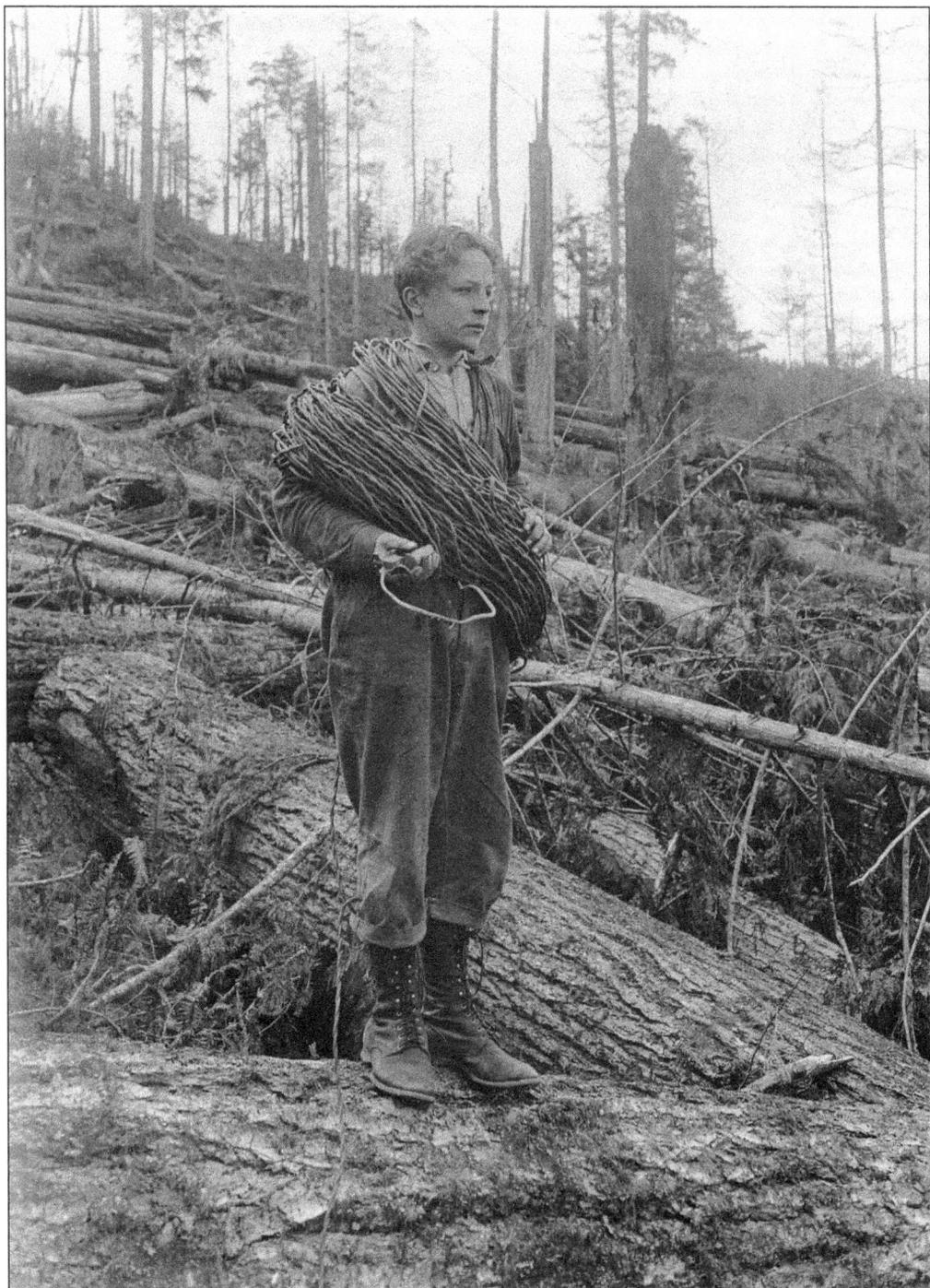

HERBERT ANDERSON. Herbert Anderson, age 12, stands on a downed tree with rope around his shoulders. With so many trees in the way, early settlers had to be loggers before they could be farmers, traders, or builders of anything. Fortunately, in the wake of the California Gold Rush, the logs provided something they sorely needed—cash.

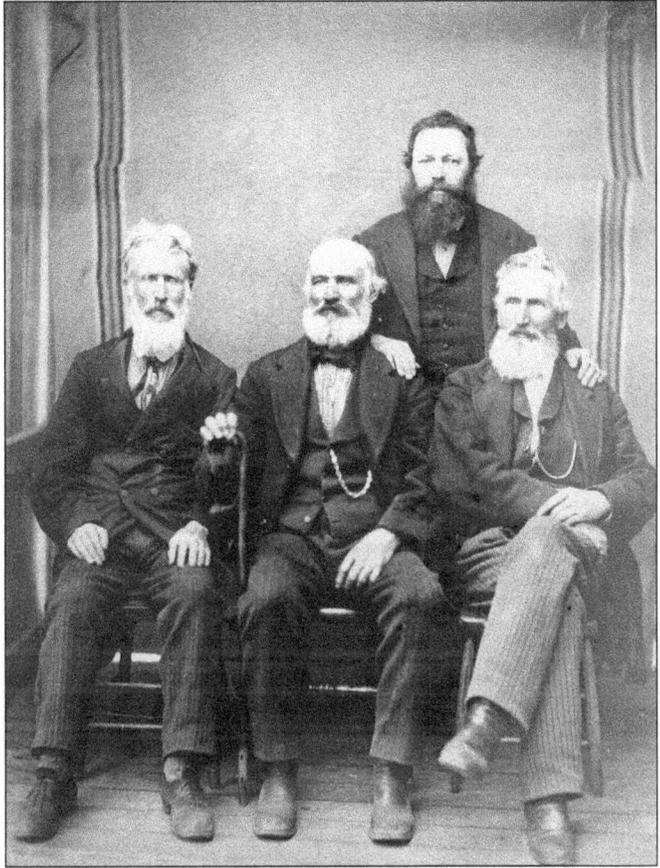

PIONEERS. Some of the first settlers in Port Townsend, pictured at a pioneer gathering, are, from left to right (seated) Francis W. Pettygrove, Capt. Enoch S. Fowler, and J. G. Clinger; (standing) Alfred A. Plummer. When they arrived in Port Townsend in 1851, Alfred Plummer was 29, Francis Pettygrove was 36, Enoch Fowler was 37, and J. G. Clinger was 29.

FIRST BUILDING. Alfred Plummer's cabin, the first building in Port Townsend, was erected by Loren Hastings, Charles Bachelder, Plummer, and Francis Pettygrove on the beach in what soon became downtown Port Townsend.

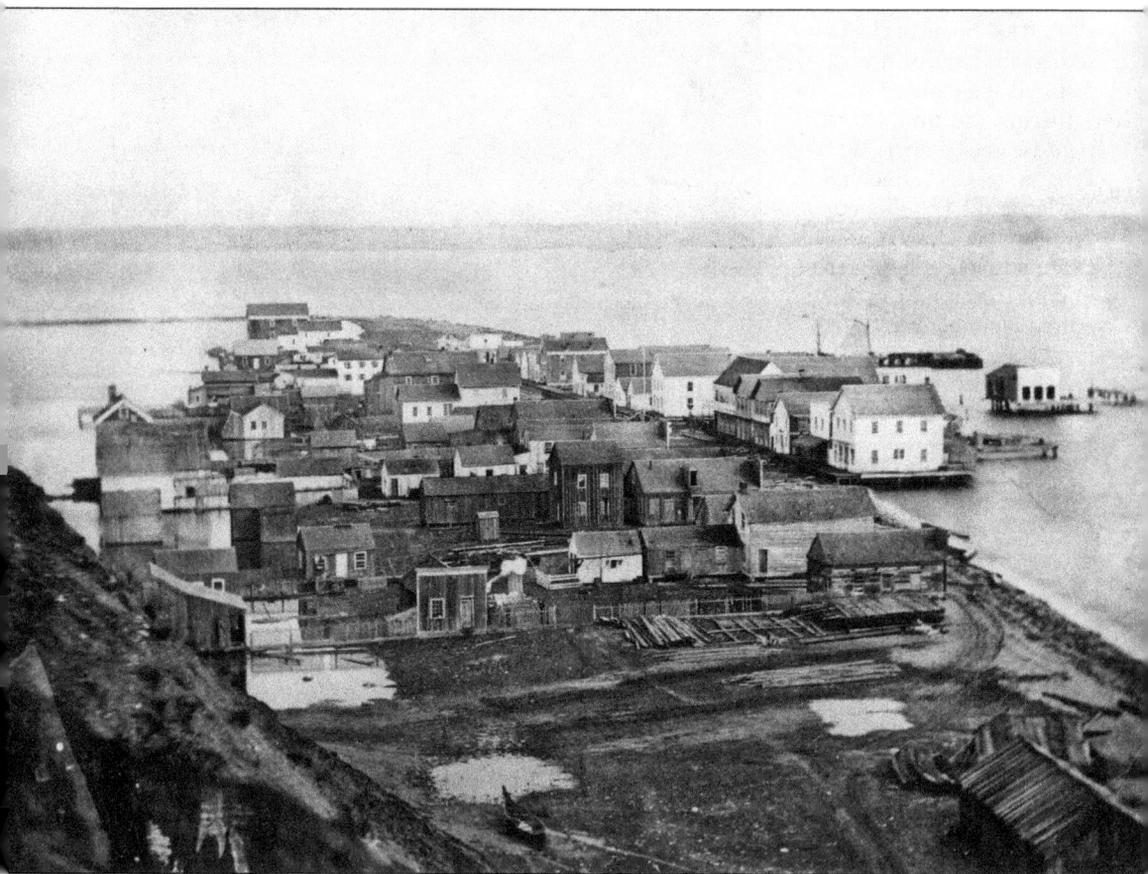

THE 1860S, BEFORE PORT TOWNSEND WAS "FILLED IN." The town was built on a finger of sand between Admiralty Inlet and Port Townsend Bay. The area to the left—under water—was later filled and built upon. Fill came from large sections of the bluff, as it was removed to provide road access along the waterfront to downtown. The Port Townsend waterfront was gradually extended out into the bay with fill, and a breakwater was constructed. Buildings and wharves were then built on the fill and on pilings over the water. Plummer's cabin is in the lower right; the two-story white building on the right was used as the U.S. Customs office, one of the last original wood buildings still standing in downtown Port Townsend.

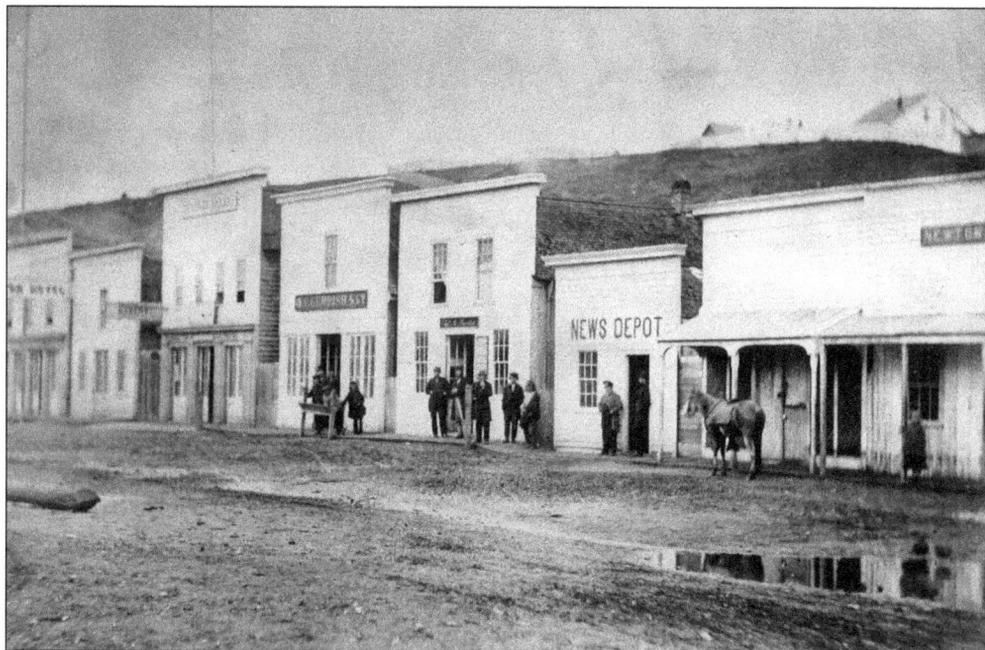

WATER STREET, 1862. The bakery, managed by Charles Eisenbeis, provisioned ships with bread and crackers. There was another bakery owned by Henry W. Watkins called the Boston Bakery that was later sold to Eisenbeis. Gerrish and Company were "Dealers in Hardware, Cutlery, Clothing and Fancy Articles," according to an advertisement in the *Northern Light* on October 28, 1860. The Washington Hotel is at the far left.

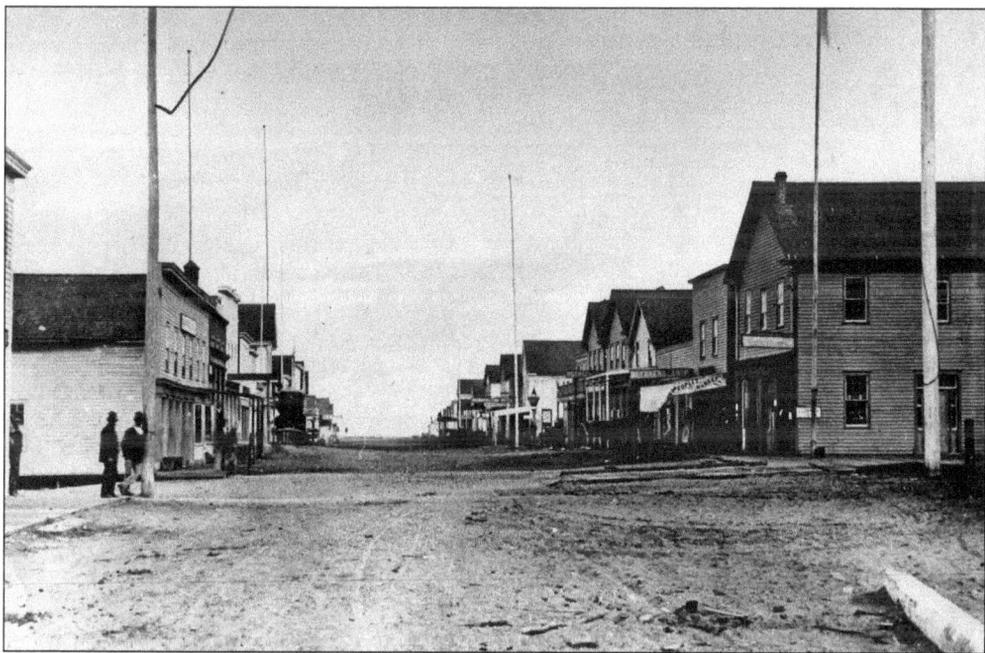

LOOKING NORTH ON WATER STREET, 1876. The first building on the left housed the offices and drugstore of the town's first physician, Dr. Samuel McCurdy. The tall poles served as landmarks for incoming sailing ships.

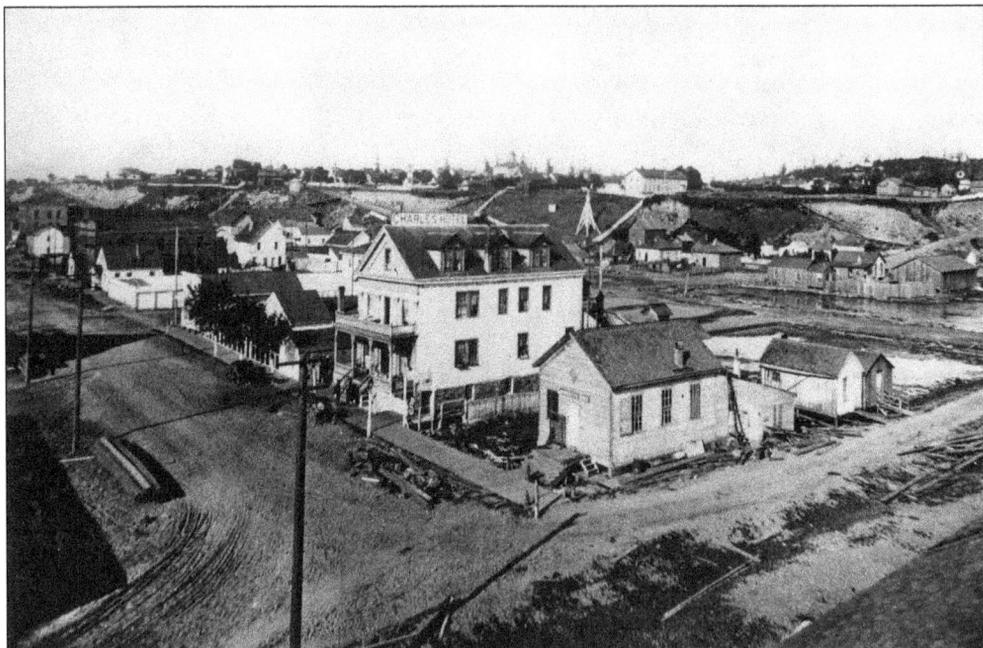

ST. ANTHONY'S. The first church in Port Townsend, St. Anthony's, was the small structure on the right at Water and Jackson Streets. James Swan wrote in his diary on February 20, 1859: "Went to hear Father Rosey [Rossi] preach . . . During the service the Indians drew guns and made a little disturbance, probably a fight among themselves."

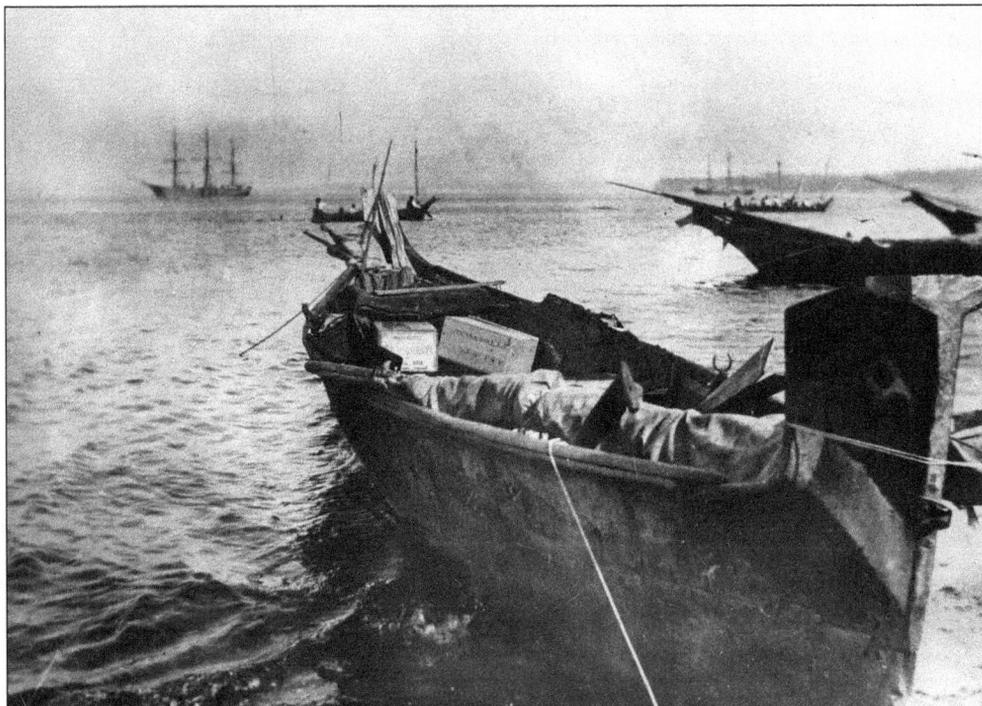

NATIVE AMERICAN CANOE. This Native American canoe is filled with provisions manufactured in Port Townsend. Other canoes and two sailing ships can be seen in the distance.

"GRANDMA NEWMAN" DRYING SALMON AT POINT HUDSON. Native Americans preserved salmon from the abundant autumn spawning runs for use throughout the year. For thousands of years, the only occupants of the Olympic Peninsula were indigenous tribal members who lived in large communal longhouses, subsisting on the abundance of fish, shellfish, wild game, roots, and berries.

CAMPING. A group of native people camps on the beach at Port Townsend. The woman on the right is weaving a basket. In the late 1700s and early 1800s, the Native American population was decimated by disease transmitted through contact with white explorers. In some areas, diphtheria, smallpox, and measles killed 90 percent of the population. By the time European settlers arrived, some local tribes were so depleted they could not effectively resist intruders.

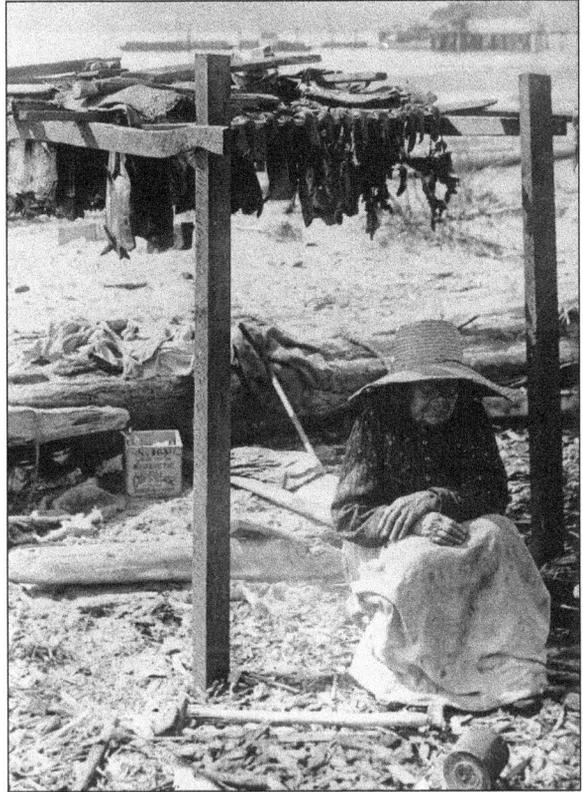

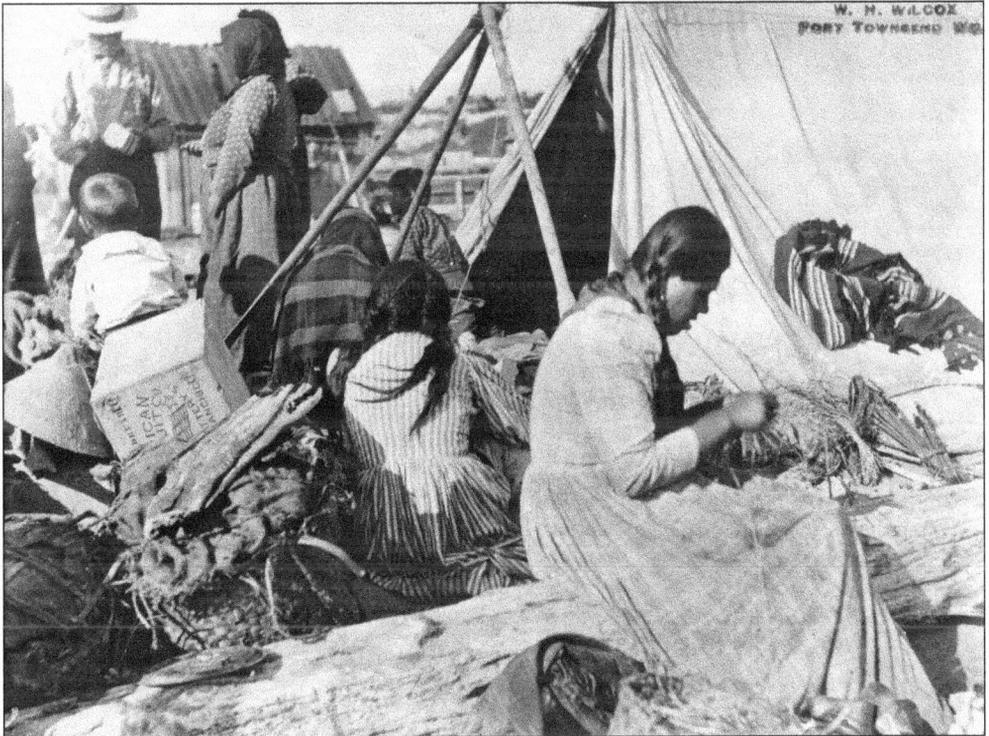

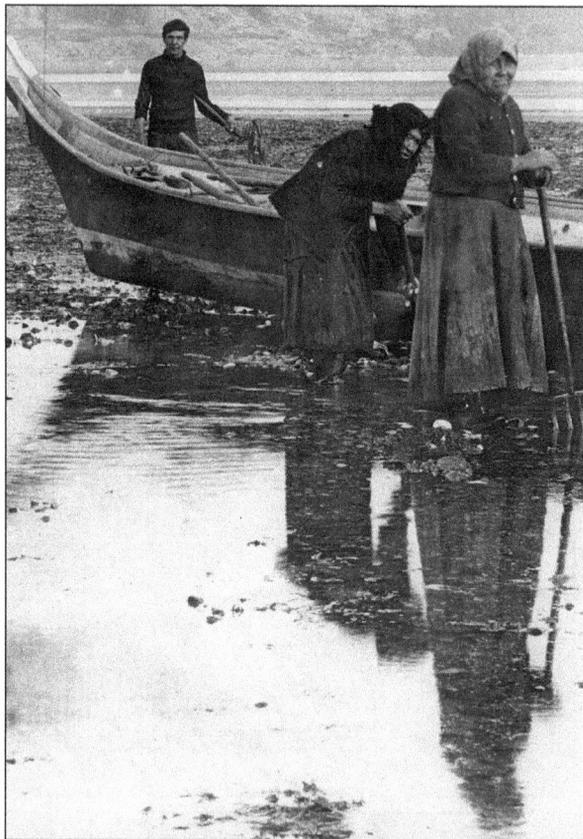

Two Native Women and a Man Dig for Clams. When Port Townsend was founded, S'Klallam chief T'Chits-a-ma-hun, most closely pronounced by the settlers as Chetzemoka, befriended the settlers. For years, he prevented warfare from erupting, even as his tribe was destroyed by disease, alcohol, and cultural disruption.

Canoes at Point Hudson. Depending upon the season, 50 to 500 S'Klallam were living at Kah Tai in 1851. In response to the rapidly growing town, they formed a small permanent colony on Point Hudson from which they sold the townspeople fish, shellfish, baskets, and weavings. Periodically, city officials sought to remove this "blight," and by 1889, nearly all of the Native Americans at Point Hudson were gone. Ironically, by the early 1900s, Native Americans were considered a picturesque attraction and their absence regretted.

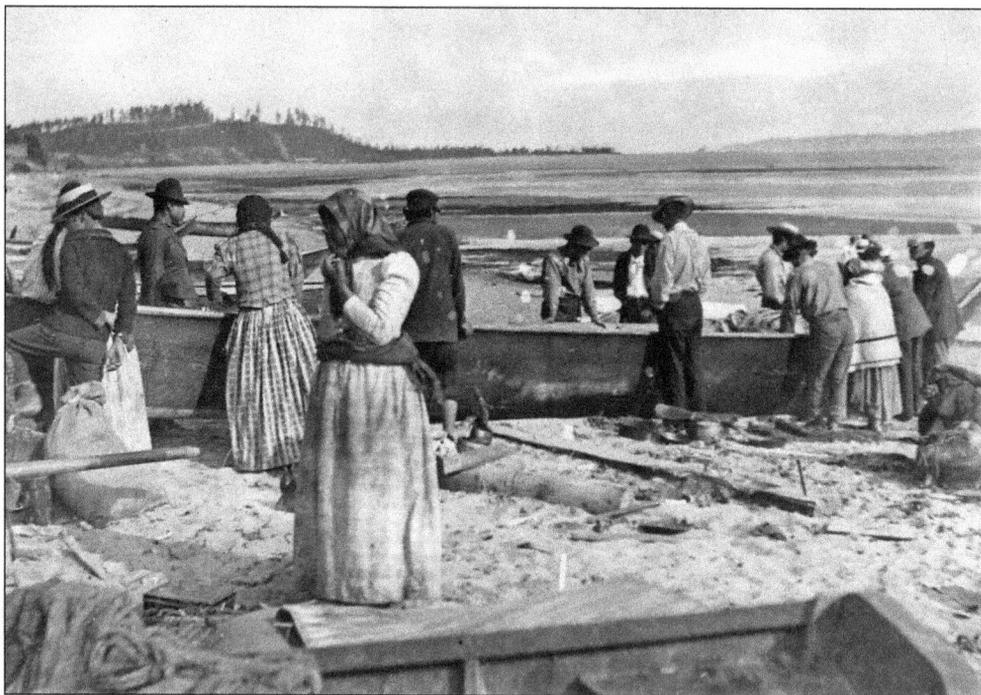

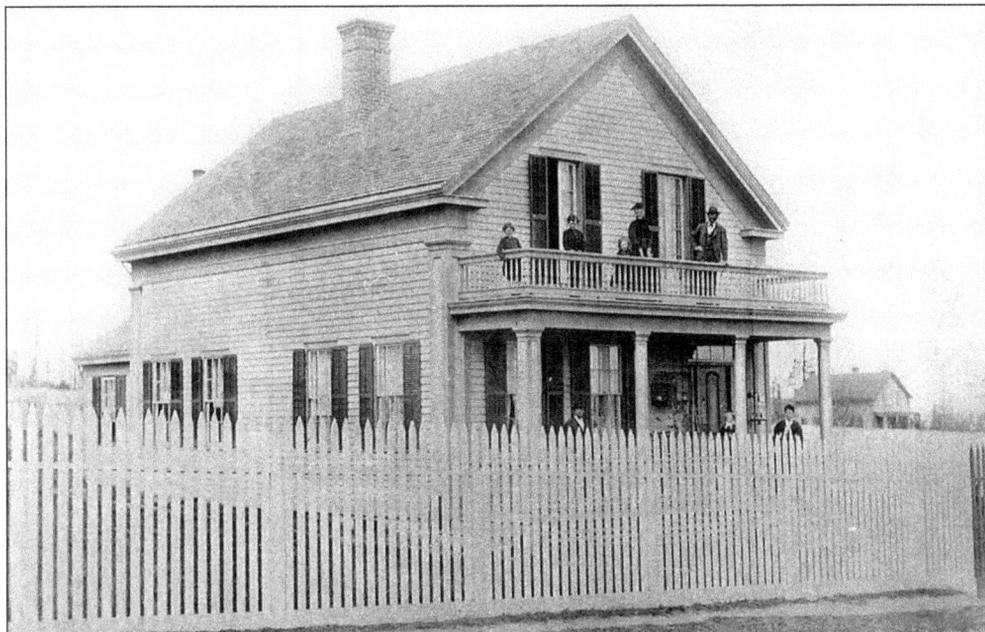

ROTHSCHILD HOUSE. The newly completed Rothschild house is pictured with the family on the second-floor porch. Horace Tucker built the house in 1868 in the Greek Revival style, which was popular in America in the mid-1800s. D. C. H. Rothschild was a merchant, the owner of the Kentucky Store, which was later named Rothschild and Company. The house is now a historic home museum filled with the family's possessions.

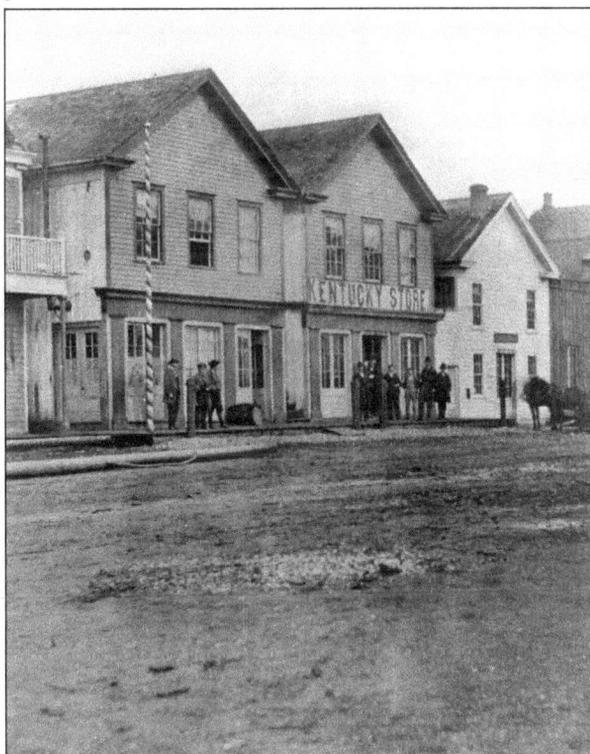

KENTUCKY STORE. D. C. H. Rothschild built the Kentucky Store in 1858 after he made his way from Kentucky to Port Townsend via the California Gold Rush and the Far East. He set up shop just in time to supply rapid growth in Puget Sound settlement shipping. He later changed the business name to Rothschild and Company and provided a vast array of merchandise: "from needles to anchors," according to newspaper advertisements of the time.

THE CAPT. ENOCH FOWLER HOUSE, C. 1870. Capt. Enoch S. Fowler also built Port Townsend's first wharf behind the old customs house at Water and Taylor Streets. Fowler built this classic Greek Revival home soon after purchasing the property in 1864, making it one of the oldest buildings in town. Members of the Fowler Family lived here until 1919.

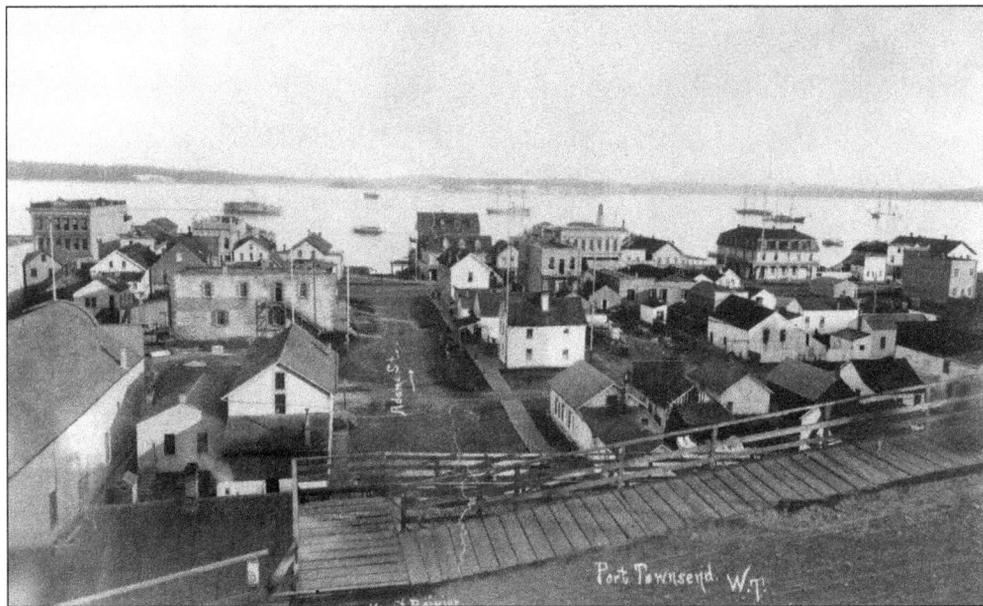

DOWNTOWN PORT TOWNSEND. This view shows the Fowler Building on Adams Street (left of center with the stairway up the side). In 1874, Capt. E. S. Fowler erected the two-story stone building, which at one time housed the Masonic Lodge and then served as courthouse until the current one was completed in 1892. The building was later acquired by the current owner, the Leader Publishing Company.

Two

BUSTLING SEAPORT

Status came quickly to the rapidly growing village of Port Townsend. In 1854, the federal government moved the official port of entry for Washington Territory from Olympia to Port Townsend. Every vessel entering Puget Sound from any foreign port was required to stop in Port Townsend for inspection and payment of duty on imported goods. It was often the first stop after a long voyage.

The majority of businesses catered to ships' needs and the entertainment of sailors. Ships were repaired and resupplied while in port. Tugboats were hired to pull sailing ships into the sound, and ferries moved people, mail, and merchandise between coastal towns. With ships came sailors, and rooming houses, hotels, waterfront bars, bordellos, gambling houses, and theatres. Port Townsend became notorious worldwide as the rowdiest port town north of San Francisco.

By 1890, little Port Townsend sported dozens of saloons, hotels, and rooming houses of more or less "ill repute." The downtown waterfront district was notorious throughout the region for the pleasures awaiting unattached, adventurous men and the treachery that stalked the naïve.

Maritime traffic increased and became more competitive. A black market flourished, keeping the customs collector's revenue cutters busy trying to catch smugglers. Fortunes were made on all aspects of maritime enterprises—legal and otherwise. At one point, there was a bar for every 75 residents, and most of the city's income came from the sale of liquor licenses. In 1888 alone, nearly 1,000 vessels with a total tonnage of over 800,000 tons cleared customs in Port Townsend, while masters of vessels and sailors spent an estimated $4 million.

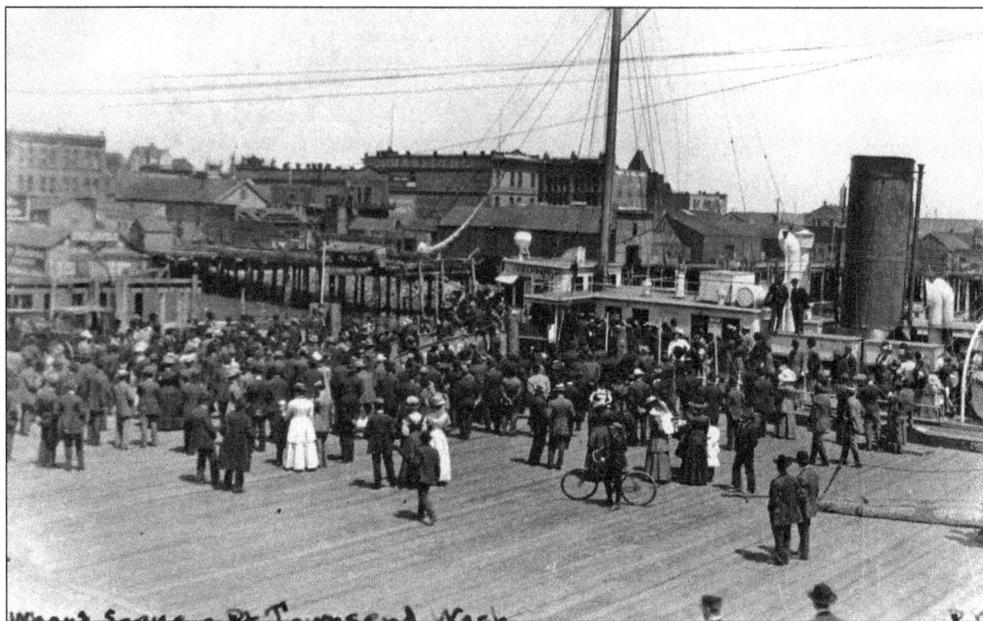

A BUSY UNION WHARF SCENE. At the end of Taylor Street, Union Wharf was a hub for small businesses catering to water-borne commerce, including saloons, boardinghouses, and shipping agents.

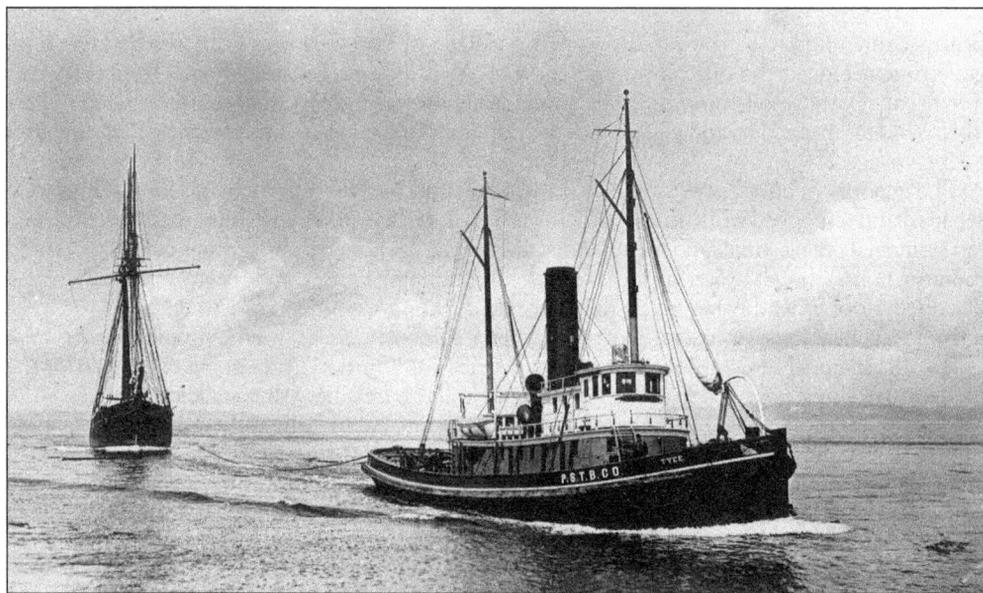

TUGBOATS. A steam-powered tugboat from the Puget Sound Tug Boat Company tows the SS *Tyee*. The deepwater sailors did not like the idea of being towed up the strait and referred to tugboats as "wood-eating, smoke-spitting, aquatic threshing machines." However, the ship owners quickly realized that it was faster, cheaper, and safer to pay for a tow than risk the vagaries and expense of uncooperative winds and tides. The tugboat earned a place as an important part of the maritime commerce of Puget Sound and remains as important as ever.

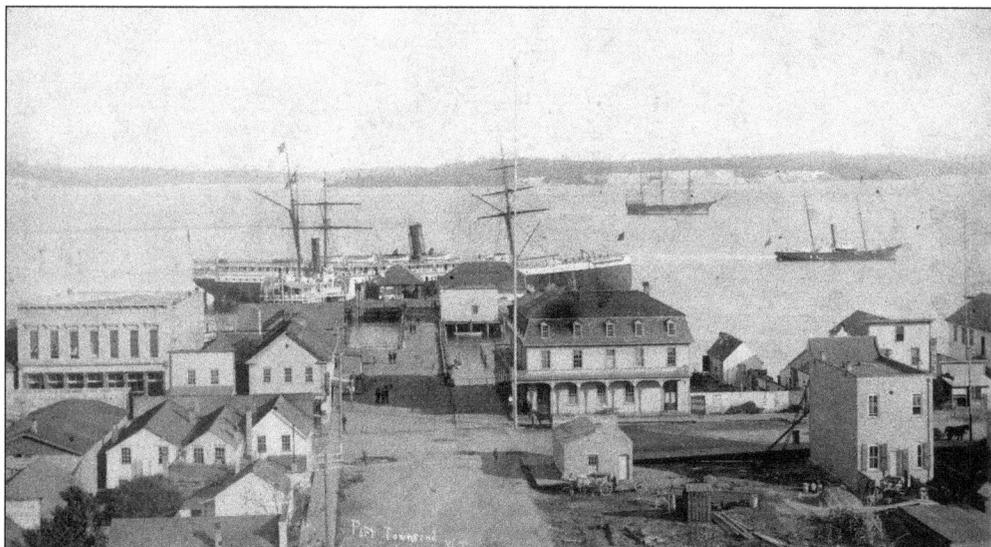

UNION WHARF. The Union Wharf is pictured prior to 1889 with the SS *Queen of the Pacific* at the dock. The Central Hotel, near the center, was a large three-story structure with an ornate balcony around two sides. It was a favorite spot for distinguished visitors and politicians to address the populace. Among the more notable were Pres. Rutherford Hayes, Sen. Benjamin Harrison, and Ulysses S. Grant. The hotel's main floor featured a large lobby, restaurant, and an ornate bar. It was a popular place for captains and their wives to stay while their ships were in port.

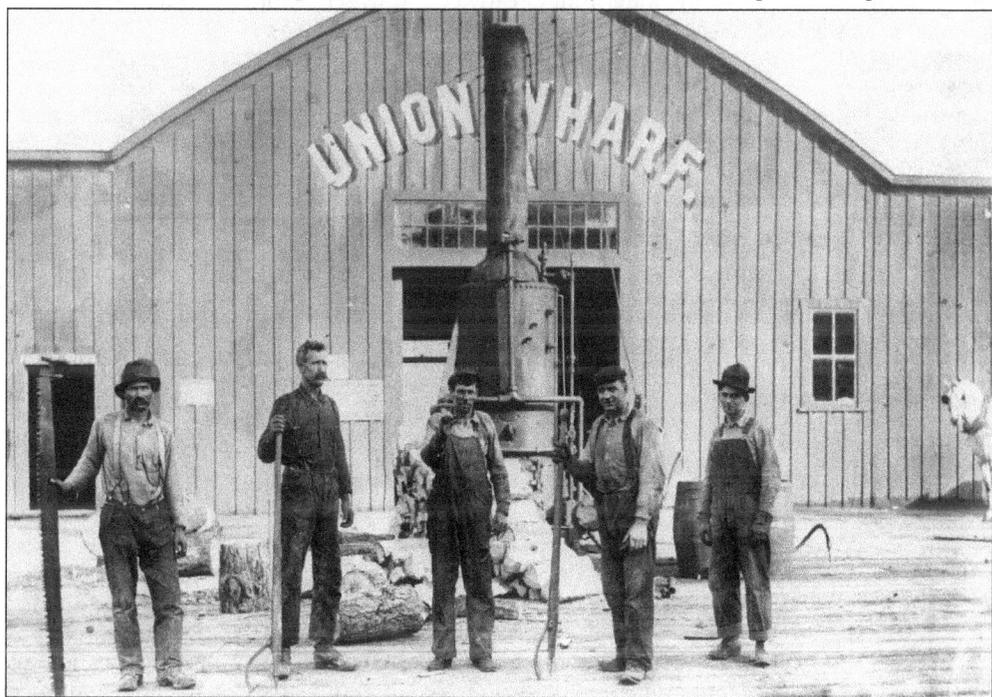

UNION WHARF CREW. This scene depicts a Union Wharf crew standing with log picks, saws, and logs in front of a large stove, possibly used to run a steam-powered saw inside the building. In 1867, Capt. Henry Tibbals, H. H. Hibbard, and L. B. Hastings formed a corporation to build Union Wharf.

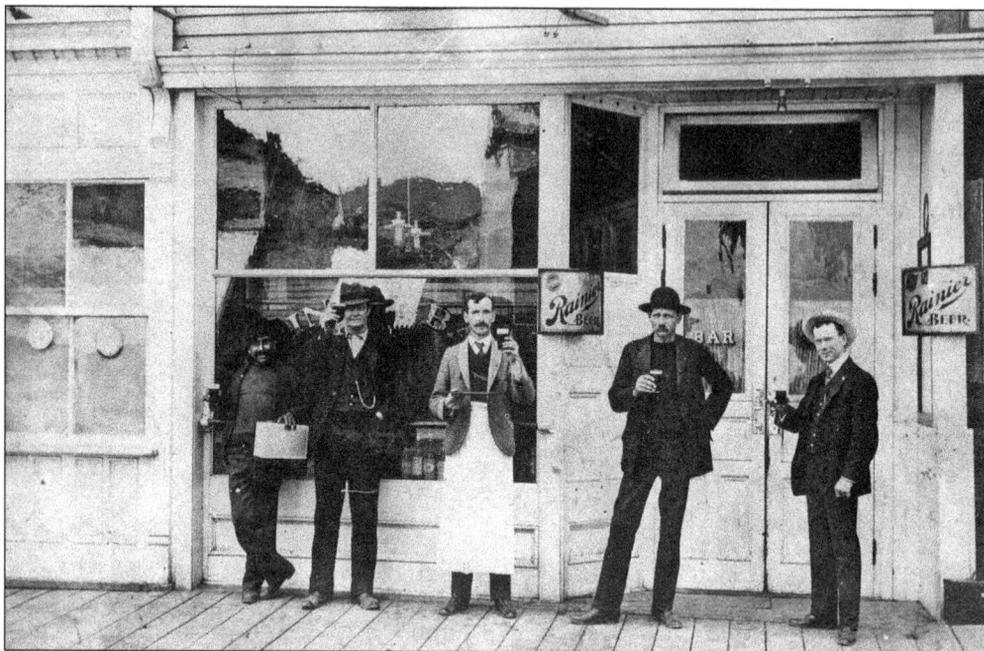

PORT TOWNSEND SALOON. Five unidentified men are seen here partaking of a glass of beer, perhaps at the Rainier Bar at 305–307 Water Street. Men looking for work or with money to spend gravitated to the bustling waterfront of early Port Townsend. Entrepreneurs of every kind followed closely behind them. In 1865, Port Townsend had six saloons.

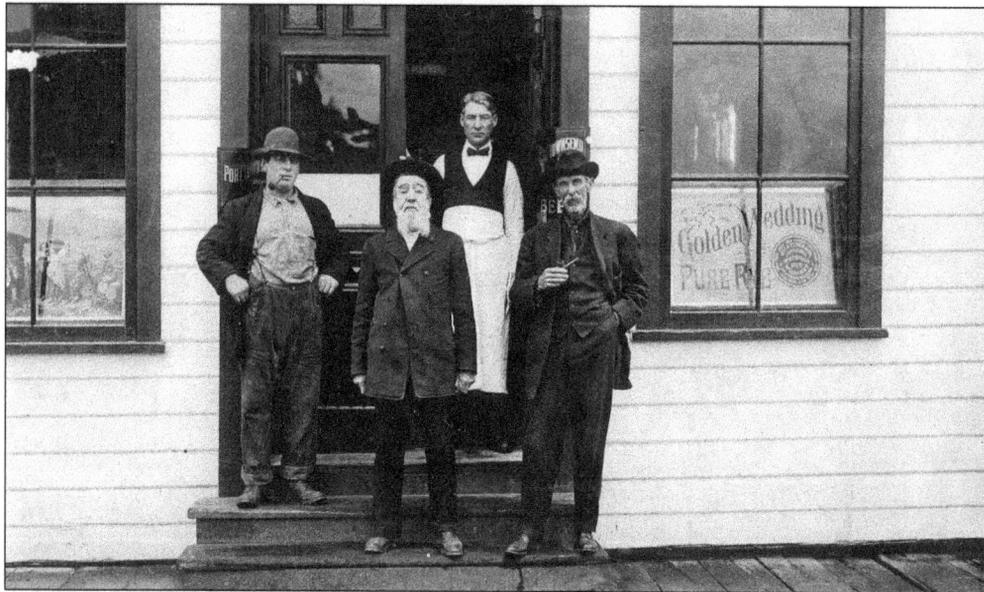

PACIFIC SALOON. Patsy Lennin's Pacific Saloon was located on Union Wharf. Sailors, joining loggers, soldiers, miners, and farmers in the search for entertainment, camaraderie, and work, converged on the bars, which sprang up like toadstools along Water Street and Front Street (formerly the boardwalk along the wharves of the waterfront). The bar clientele was typically transient and often on a spree after a long stint in service. Joe Kuhn is pictured at center front. Kuhn was an early settler who was the town's first photographer, a lawyer, judge, mayor, and entrepreneur.

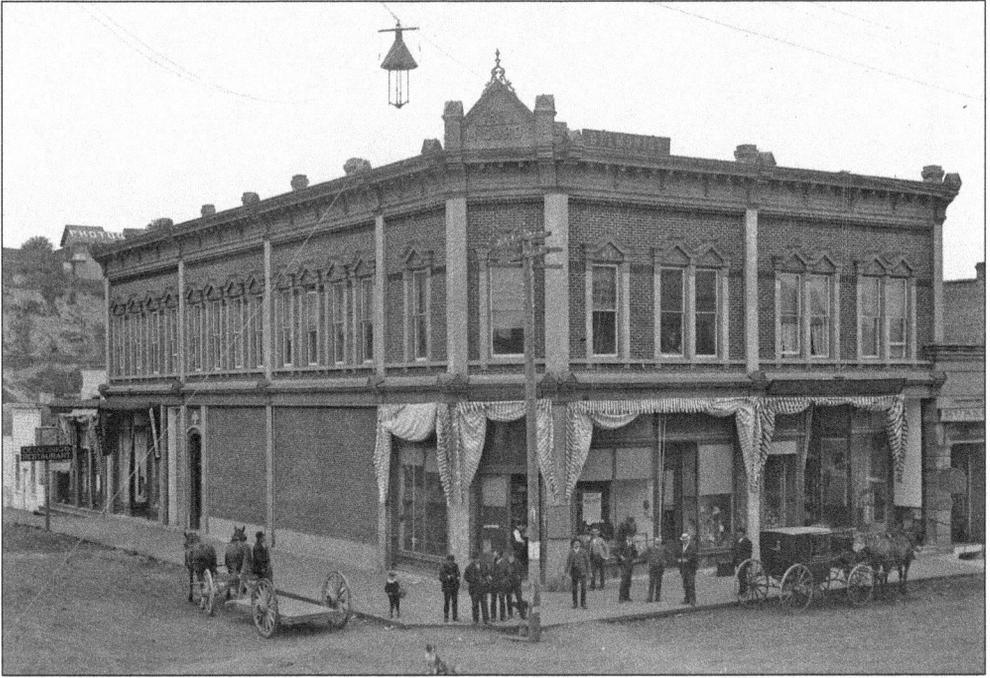

McCurdy Building The McCurdy Building was located downtown at Water and Taylor Streets. It housed Delmonico's, which consisted of a bar, hotel, restaurant, and card room. For over 85 years, it was one of Port Townsend's most popular spots, especially for the male population.

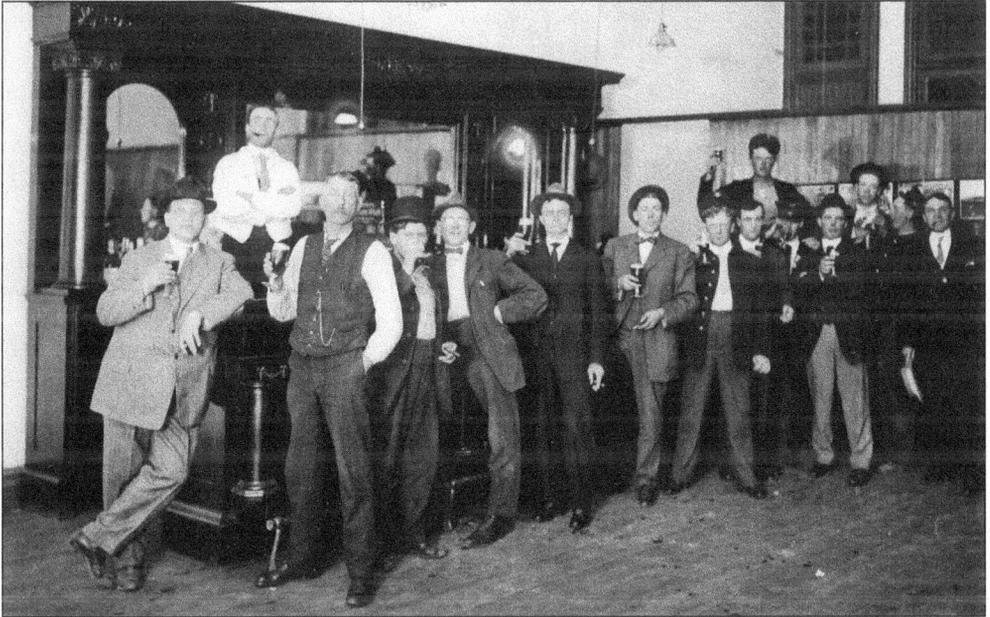

The Chandler and Andrews Bar. Port Townsend's early bars and bordellos were an essential part of the local economy. A functional saloon required little more than alcohol and someone to dispense it, but many were embellished with fancy wooden bars with mirrored backs, tables and chairs, gilt wallpaper, paintings, and female company. A bar's style determined the character of its clientele, but "respectable women" never entered these early establishments.

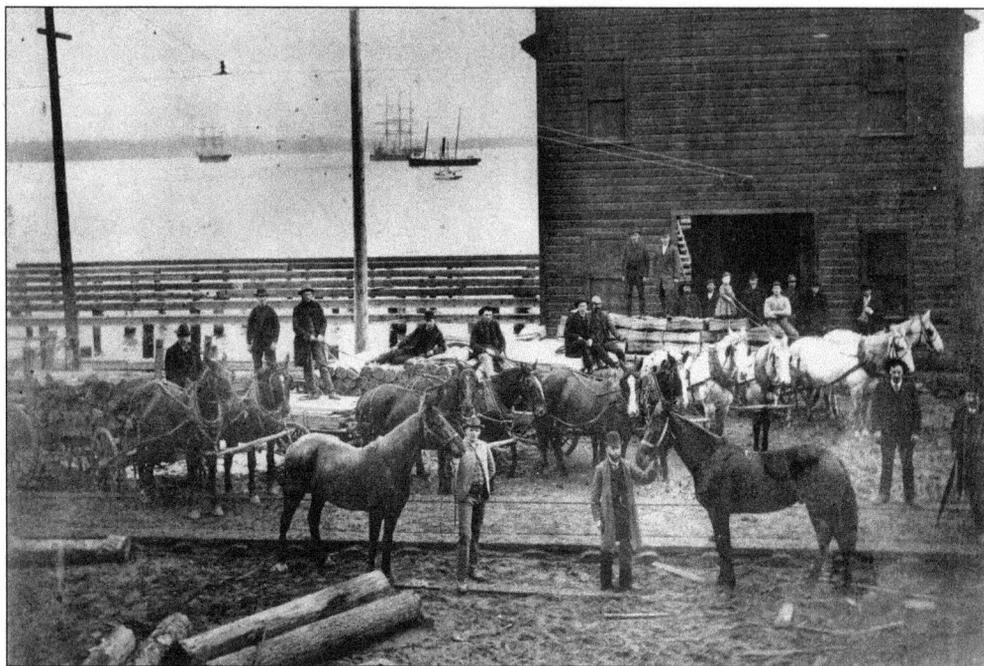

"HORSES FOR TIBBALS' RACETRACK." Written on the back of this photograph is the following: "Horses for Tibbals' racetrack, William Laubach's Stables, 1890, Nelson with registered trotters, Eddie Pibb with Old Charlie." H. L. Tibbals was a colorful character involved in many local pursuits. In 1888, he built Tibbals Lake Park and racetrack just outside town. The local streetcar provided easy access to the park and racetrack.

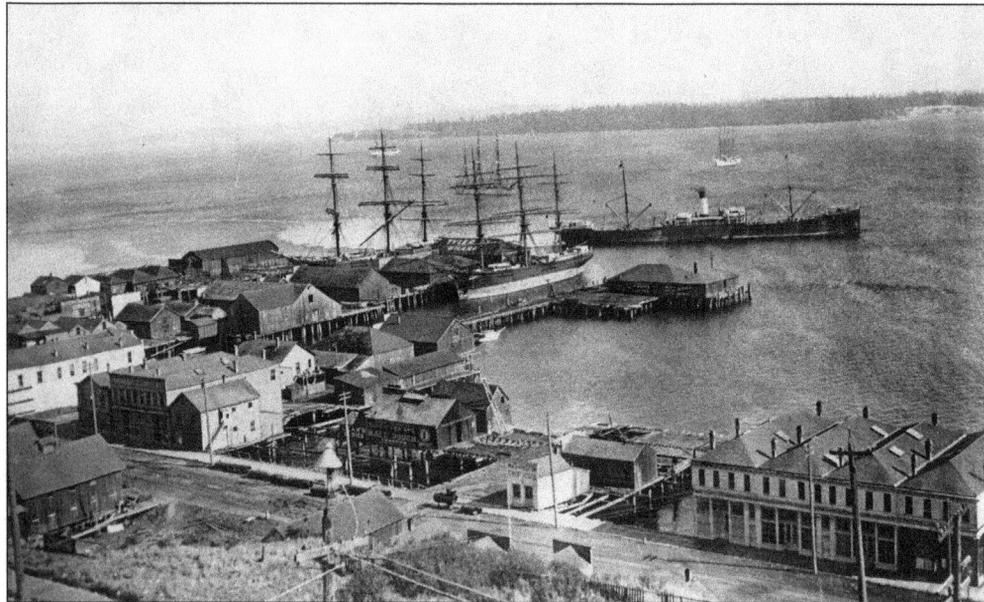

TYLER STREET WHARF. The Tyler Street Wharf is seen from the bluff above with a departing steamer and moored sailing ships. The Majestic Hotel (the large building to the right) was built around 1888. It was sold in 1912 and its furnishings auctioned off in 1915. By 1923, the city put out a contract bid to tear the building down.

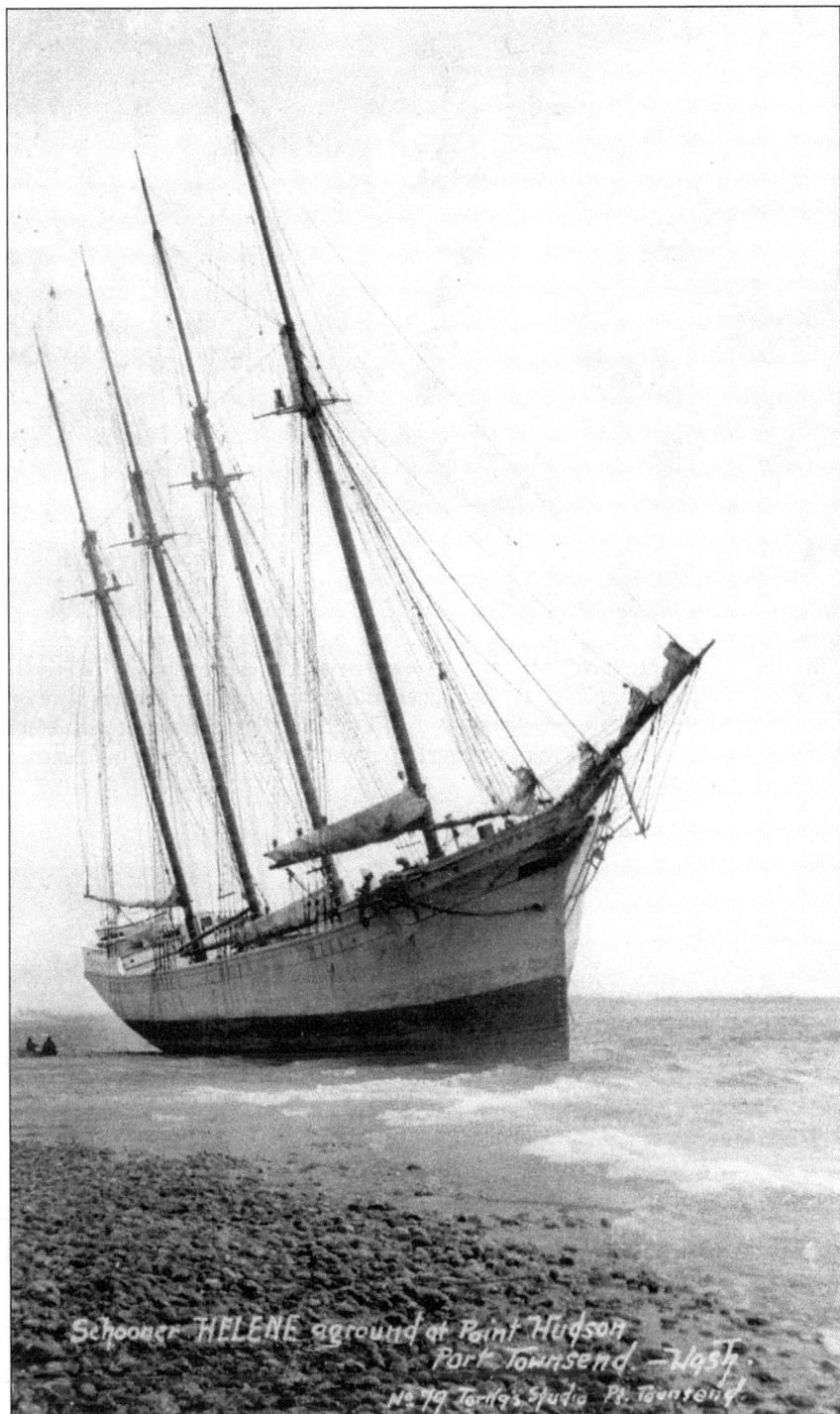

SV HELENE. The *Helene* ran aground at Point Hudson just off Port Townsend's waterfront. Hall Brothers built the 202-foot, four-mast schooner in 1900 in Port Blakely, Washington. Admiralty Inlet connects the Strait of Juan de Fuca and Puget Sound. Its colliding currents stir up some of the most treacherous riptides in the region.

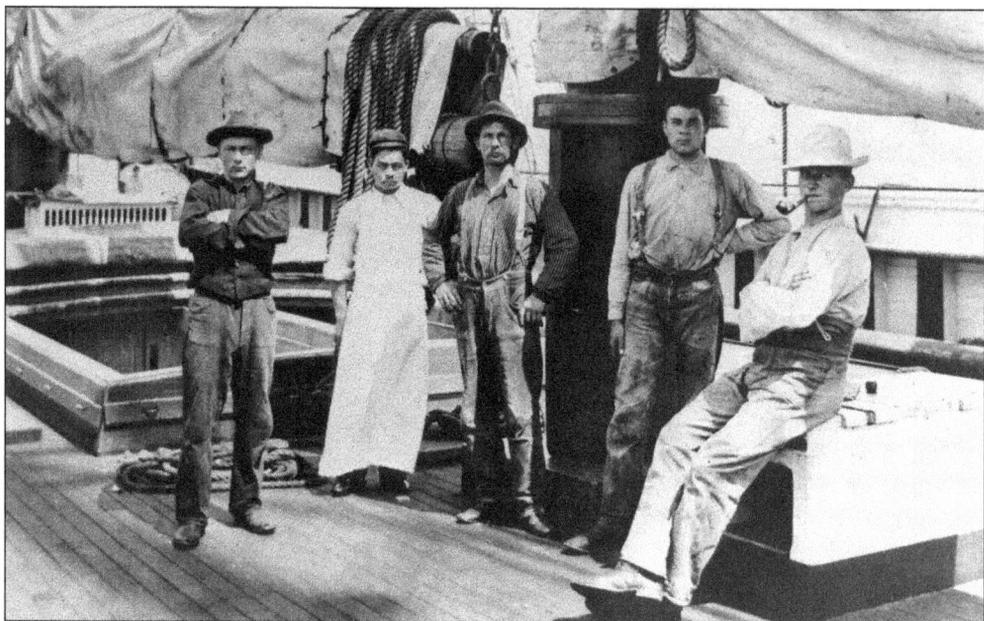

MERCHANT SEAMEN. The five-man crew of the SV *Winslow*, a four-mast schooner, is pictured here. Until the early 1900s, merchant seamen were among the most exploited, ill-treated, and maligned of any workers. Danger at sea, low wages, and mistreatment by officers were only part of the abuse they suffered. Many were shanghaied—a legal practice no different than kidnapping. Once ashore, a variety of "sharks" were waiting to separate sailors from their hard-earned pay

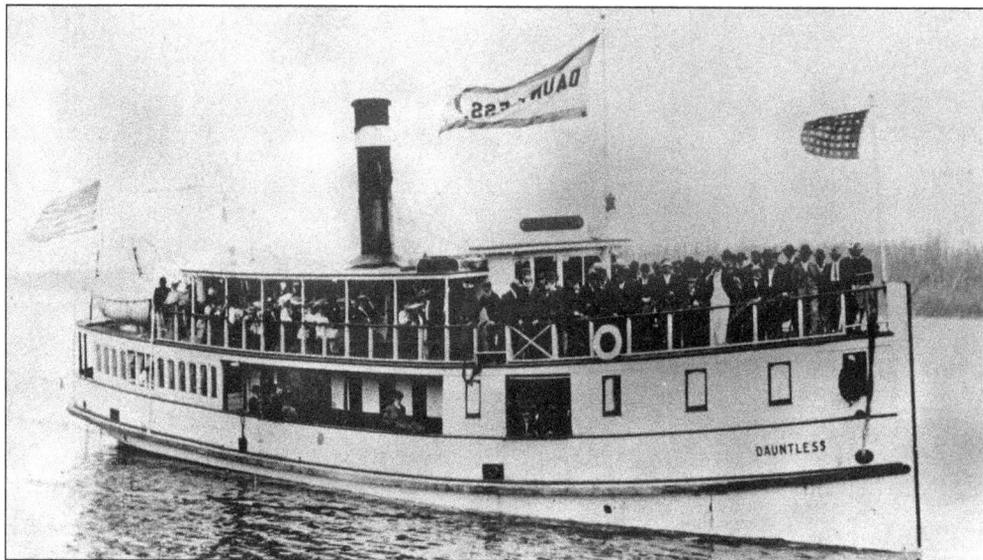

SS *DAUNTLESS*, PASSENGER FERRY UNDERWAY. Known as the Mosquito Fleet, more than 2,500 steamships navigated from port to port around the Puget Sound from the 1850s to the 1930s. They were so numerous that people said they resembled a "swarm of mosquitoes." Vessels large and small moved settlers, farm produce and livestock, machinery, troops, timber, tourists, mail, and everything else needed to build and serve towns at and near the water's edge. Every settlement, no matter how small, had a pier, dock, or float. These "whistle stops" were their link to the greater community.

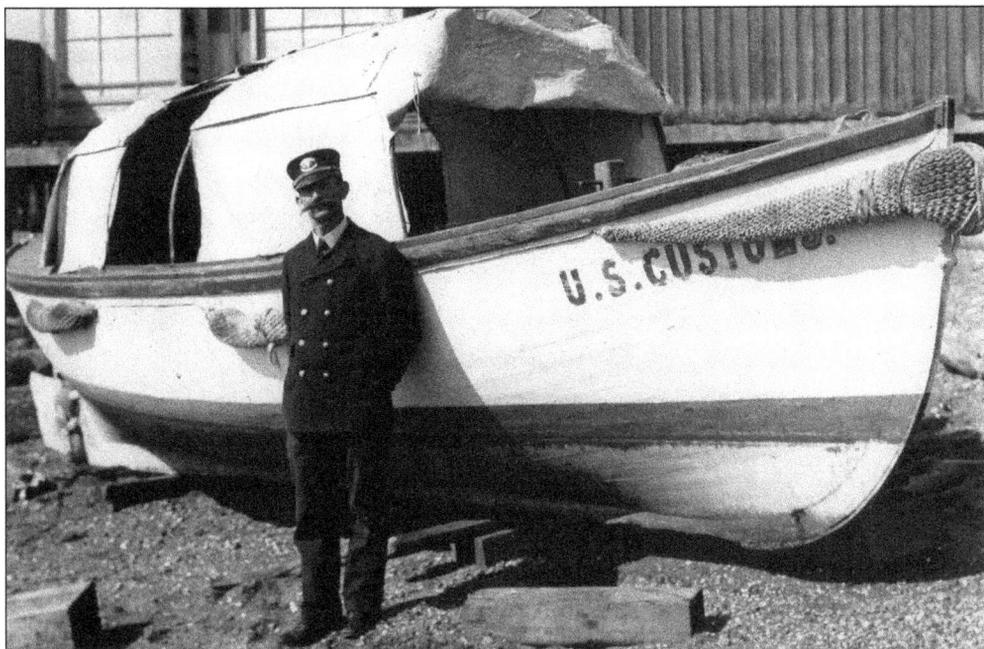

SMUGGLERS. Customs inspector Fred C. Dean poses with a smuggling launch that was seized and converted into a customs launch. Inspector Dean captured Larry Kelly, a famous smuggler.

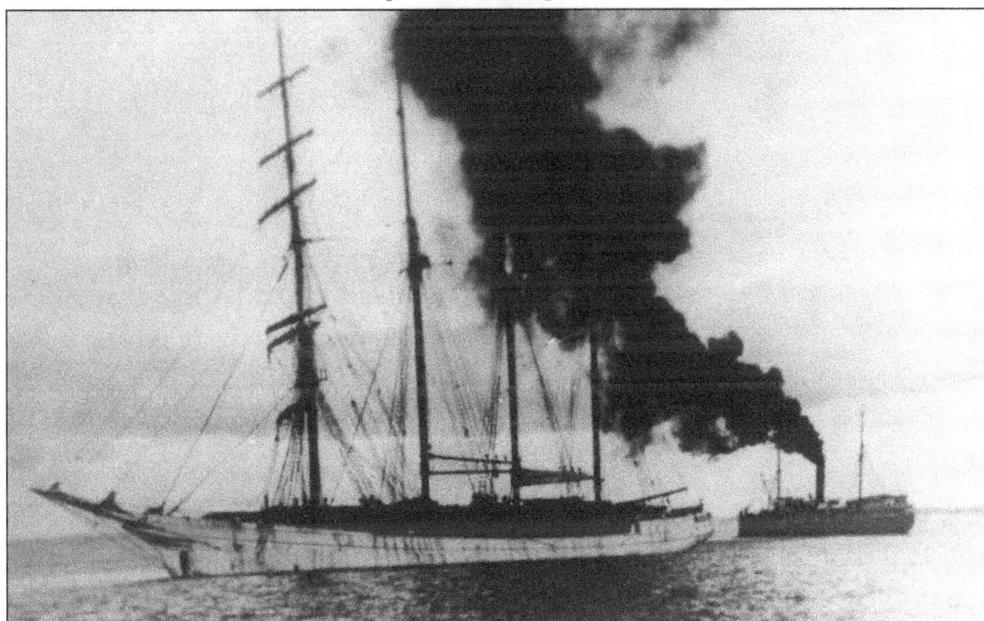

PORT TOWNSEND SHIPS. A steam passenger ferry passes behind an anchored four-mast ship in Port Townsend Bay. Steamship technology replaced the beautiful sailing ships and rendered Port Townsend's strategic location at the entrance to Puget Sound insignificant. By the late 1920s and early 1930s, regular steamboat passenger and freight service among Puget Sound communities was waning. Many of the wooden steamers met with disaster in one form or another. If they didn't explode, collide with other vessels, or succumb to often treacherous weather, they suffered from competition as roads and bridges were built.

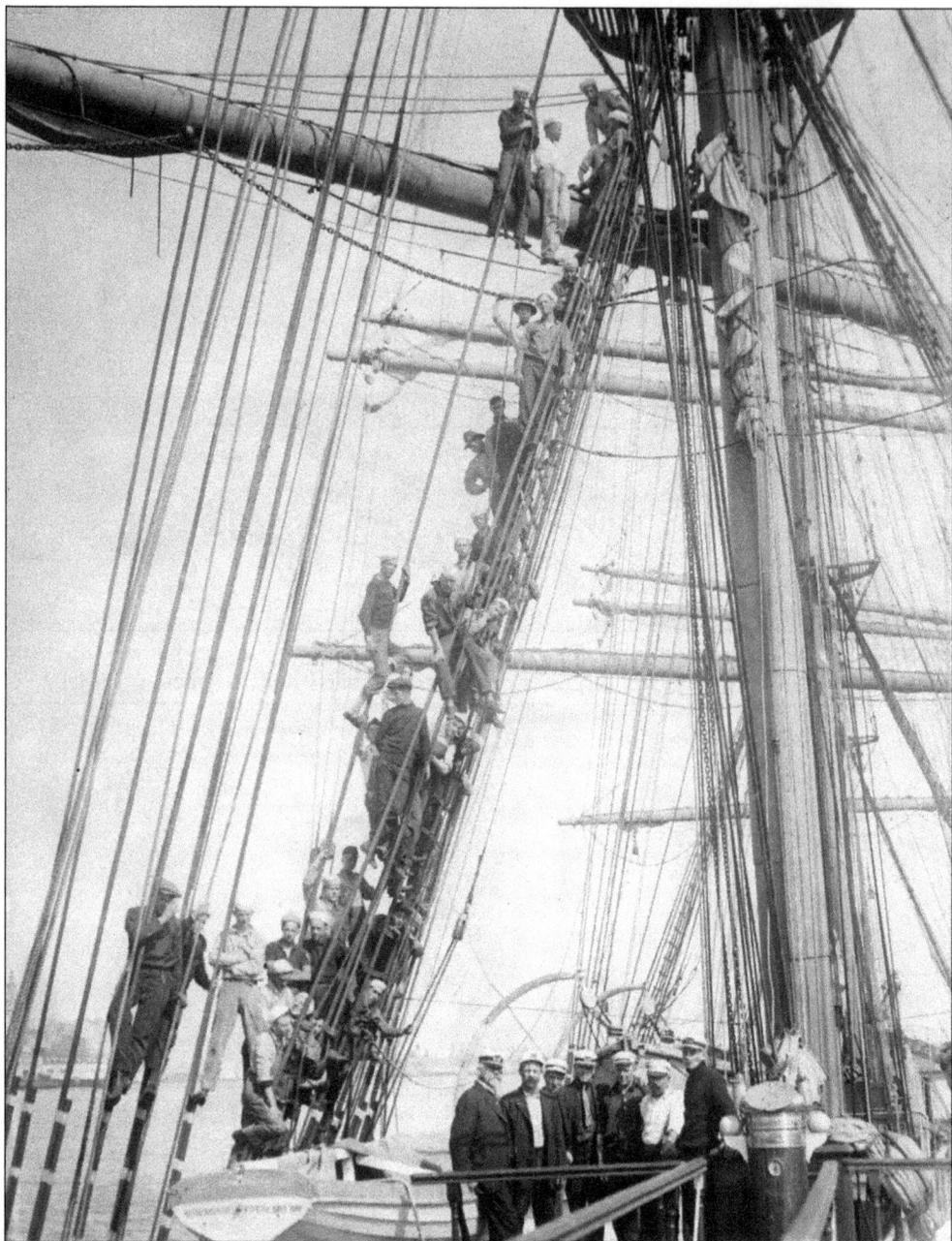

USS Monongahela. The USS *Monongahela*, a three-masted training ship at Fort Worden, is pictured with the crew in the rigging and officers and captain on deck. The *Monongahela* was a 2,078-ton steam screw sloop built at the Philadelphia Navy Yard in 1863. Her long, illustrious career ended in 1904, when she became a storeship at Guantanamo Bay, Cuba. She was destroyed by fire there on March 17, 1908.

Three

CITY OF DREAMS

By 1870, nearly 600 new settlers had arrived in Port Townsend, building most of their homes on the bluff above the waterfront. Property owners' imaginations were inflamed with speculation that the transcontinental Union Pacific Railroad, under construction to Portland and then north to Puget Sound, would make its terminus at Port Townsend.

Despite intense lobbying and boasts that Port Townsend was the "Key City" of Puget Sound, Tacoma was chosen for the terminus in 1873. Undeterred, Port Townsend investors formed the Port Townsend Southern Railroad to connect to the Tacoma line.

In 1890, the Oregon Improvement Company, a subsidiary of the Union Pacific, agreed to build and operate the railroad between the two points. The trustees of the Port Townsend Southern transferred their franchise and holdings to the new group. Following completion of the deal in March 1890, a crew of 1,500 men started work on the track.

Property values skyrocketed and businesses flourished as the population doubled. Most of the architecture that characterizes Port Townsend's historic district was built between 1889 and 1892 on the momentum of this economic boom. At its peak, the city boasted six banks, three street railways, and a new electric company. Consulates for Peru, Chile, Great Britain, Germany, France, and the Hawaiian islands were established. Major public buildings were constructed to serve a predicted population of 20,000, including the customs house and post office, the Jefferson County Courthouse, and the city hall.

There were storm clouds on the economic horizon as early as 1890, but Port Townsend's ecstatic speculators and investors appeared to have ignored them. The railroad never connected to Tacoma. When the nationwide financial panic of 1893 brought virtually all enterprises to a crashing halt, most Port Townsend property owners were extended far beyond their means and lost everything. Construction stopped, banks failed, and stores closed. Ships without commissions lay at anchor in the bay.

Although Port Townsend continued as the port for customs clearance, the ports of Seattle and Tacoma had direct access to railroad connections. These cities continued to flourish while Port Townsend was virtually forgotten.

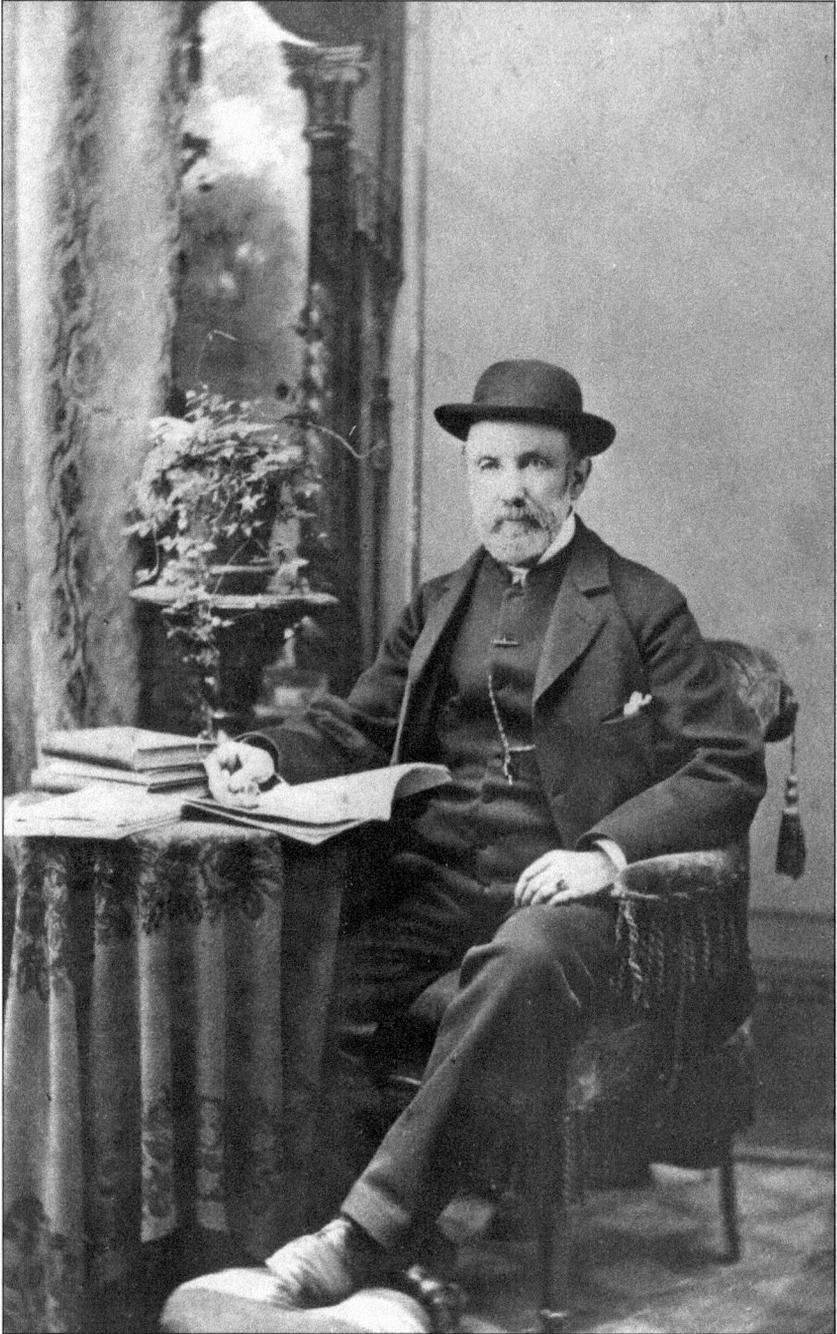

JAMES G. SWAN. This portrait of James G. Swan was taken in 1883, prior to his trip to the Queen Charlotte Islands to collect artifacts for the Smithsonian Institute. Swan made Port Townsend his home in 1866. An educated gentleman from Massachusetts, he served as customs inspector, secretary to congressional delegate Isaac Stevens, journalist, reservation schoolteacher, lawyer, judge, school superintendent, railroad promoter, natural historian, and ethnographer. He was a great friend to area natives, collecting and documenting Native American art, technology, history, and legends.

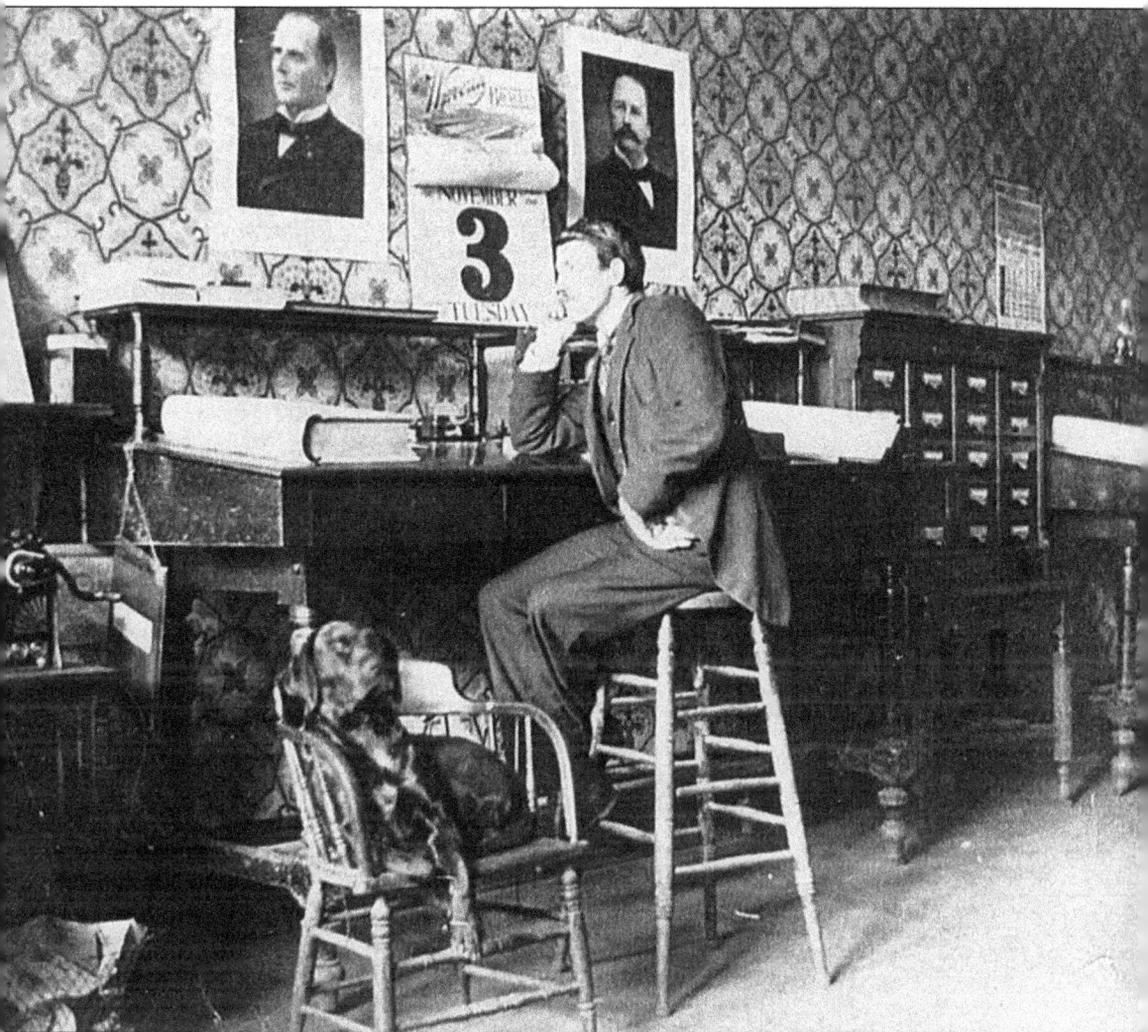

JAMES G. MCCURDY. James G. McCurdy sits on a stool in his office, apparently contemplating the election of November 3, 1896. Jumbo, the often-photographed family dog, is seated nearby. McCurdy was an assistant bank president at First National Bank. He left behind hundreds of glass-plate negatives that intimately illustrate the history of family and social lives of early Port Townsend settlers.

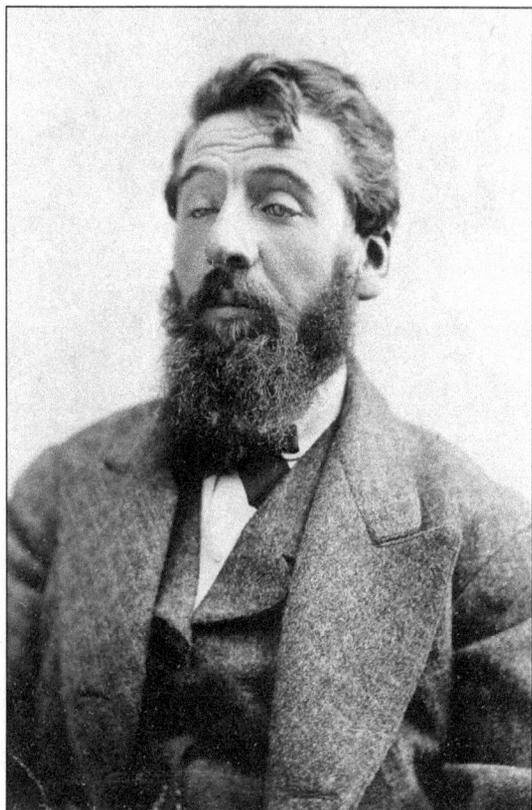

JOE KUHN. Another of Port Townsend's dreamers, Joe Kuhn was the city's first photographer, supporting himself with this new trade while he studied law. Admitted to the bar in 1870, he served in the state legislature, on city council, as commissioner of immigration, and as mayor. As a businessman, Kuhn was one of the founders of the Commercial Bank and was connected with the Merchants and First National Banks. He was active in the organization of the Port Townsend Southern Railroad Company. The Kuhn Building is located at Water and Polk Streets.

JOE KUHN'S DOG. This charming picture is of Joe Kuhn's dog on Water Street.

CHARLES EISENBEIS. Charles Eisenbeis, a baker, merchant, brewer, builder, speculator, and politician, was Port Townsend's first mayor. His bakery sold bread, biscuits, and hardtack to ships—staples needed by oceangoing vessels. In 1873, he built the first stone building on Water Street, and in 1890, he built the Mount Baker Block. He had interests in a brickyard, wharves and docks, a lumber mill, the Port Townsend Southern Railroad, the Port Townsend Steel Wire and Nail Company, banks, and a huge hotel that was later converted into the Northwest Sanatorium. He built a brick-and-stone family home that was expanded to serve as a Jesuit seminary for many years. It is now a hotel known as the Manresa Castle.

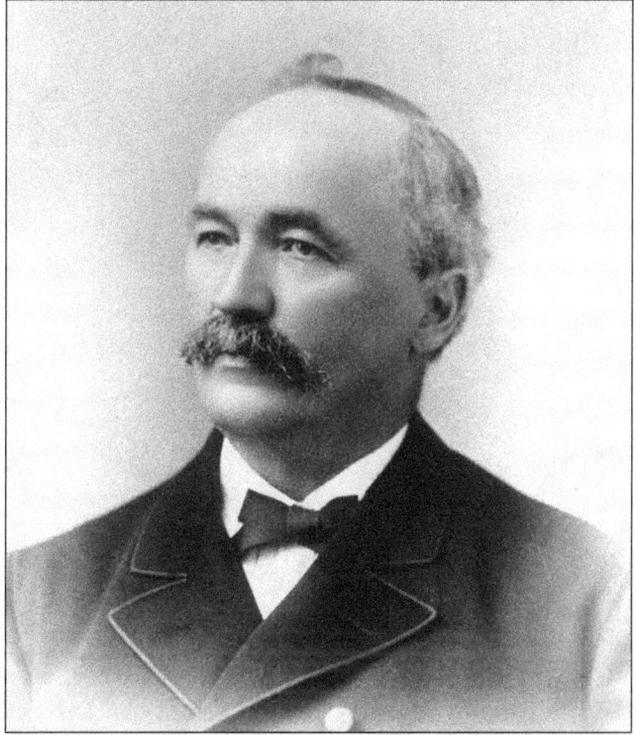

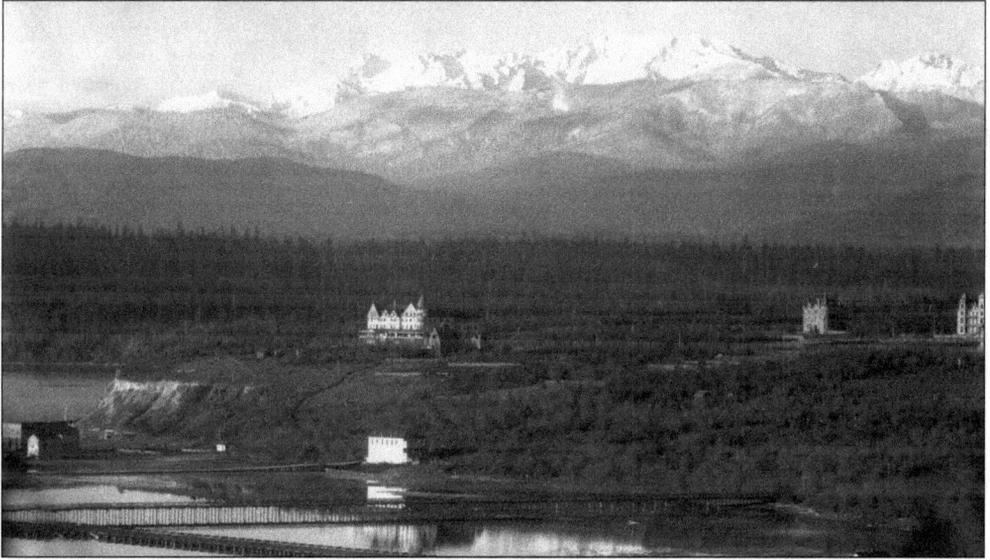

BOOM TIMES. With the snowcapped Olympic Mountains in the background, major boom time buildings look out over Port Townsend Bay. From left to right are the Eisenbeis Hotel (later the Northwest Sanatorium), the J. C. Saunder house, the Eisenbeis house (later Manresa Castle), and St. John's Hospital. In the foreground, Kah Tai Lagoon is crossed with trestles for the trolley car. The Eisenbeis Hotel was completed in 1903. Nothing remains of the five-story, wood-frame hotel that had more than 100 rooms. It cost $96,000 to build and was auctioned off for $11,000 just a few years later. In 1906, it was renovated as the Northwest Sanitarium (a hospital) and used as such until 1914. An arsonist set it ablaze in 1923.

BRIGGS FARM. Briggs Farms was located two miles west of Port Townsend. Judge Briggs turned the first shovelful of earth, beginning construction of the Port Townsend Southern Railroad on March 23, 1889. The railroad became a subsidiary of the Union Pacific with Port Townsend announced as the terminus in the Pacific Northwest. The dream (and rush of real estate speculation) died when the terminus was located in Tacoma.

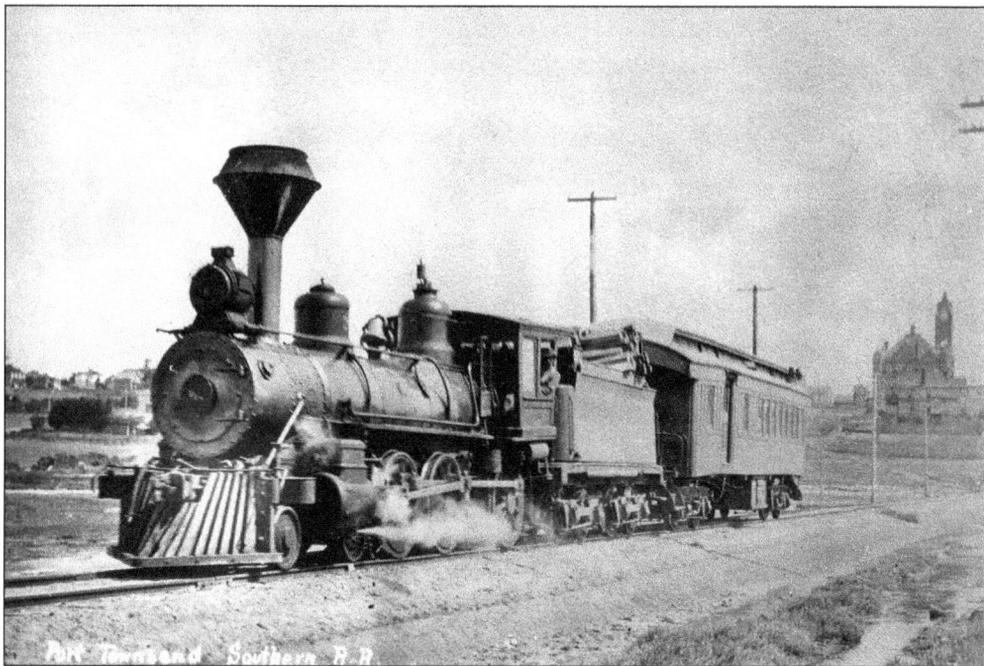

PORT TOWNSEND AND SOUTHERN RAILROAD. Port Townsend and Southern Railroad is pictured here on the flats across from Kah Tai Lagoon. Originally intended to connect with the Tacoma terminus of the Northern Pacific Railroad, the Southern ran from Port Townsend to Discovery Bay and Quilcene into the 1920s. It was then taken over by the Milwaukee Railroad, which ran service to Port Angeles until the 1980s.

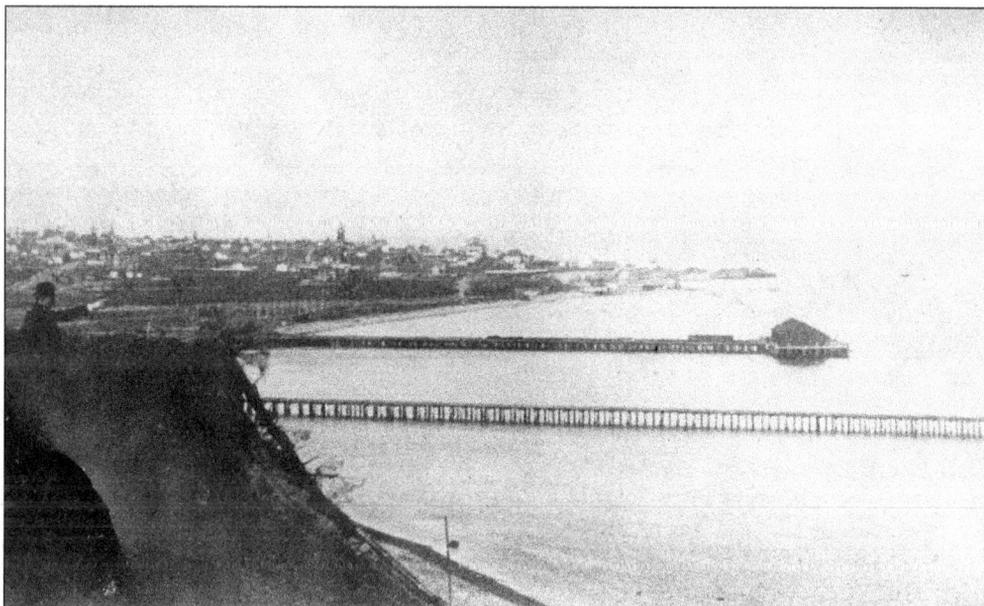

SOUTHERN RAILROAD. Pictured is the Port Townsend Southern Railroad dock into Port Townsend Bay in 1892.

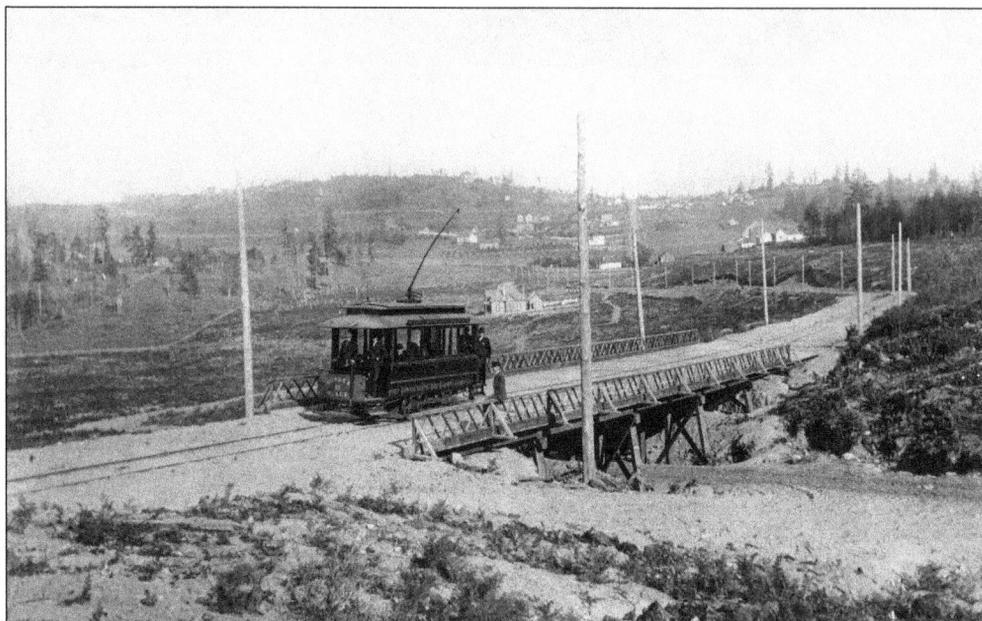

PORT TOWNSEND ELECTRIC RAILWAY COMPANY. The Port Townsend Electric Railway Company's Water, Lawrence, and Scott Street line is pictured here. In another 1880s frenzy of speculation, three streetcar lines were built to serve both existing and anticipated neighborhoods. Speculators financed the lines as a means of making their subdivisions more easily accessible, but the population never grew to support the service.

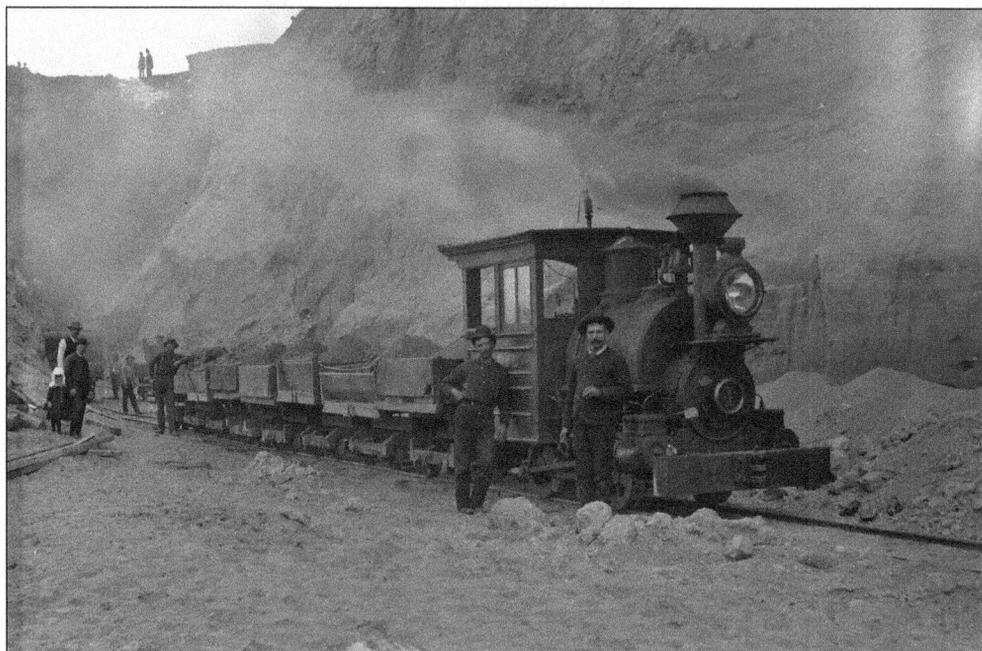

CUTTING BACK THE BLUFF. Cutting back the bluff along Water Street was achieved using a steam engine and railroad cars. Isolated by the high bluff behind it, the downtown business district was made more accessible by blasting and hauling away sections of the bluff and building a street at its base and to uptown.

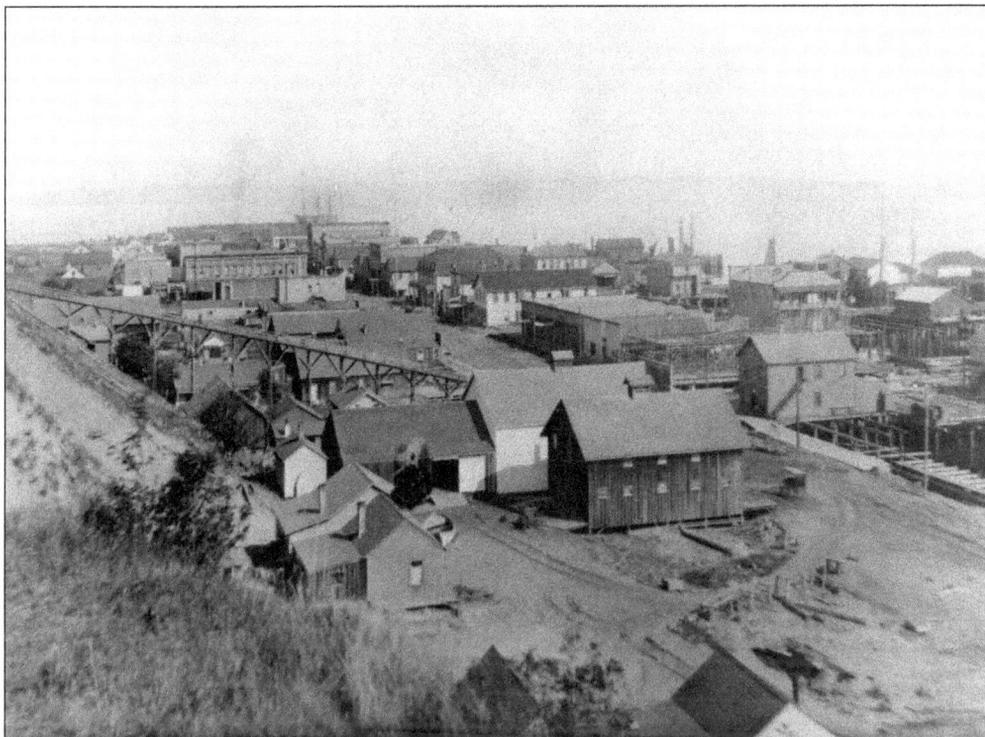

DOWNTOWN PORT TOWNSEND, 1887. This picture depicts downtown Port Townsend in 1887, just before the building boom swept the town into a frenzy of real estate speculation and construction, both commercial and residential.

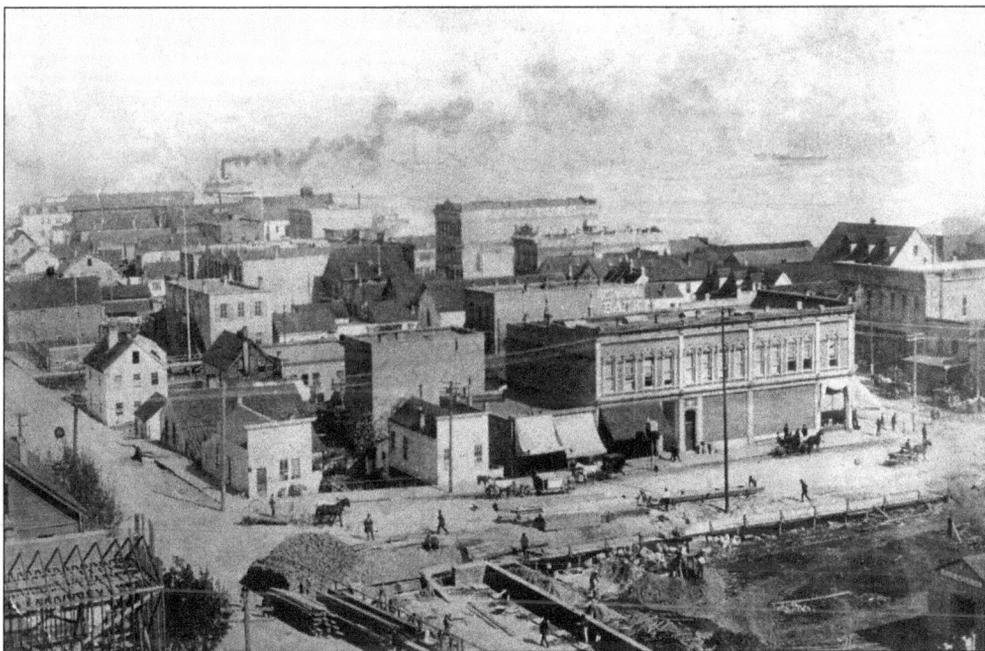

BUILDING BOOM. This view of the Port Townsend downtown shows Taylor Street with the Miller Burkett Building under construction and a steam ferry in background.

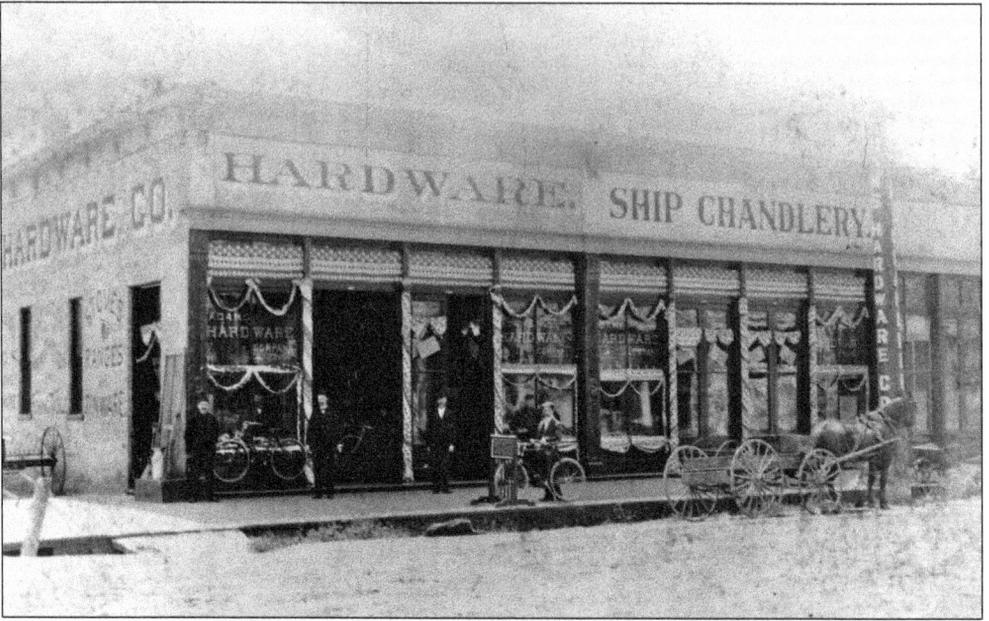

ADAMS HARDWARE COMPANY AT WATER AND TYLER STREETS, 1890. The store carried a great assortment of merchandise, including ship chandlery, hardware, paints, sporting goods, and household items. The Flagship Landing building is currently on the site.

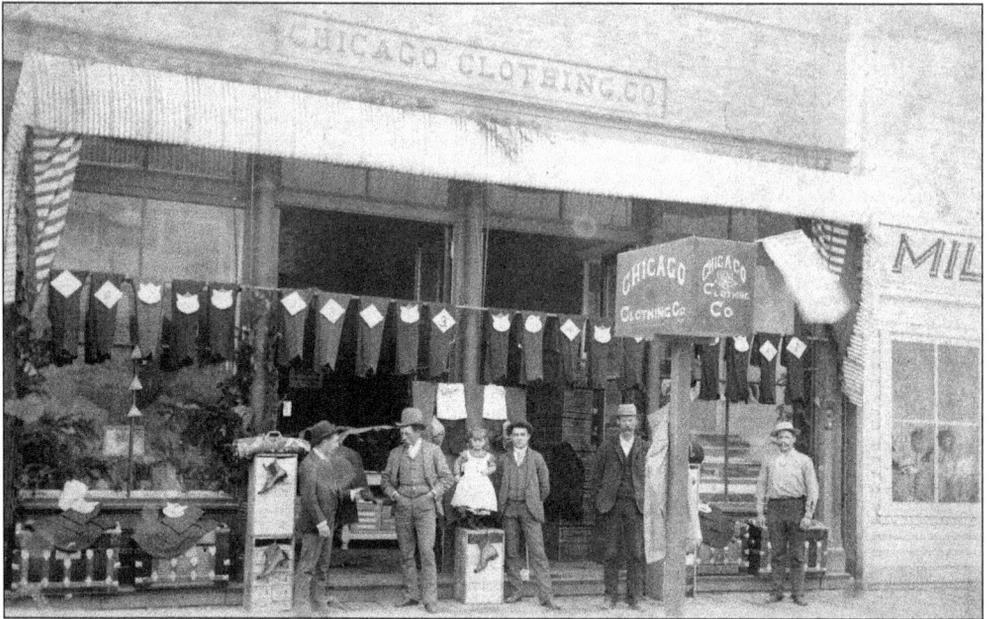

CHICAGO CLOTHING COMPANY, 1889. Pictured are, from left to right, Max Levy, unidentified, Dollie Pillep Robbins, Ed Newmann, unidentified, and Fredrick Abrath. Max Levy, left, was one of Port Townsend's more notorious shanghaiers. From the 1890s to 1910, Levy was the "king of the crimpers." Crimps were in the business of entrapping sailors into service against their will. Men were sent to Shanghai when, in the most extreme case, they were knocked out and placed on a ship on its way to the Far East. Levy was never convicted of any crime. Changes in laws and the switch to steamships, which required fewer sailors, forced him to give up his lucrative business.

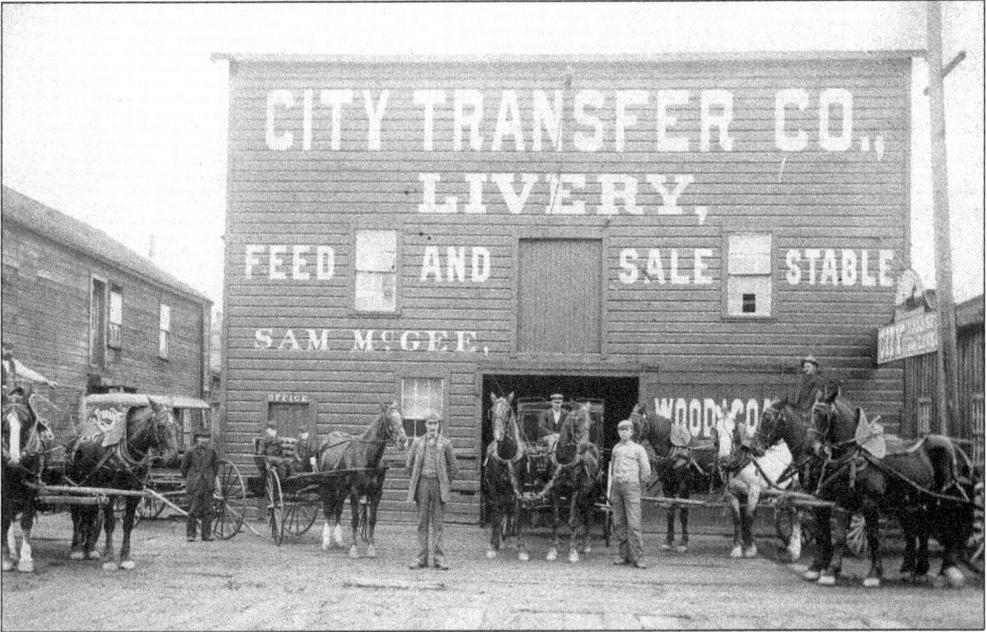

SAM MCGEE'S CITY TRANSFER COMPANY. Sam McGee's City Transfer Company was located on the Tyler Street Wharf, adjacent to Mount Baker Steam Laundry. McGee provided horses, buggies, and drayage services. He made the transition to horseless carriages when he started a taxi service and, by 1910, a bus to Quilcene. By World War I, he had a jitney service between Fort Worden and downtown. The wharf at Tyler Street was destroyed in a 1934 storm.

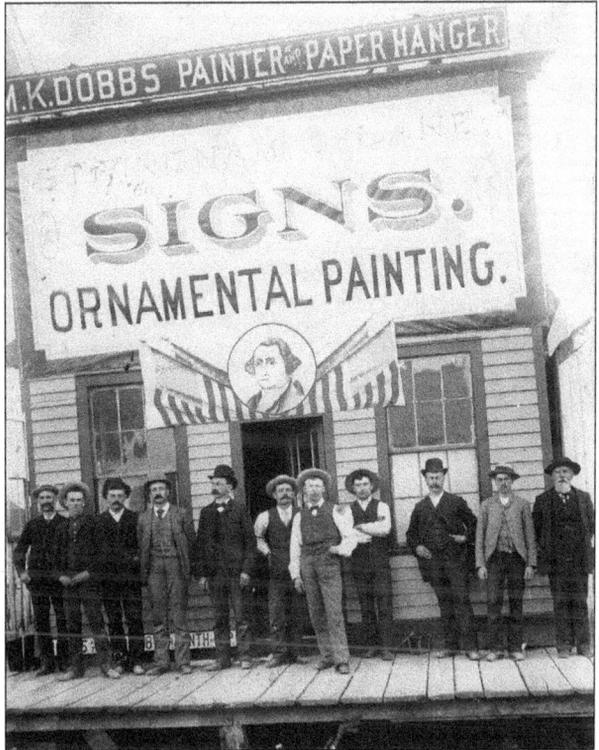

ADAMS STREET. The combined storefront of Charles Stringham and Cornelius Lane's sign shop and M. K. Dobbs Painter and Paper Hanger at Adams Street between Water and Washington Streets is pictured here.

39

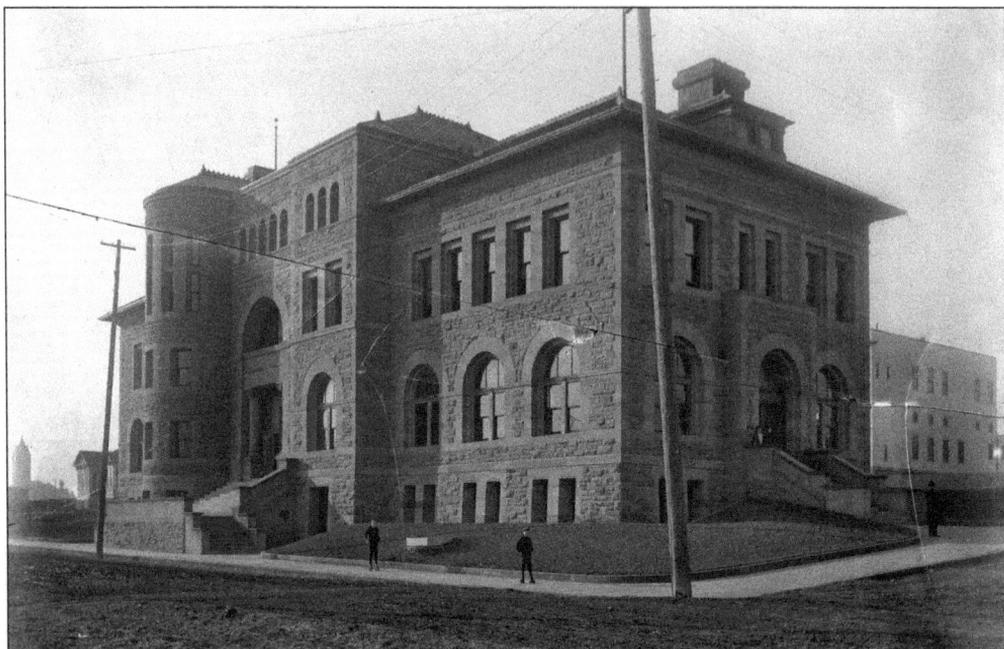

CUSTOMS HOUSE AND POST OFFICE. The customs house and post office were completed in 1892, with the old Masonic Hall behind them. For many years, the customs work was done in wooden buildings on the docks. In March 1885, Congress appropriated $70,000 to build a new customs house in Port Townsend. Plans changed many times before it was completed in 1893 for $241,822.81, making it the most expensive building in town.

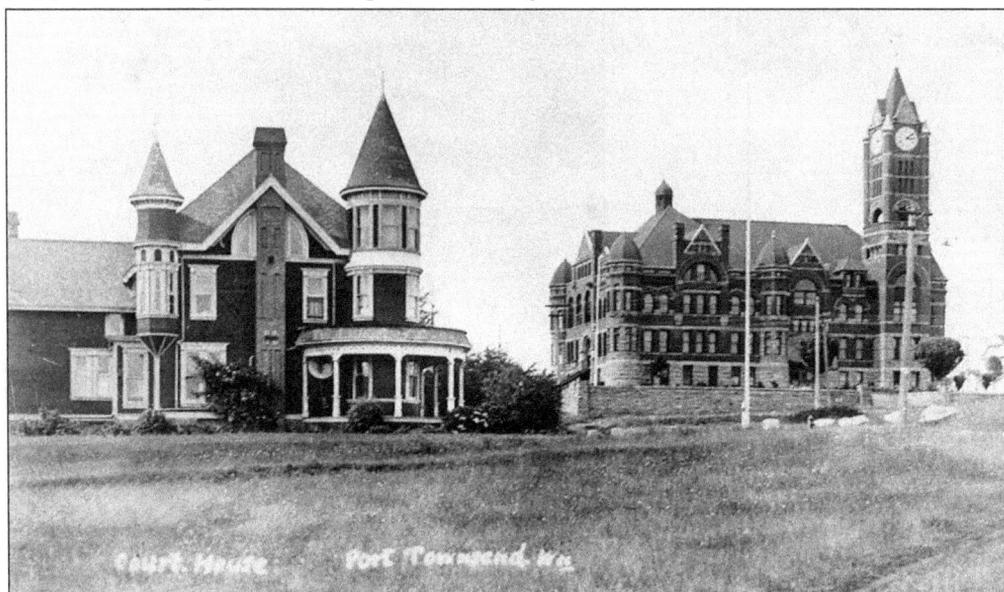

FRANK W. HASTINGS HOUSE. The Frank W. Hastings house, left, is known as the German Consulate House today because August Duddenhausen lived there when he received his appointment as German consul. The shell of the Jefferson County Courthouse, right, was completed in 1892. O. A. Olson purchased the shell and completed the interior in 1904. It still serves as the county seat, and the courthouse clock tower bell still rings out every hour of the day.

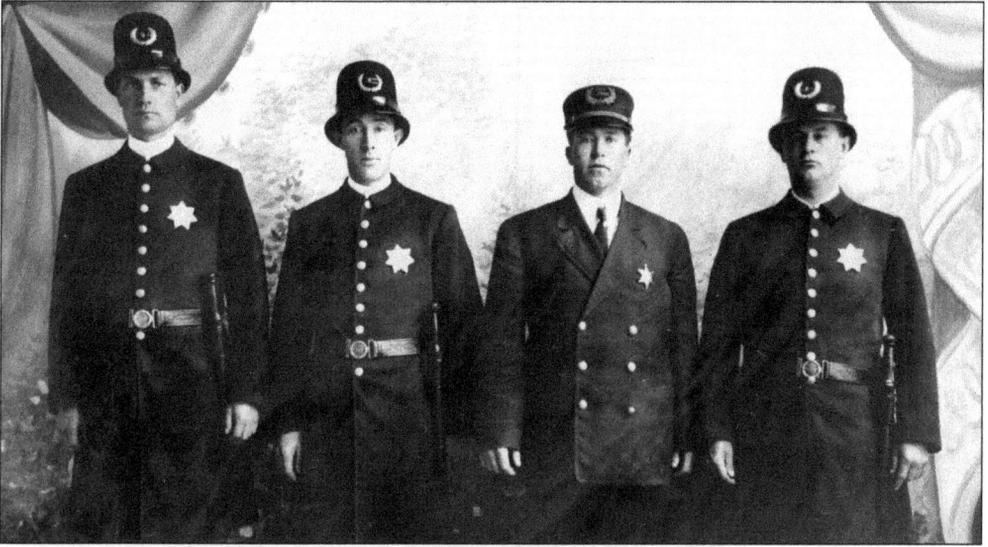

PORT TOWNSEND POLICEMEN. Pictured are, from left to right, Fred Polk, Albert Clouse, Jack Clouse (chief of police), and unidentified. Fred Polk was the fire chief in the early 1900s. He also served as police chief and owned Port Townsend Machine Works at 211 Water Street. Albert Clouse resigned in 1911 because of ill health. His brother, John W. Clouse, was the Port Townsend city marshal from 1911 to 1913.

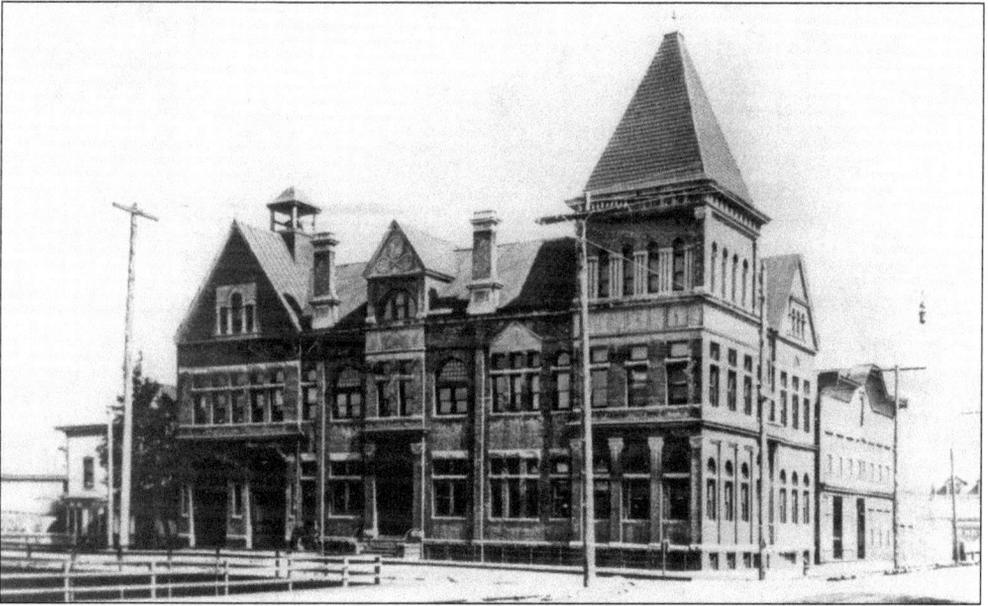

CITY HALL. Against the wishes of many of Port Townsend's prominent citizens, city hall was built "on the flat" adjacent to a "low resort," according to the citizen petition objecting to the site. The Green Light, one of the fancier brothels, is to the left of the multipurpose municipal building. City hall housed administrative offices, council chambers, the municipal courtroom, the fire hall, firemen's quarters, and the city jail. City government still meets in the second floor council chambers. The Jefferson County Historical Society operates a museum in the original courtroom, fire hall, and jail spaces. The top floor and peaked roof were removed in the late 1940s following decades of deferred maintenance.

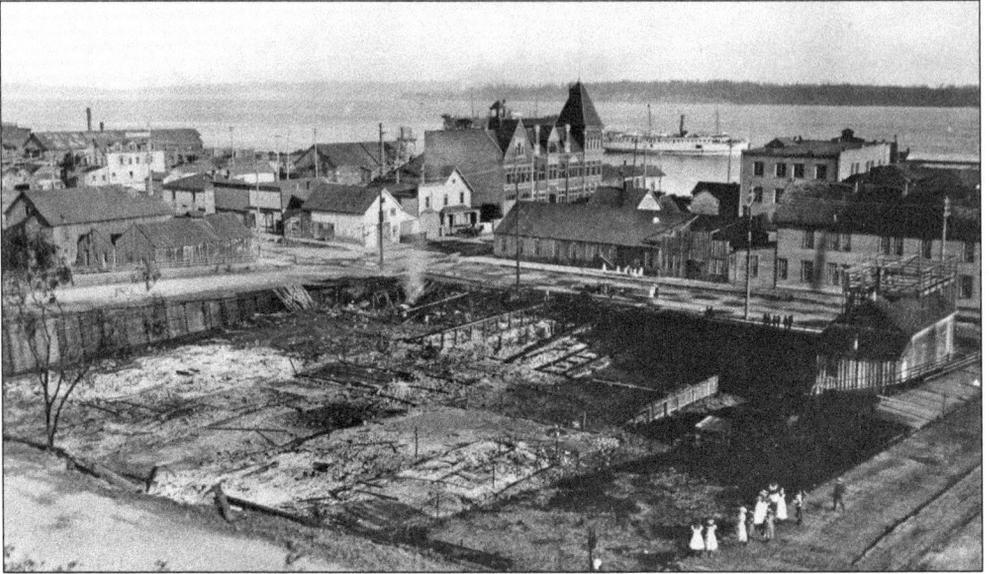

DOWNTOWN. Pictured here is the downtown area with city hall in the background. This still smoldering pit at Madison and Washington Streets shows the site of the big fire of 1900 that burned down a whole block of one and two-room houses, occupied mostly by Chinese and ladies of the night. It was a bad year for fires in town. Another burned an entire uptown block.

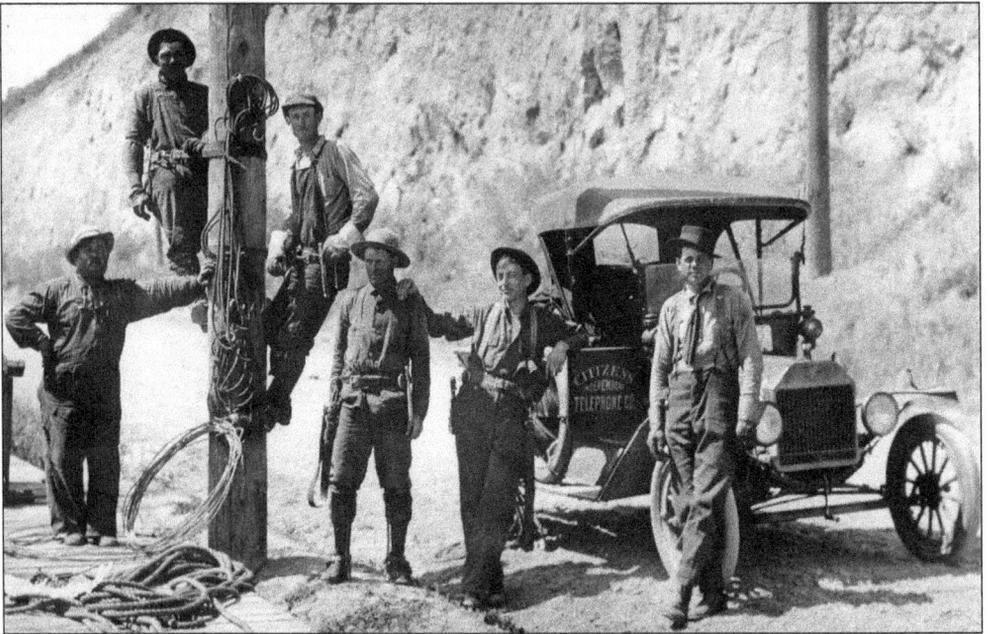

CITIZEN'S INDEPENDENT TELEPHONE COMPANY CREW. Photographed around 1916 at Fort Worden is the Citizen's Independent Telephone Company crew. From left to right are Charles Revello, two unidentified men, Jesse Loman, Robert Sands, and Roy Dale. The Port Townsend telephone exchange was established in 1885 by the Sunset Telephone and Telegraph Company. By 1900, there were 147 telephones in Port Townsend. By 1903, a second telephone system was established and both operated until 1916, when the Citizen's Independent Telephone Company consolidated the two.

CHINESE IN PORT TOWNSEND. An unidentified Chinese man and child are pictured in downtown Port Townsend, near the corner of Taylor and Water Streets. Driven by regional poverty and China's political turmoil in the mid-1900s, tens of thousands of Chinese immigrants came to America's West Coast to establish businesses or work as laborers so they could support their families in China. Those arriving in the Pacific Northwest came in through Port Townsend, where a sizeable Chinese community formed.

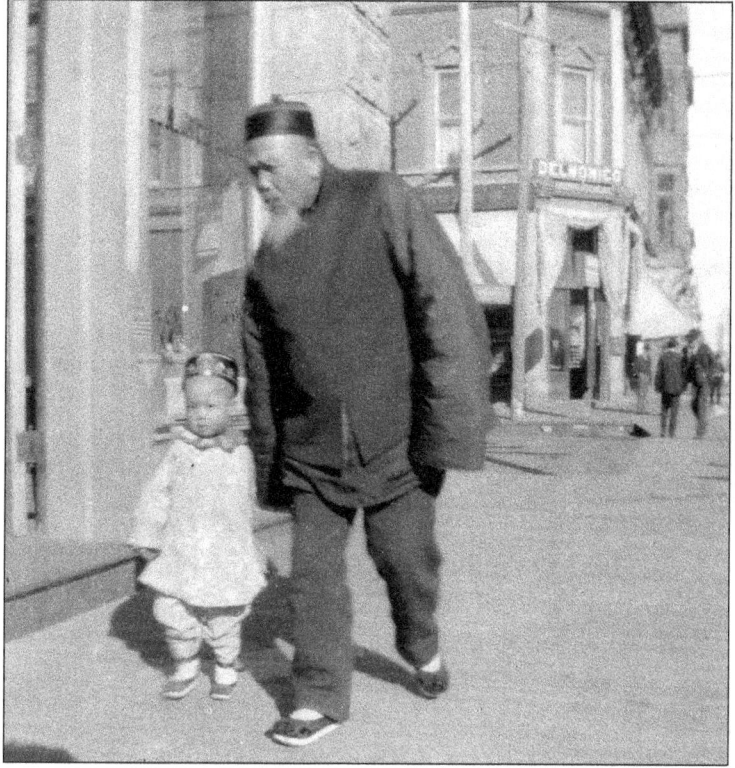

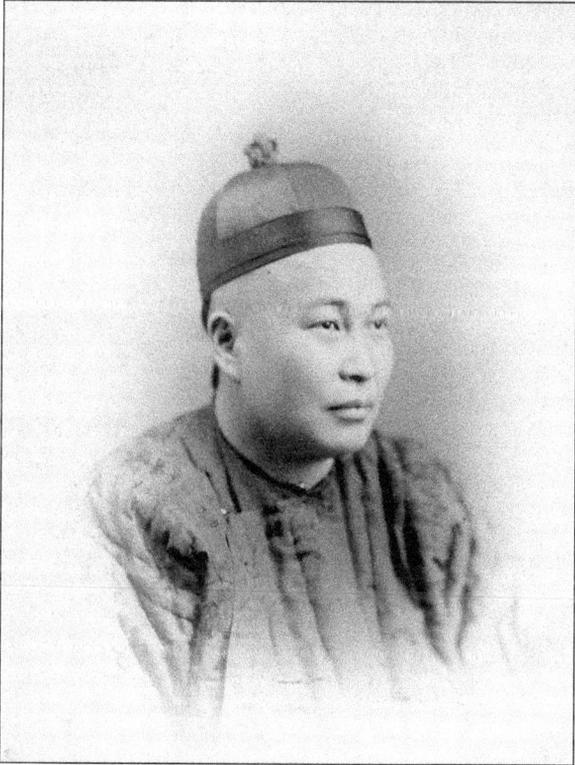

CHARLIE TZE HONG. Charlie Tze Hong was an agent for the Zee Tai Company (Greater Harmony Company), owned by the Ng family. The Zee Tai Company, established in 1879, was the earliest and the most prosperous of the Chinese mercantile houses in Port Townsend.

43

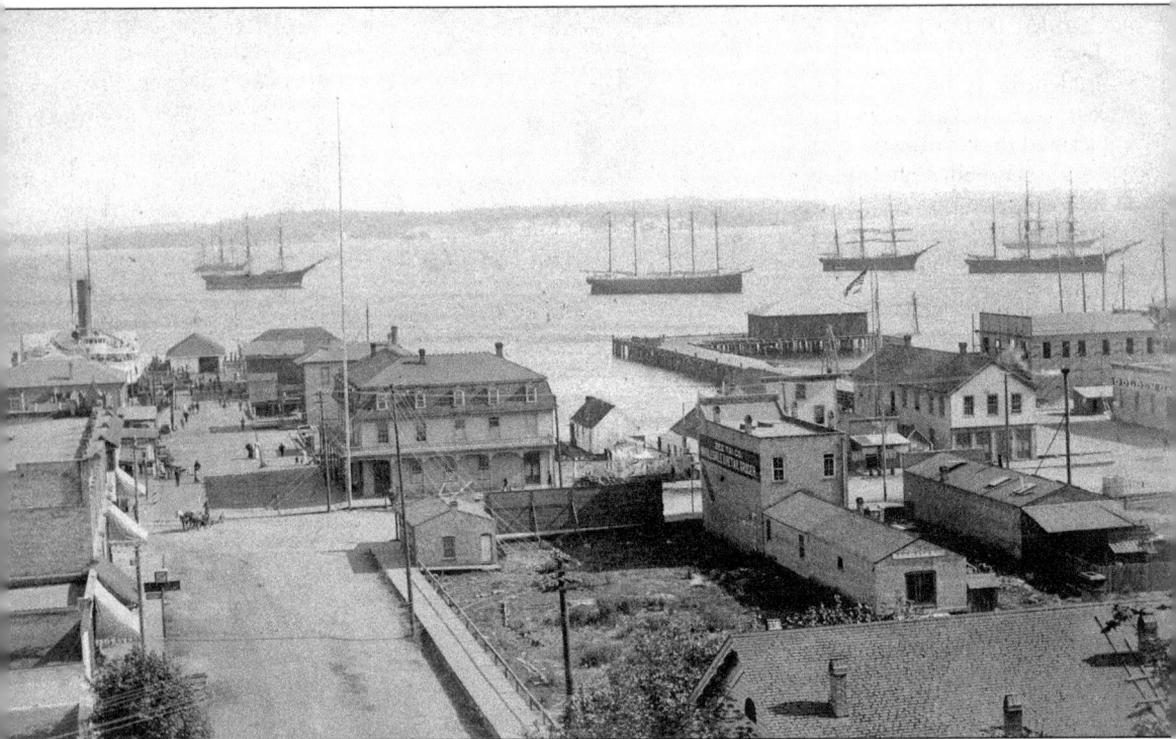

DOWNTOWN PORT TOWNSEND WITH ANCHORED SHIPS IN THE BAY. The Zee Tai Company building is near the center with the long extension off the back. Successful Chinese companies, such as Zee Tai, provided goods and a considerable and solid tax base. When the Chinese Exclusion Acts (1882–1943) allowed only merchants to immigrate, the Chinese opened businesses with multiple partners. In Port Townsend, shops were opened with as little as $300 worth of merchandise and 20 partners, so each could be classified as a merchant.

Four

MORAL HIGH GROUND

The uptown residential district became the moral high ground of Port Townsend. The good people of the town built a commercial and residential haven away from the lowlife of the rowdy seaport. Every convenience could be found "on the hill." Schools, hospitals, a college, churches, shops, lodges, and the courthouse all came by 1892. The uptown business district of Lawrence Street was developed so respectable families could shop and attend social functions without exposure to the hazardous environment created downtown by the presence of alcohol.

Uptown is where the city's entrepreneurs, politicos, and professionals built their elaborate Victorian homes. Space was ample with plenty of views of the water and mountains. Life uptown was genteel, refined, educated, religious, and orderly.

Formal education began in 1867 when Capt. Enoch Fowler donated land to build a three-room school building. In 1884, George Starrett obtained additional lots and began constructing the Central School. It was an impressive structure and served as the hub of uptown's commercial district. The Lincoln School and Northwest Normal College were testaments to the high hopes and ambitions of the town's citizens.

The first church established in Port Townsend was Roman Catholic, built eight years after the town was founded. St. Anthony's was a crude, small wood-frame structure built on Water Street near Point Hudson. It was replaced by a lovely church building and rectory, and later by the current brick structure near the Lincoln School. St. Paul's Episcopal Church is one of the oldest surviving structures in town, despite being severely damaged when it was loaded on logs and pulled by horses to its present location at Franklin and Tyler Streets.

Port Townsend's early years were also the golden age of beneficial societies. In a time before life or health insurance, fraternal organizations provided a national network of economic security to workers and relief to people in need. The Masons and Red Men built cemeteries, and many built lodges large enough to offer ballrooms and other meeting spaces, adding much to the enjoyment of the community.

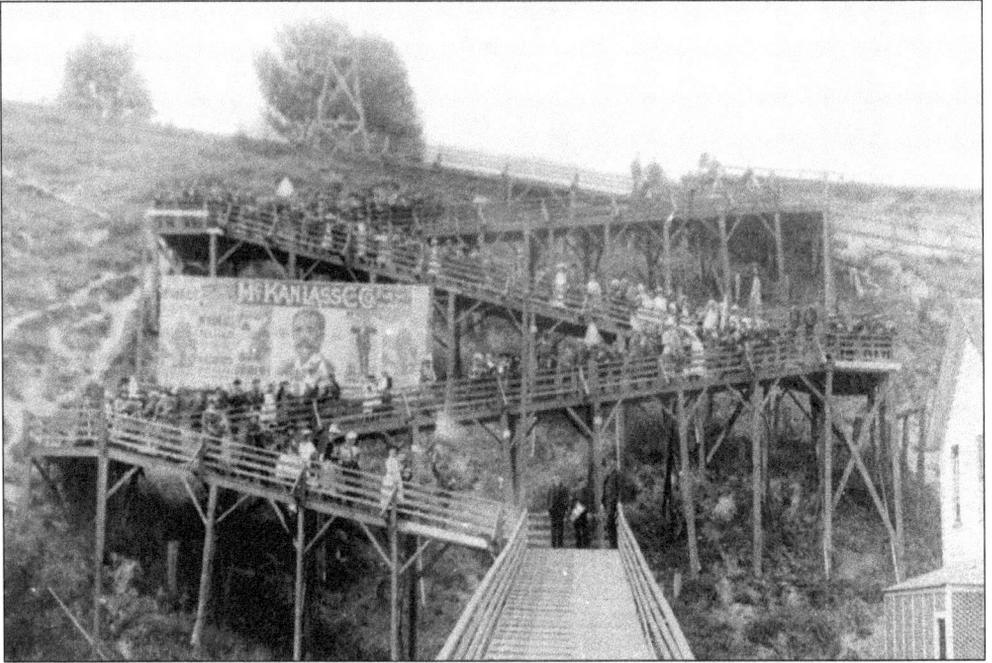

PORT TOWNSEND AT ADAMS STREET. Wooden stairs between downtown and uptown Port Townsend at Adams Street are visible here. Later there was a cable car up the hill on a road cut into the bluff. Today the cable car is gone, but concrete stairs, wooden stairs, a dirt path, and paved streets provide access between the two.

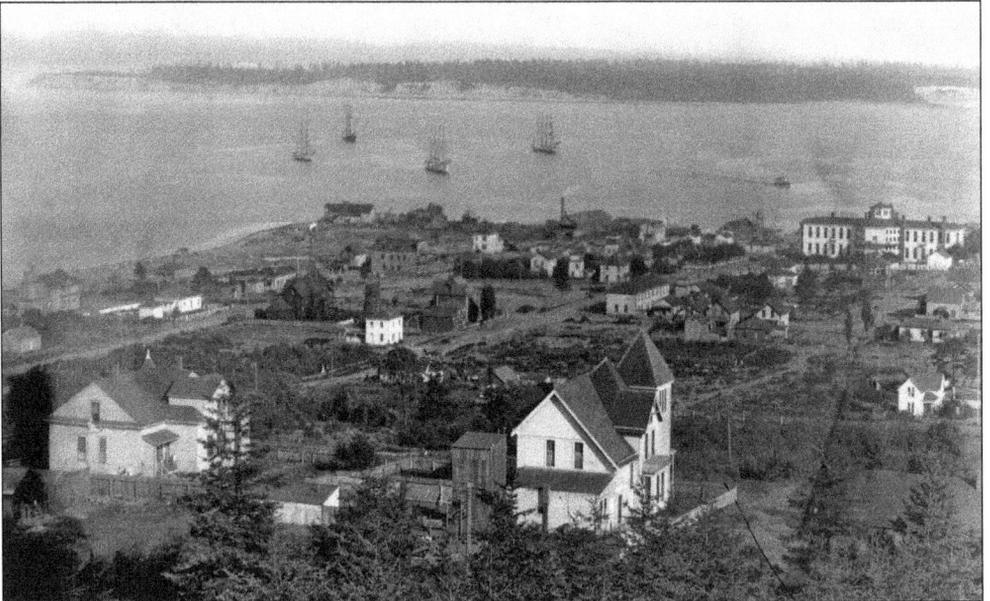

VIEW FROM MORGAN HILL. A view of the uptown residential district and Port Townsend Bay from Morgan Hill was taken about 1895. Marrowstone Island is in the background. The large building on the right is the U.S. Marine Hospital and patient barracks, built in 1896. It was a federal facility where seamen were provided government subsidized health care. It was torn down in the 1970s.

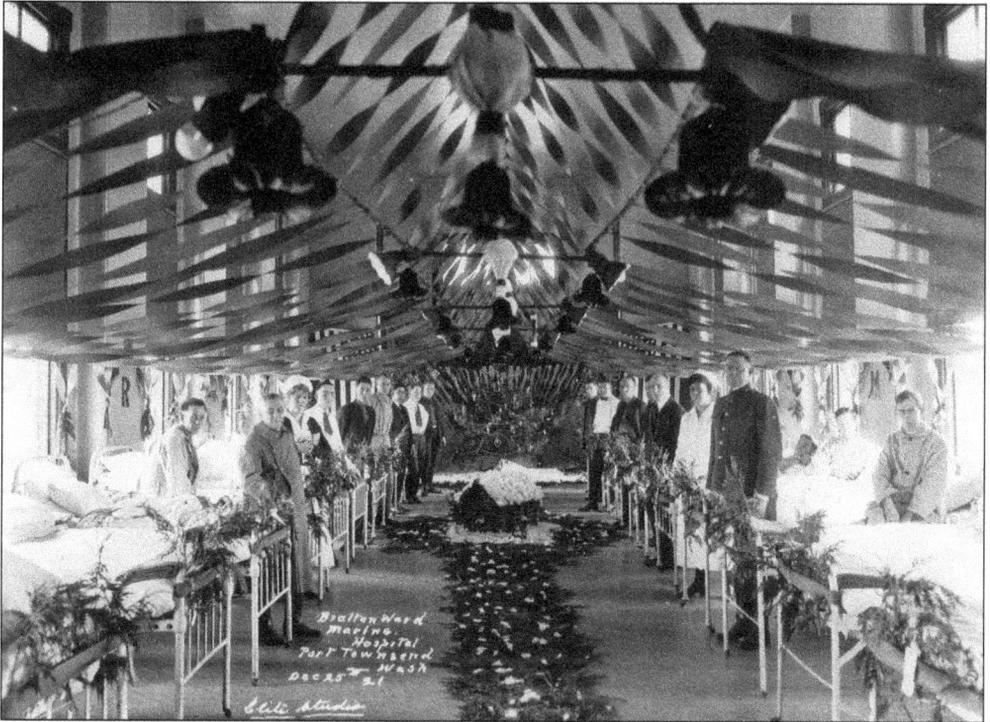

U.S. MARINE HOSPITAL. This view shows the U.S. Marine Hospital Bratton Ward, in the north wing on the second floor. Bratton Ward was one of the two assigned to soldiers of World War I. Here the ward is decorated for Christmas.

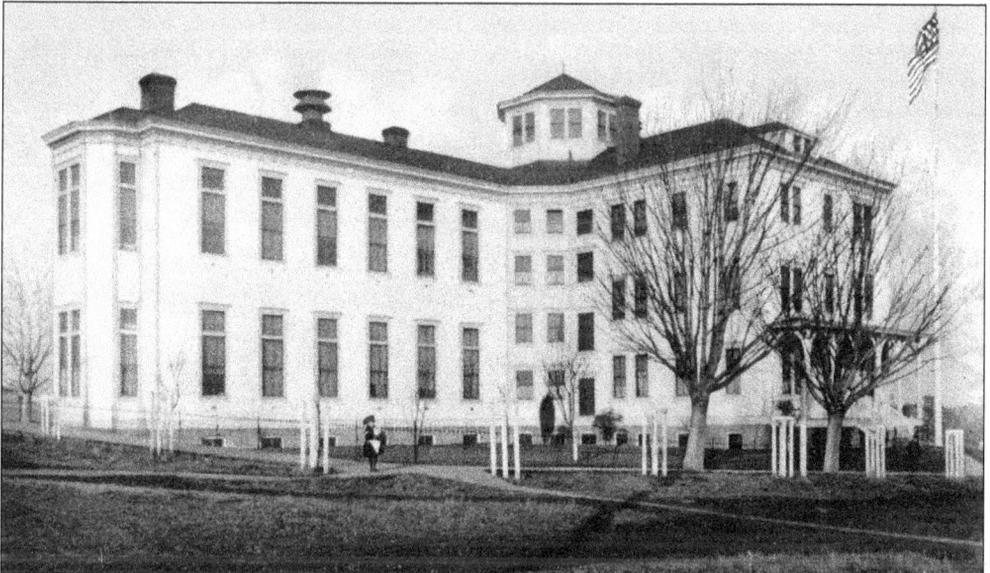

THE MARINE HOSPITAL POSTCARD. In 1893, Congress appropriated $30,000 for this health care facility for American merchant seamen. It was multistoried, including a full basement. It could accommodate 100 patients in four wards and several private rooms. It had surgery and treatment rooms, and provided dental care. The hospital was in use for 37 years. During and just after World War I, disabled veterans were also treated. It closed in 1933 and was demolished in 1971.

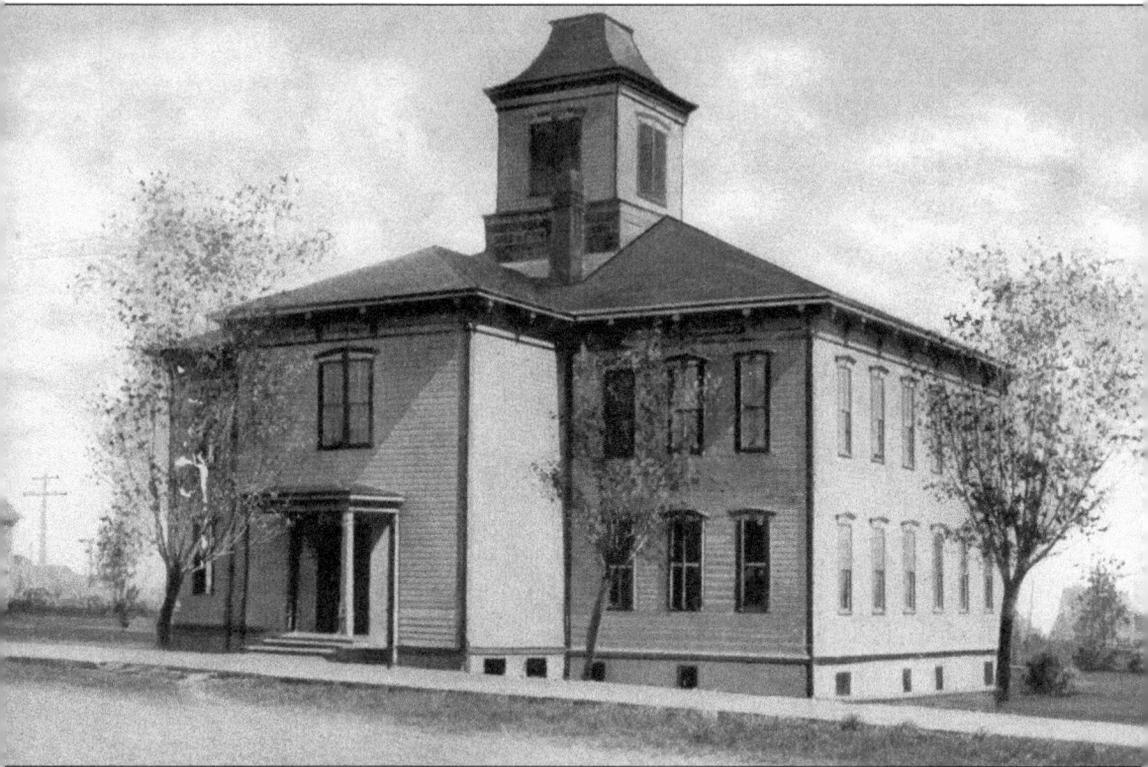

THE CENTRAL SCHOOL. The Central School was built by George Starrett in 1884 and was in use for more than 40 years. In 1921, the community raised funds and provided labor to construct a separate gymnasium that remains in daily use. The empty school building was pressed into service for the USO during World War II, but burned down on September 20, 1943.

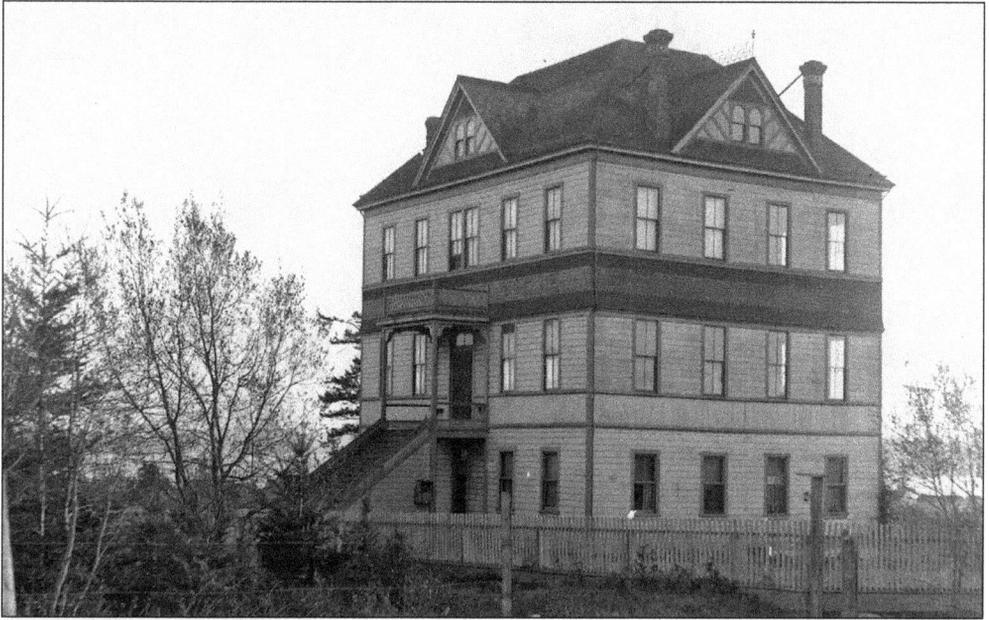

PORT TOWNSEND AND NORTHWESTERN NORMAL COLLEGE. In 1889, the Port Townsend and Northwestern Normal College was founded and built. It towered over the residential district with its three stories atop Morgan Hill. English, science, and classical degrees were offered. The Art Department, headed by Hattie Foster Beecher, was well regarded and remains the most remembered part of the Normal College. In a *Port Townsend Leader* article, the college was claimed to have "no peer on Puget Sound," but it suffered from a lack of enrollment and was sold to the Port Townsend School District in 1891 to be used as an extension of the Central School. By 1918, the building was condemned, and it was demolished in 1928.

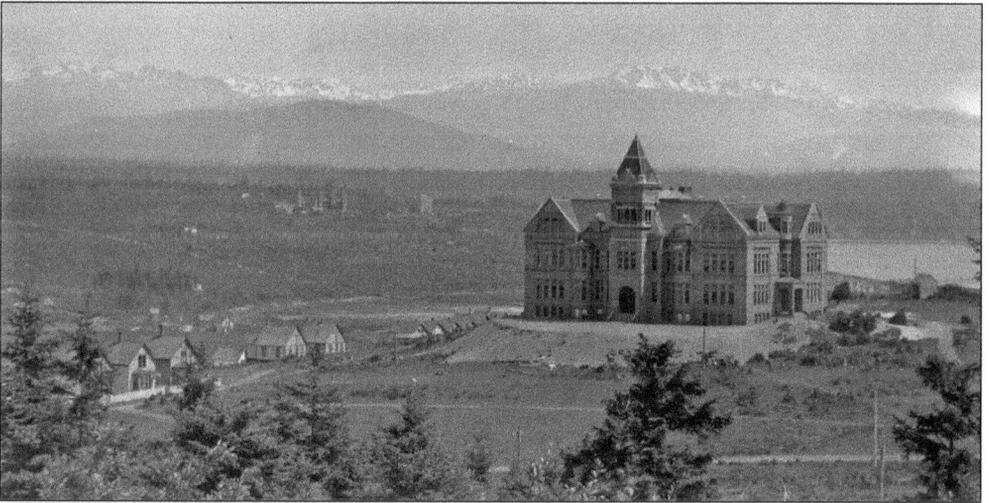

THE LINCOLN BUILDING. The Lincoln Building, a brick palace version of an elementary school, was opened to students in 1894. (The Central School became the high school.) Lincoln School was used for the next 86 years, eventually becoming the high school. Following a windstorm in 1934, the third story was deemed unsafe and was removed. The building has since fallen on hard times. The Port Townsend School District uses it as office space as it awaits a plan for restoration or demolition.

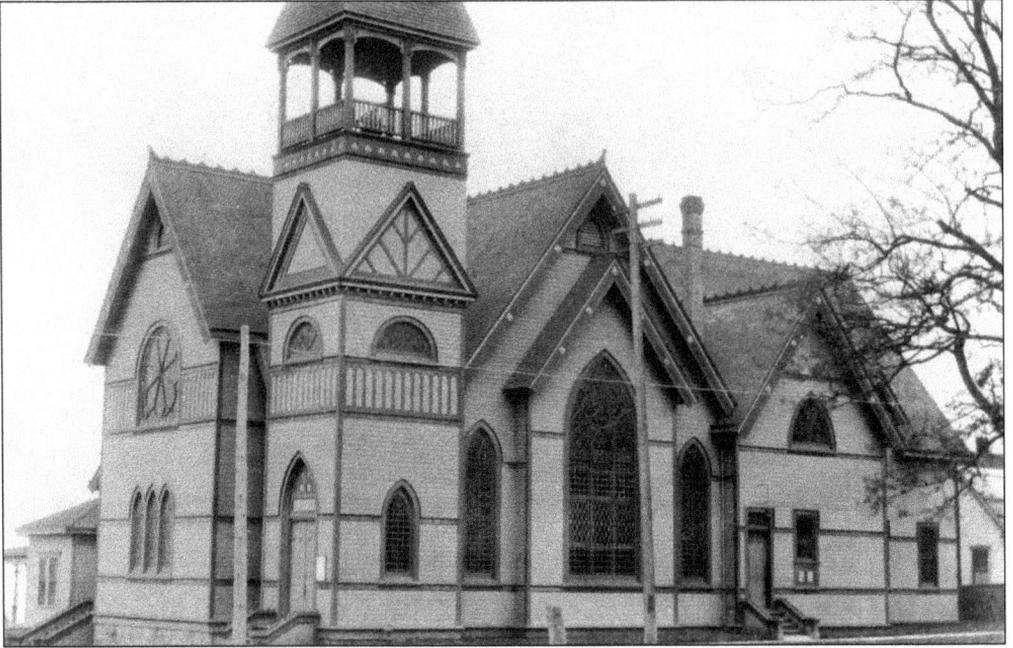

FIRST UNITED PRESBYTERIAN CHURCH. The First United Presbyterian Church was built of stone. Only 12 years later, in a frenzy of speculative growth, church members tore it down to make way for the new Presbyterian church, which is still at Franklin and Polk Streets. The new church left the congregation heavily in debt when the town didn't grow as anticipated. It features a spectacular pipe organ, still in excellent condition.

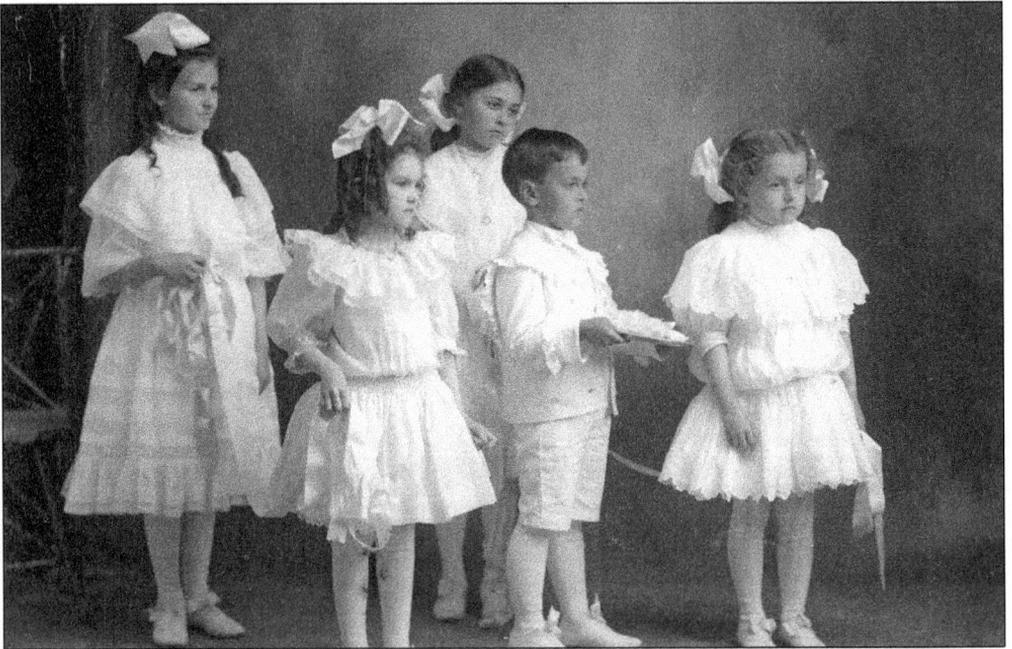

WEDDING FINERY. These children are dressed for the wedding of John Evans Dobbs and Harriet Heath on May 16, 1906. From left to right are Florence Pink, Ethelyn Lumsden, Osceola House, Ben Dobbs, and Rosetta Klocker.

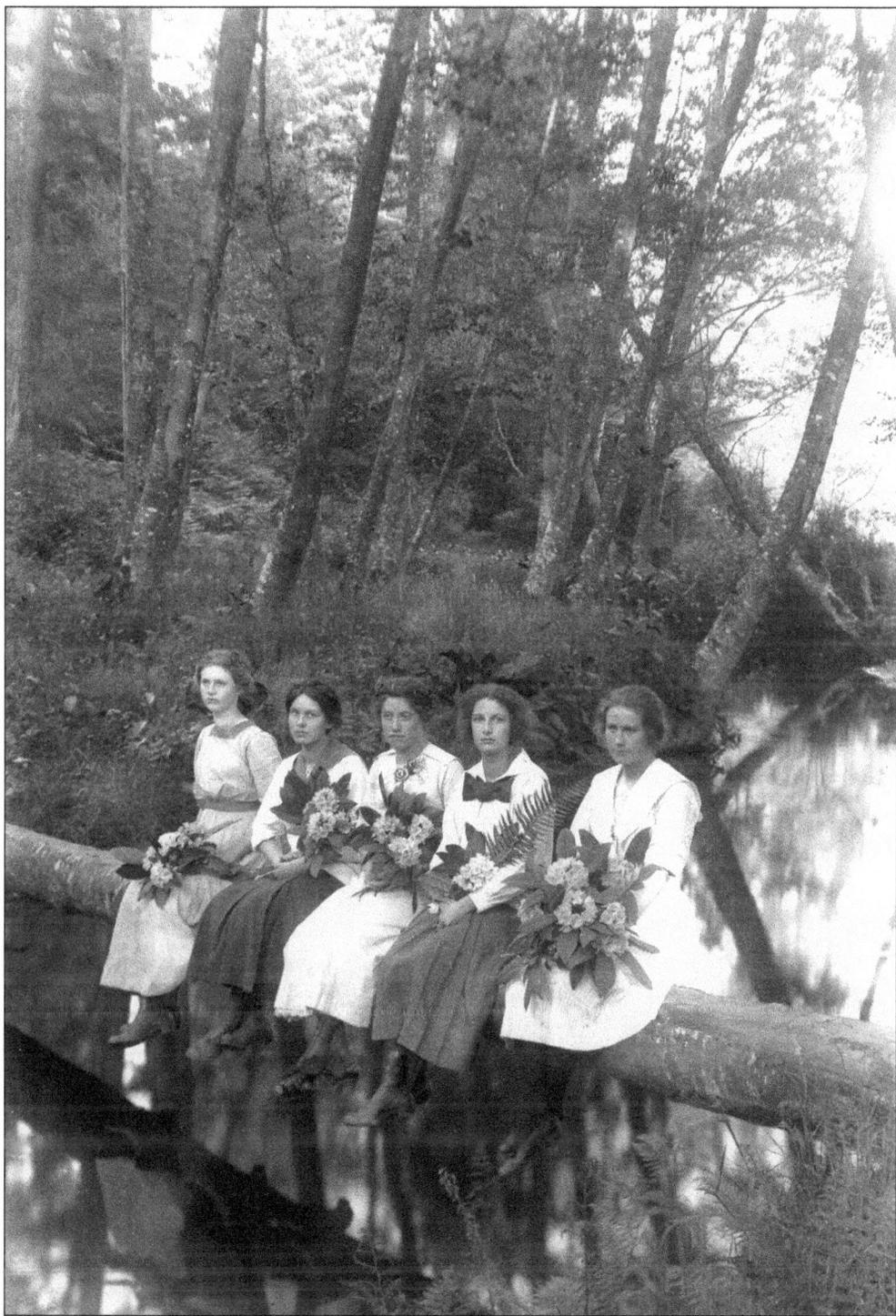

SUNDAY SCHOOL CLASS. James G. McCurdy photographed his Sunday school class seated on a fallen log over a stream. Each holds a bouquet of rhododendrons.

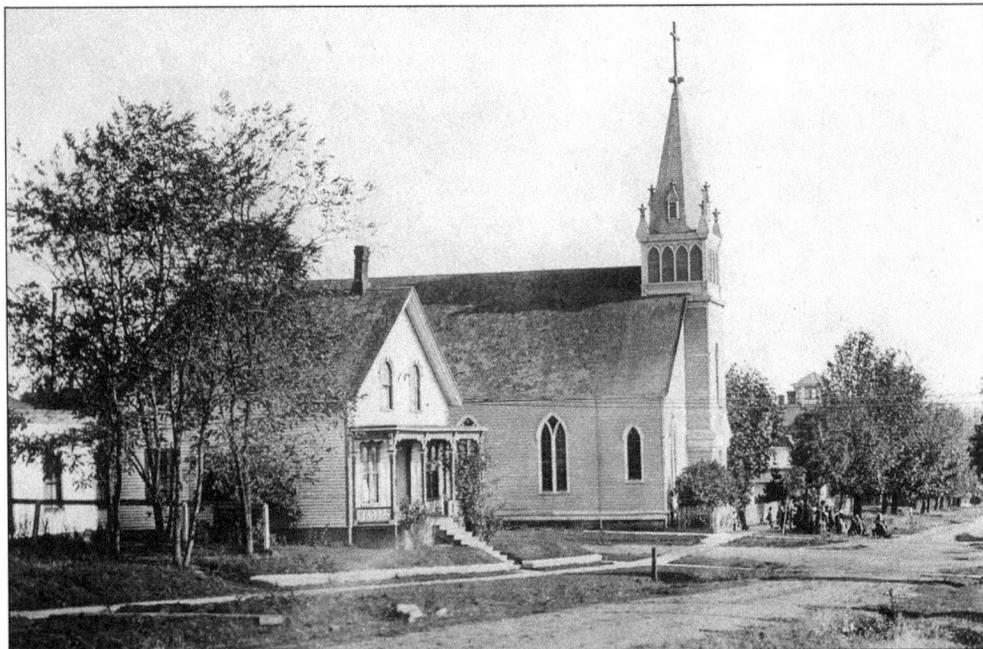

ST. MARY'S STAR OF THE SEA CATHOLIC CHURCH. The St. Mary's Star of the Sea Catholic Church was built on the corner of Taylor and Franklin Streets during the boom times. Fr. Regis Maniouloux served as resident pastor for nearly 40 years. In this photograph, Mass is being held outdoors during the 1918 Spanish influenza epidemic. By 1896, the parish was in financial difficulties, and Father Maniouloux borrowed money from relatives in France, backed by a mortgage. Following his death in 1919, the church building was inherited by his French Huguenot niece and housekeeper who locked the doors to services.

ROTHSCHILD HOUSE. The Rothschild house is pictured here with the first St. Mary's Star of the Sea Catholic Church under construction in the background.

ST. PAUL'S EPISCOPAL CHURCH.
St. Paul's Episcopal Church was
built in 1865 on the bluff above
what is now Memorial Field. It was
moved uptown to Jefferson and
Tyler Streets in 1883, suffering
severe damage along the way. It had
to be reinforced by iron rods, which
are still in place.

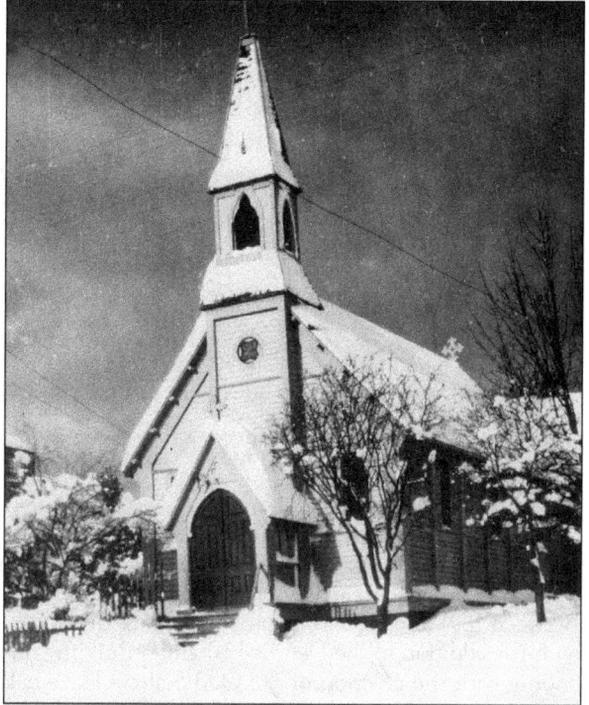

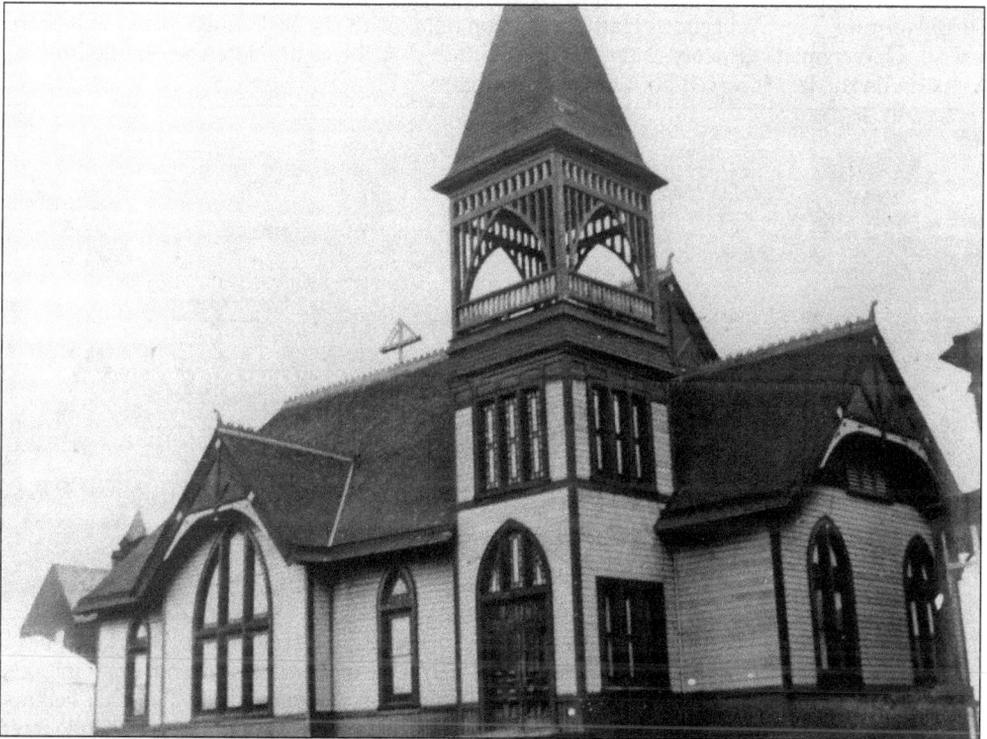

CONGREGATIONAL CHURCH. The impressive boom-time Congregational Church was built on
Harrison Street in 1889. By 1903, the structure had been vacant for some time and was rented
out to a Seventh-day Adventist denomination. It was torn down sometime during the 1920s.

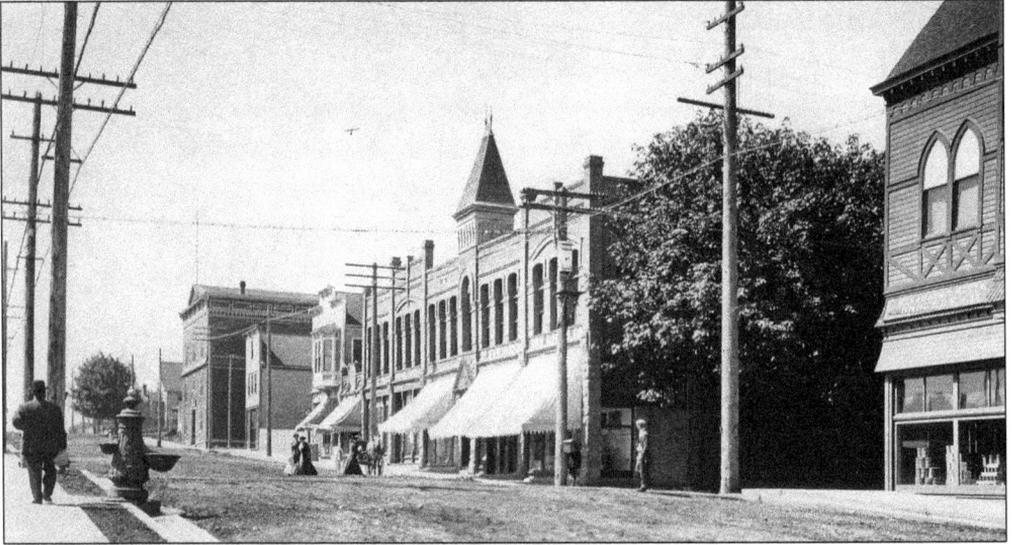

UPTOWN BUSINESS DISTRICT. This view was taken at the main intersection of the uptown business district, Lawrence Street at Maple Avenue (now Tyler Street), before Lawrence Street was paved. Between 1891 and 1897, the uptown business district grew to its present proportions, beginning with the addition of the Dennis-Halteman Building on the north side of Lawrence in 1891 and ending with the erection of the Odd Fellows Hall in 1897. By this time, dry goods, furniture, shoes, and a billiards hall were available. Despite the economic slump of 1893, business uptown surged forward. The Odd Fellows Hall is at the top right., with the McLennen Dry Goods Store, then J. O. Biergman's Grocery (later Aldrich's Grocery) at the right. Note the ornate drinking fountain on the left. It served both people and horses.

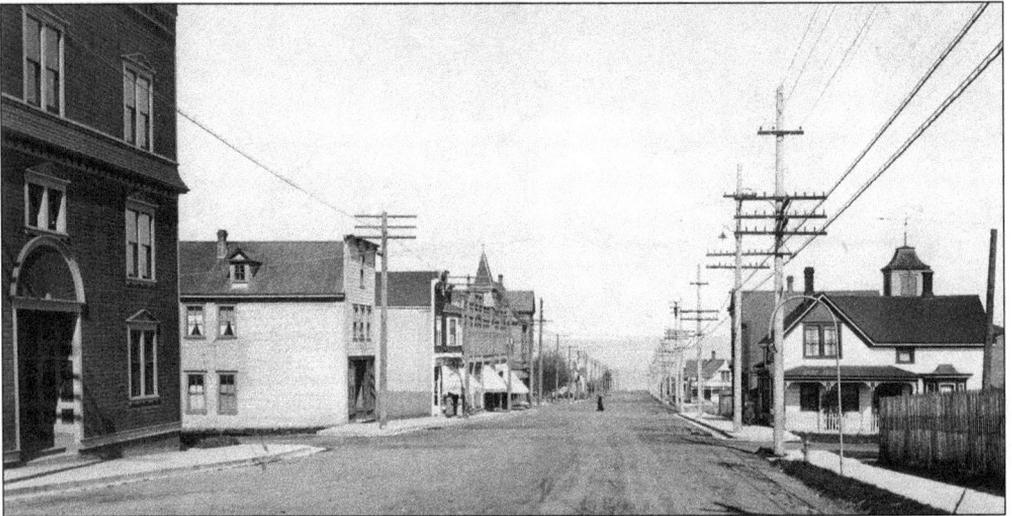

LOOKING DOWN LAWRENCE STREET. The large structure on the left is the Mount Baker Lodge No. 9 of the Independent Order of Odd Fellows, built in 1897. Like many other fraternal organizations, the Odd Fellows held their meetings upstairs and rented out the main floor. The Odd Fellows, the oldest fraternal organization in America, allowed membership only to those of "undoubted probity" and specifically denied access to known gamblers and heavy drinkers. Though reduced in ranks, Port Townsend Odd Fellows are still active and meet in a smaller building next door to the large lodge. Since 1947, the Uptown Theater has been located in the downstairs space.

RED MEN. Red Men pose in front of their newly completed lodge in 1887. The crowd includes Mr. and Mrs. John Thornton, Mr. and Mrs. John Tukey, James McCurdy, James Smith, J. J. H. Van Bokkelen, James Woodman, Tom Bracken, James Dalgarno Sr., D. M. Littlefield, Capt. John Butler, and James G. Swan. In October 1872, the Port Townsend Improved Order of Red Men, Chemakum [sic] Tribe No.1 was formed, the first such lodge in Washington Territory. The order itself was originally established to promote patriotism in the early colonies; friendship and charity were later added to their mission.

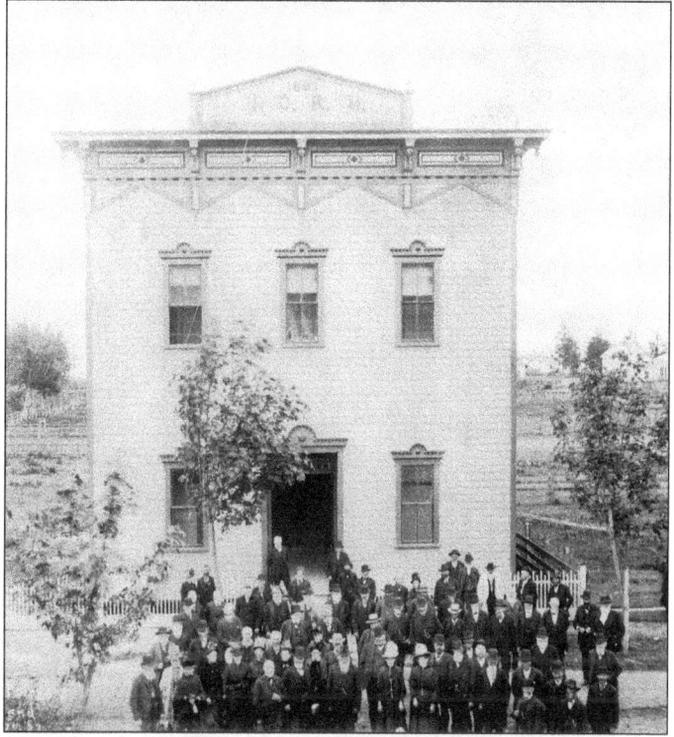

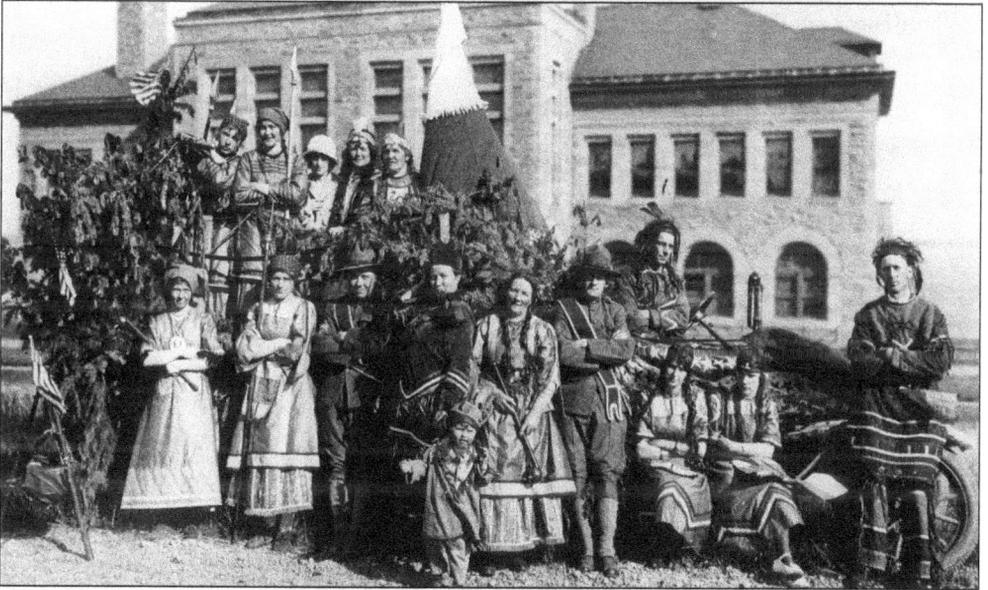

RED MEN IN COSTUME. The Red Men group is pictured here in parade costume with their decorated car. This was a very active group, providing a number of social events as well as sick, death, and burial benefits for its members. It regularly contributed money to support orphans of members around the state. The Red Men purchased land for and maintained the Red Men's Cemetery in Port Townsend until the 1930s when the local order disbanded. There was also an active women's group known as Pocahontas Nodawn Council No. 2. The customs house and post office building is in the background.

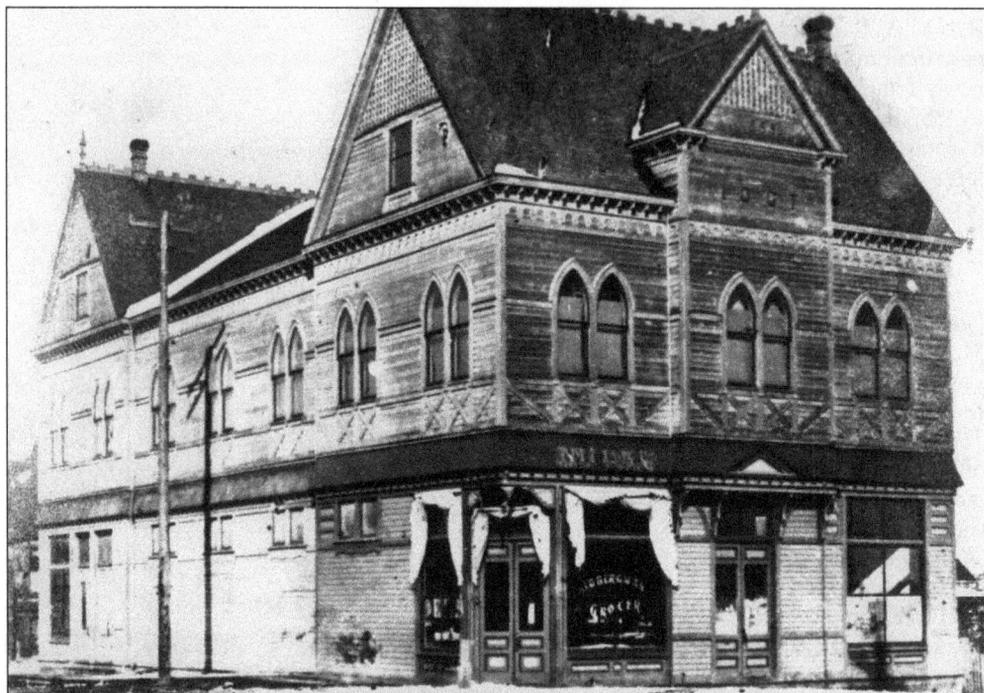

INDEPENDENT ORDER OF GOOD TEMPLARS BUILDING. Built in 1889 by the Independent Order of Good Templars (IOGT), the ground floor was rented to Julius Bergman Grocery and C. C. Holburg Furniture. The Palace Drug Store was on the side street. In 1900, Wanamaker and Mutty took over the premises with their grocery store. Clark Aldrich Jr. bought the building in 1926 to move his family store to the ground level, and it was Aldrich's Grocery until it burned down in 2003. A new store, with condominiums above, opened on the site in 2005.

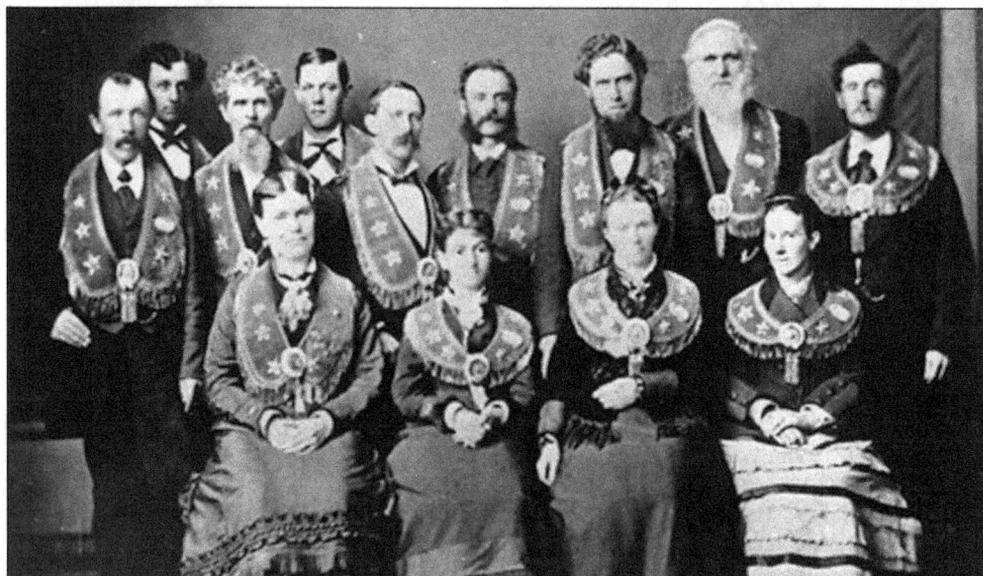

INTERNATIONAL ORDER OF GOOD TEMPLARS. Port Townsend's chapter of the International Order of Good Templars joined via the British Columbian chapter at a convention in Victoria in 1877. Standing second and third from right, respectively, are N. D. Hill and L. B. Hastings.

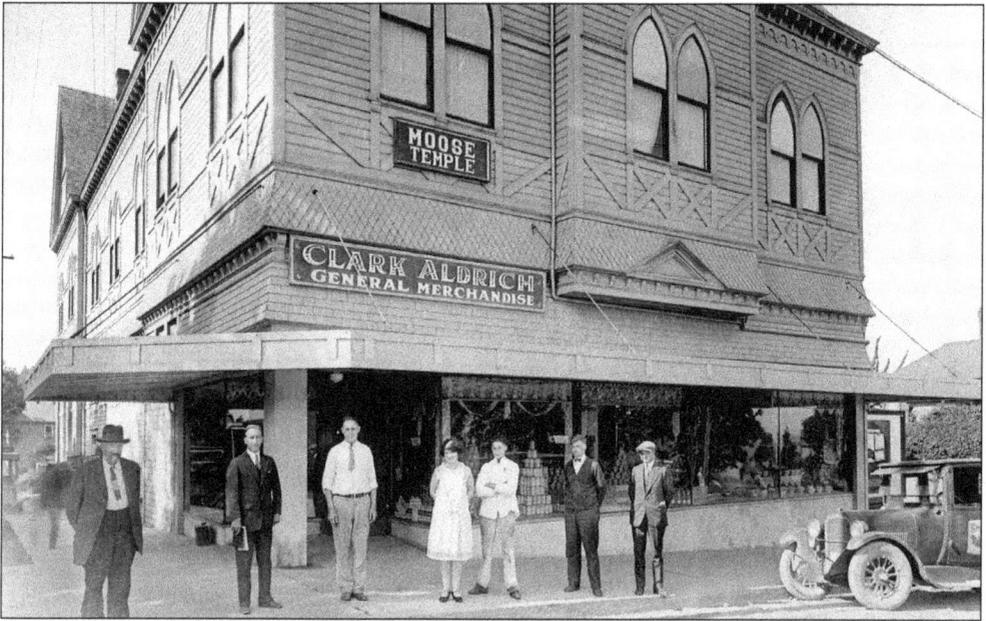

ALDRICH'S GROCERY STORE. Aldrich's Grocery store, pictured here in 1927, sat across the street from the Central School. From left to right are William Lammers, an unidentified salesman, Bill Carder, Margaret Aldrich, Phil Brown, Ben Aldrich, and unidentified. Clark Aldrich Sr. came to the Port Townsend community in 1882 and, within a few years, opened a store on Tyler Street. That site burned in 1900. Following the fire, he moved across the street. His store featured tinware, stationery supplies, candy, fruit, and musical instruments.

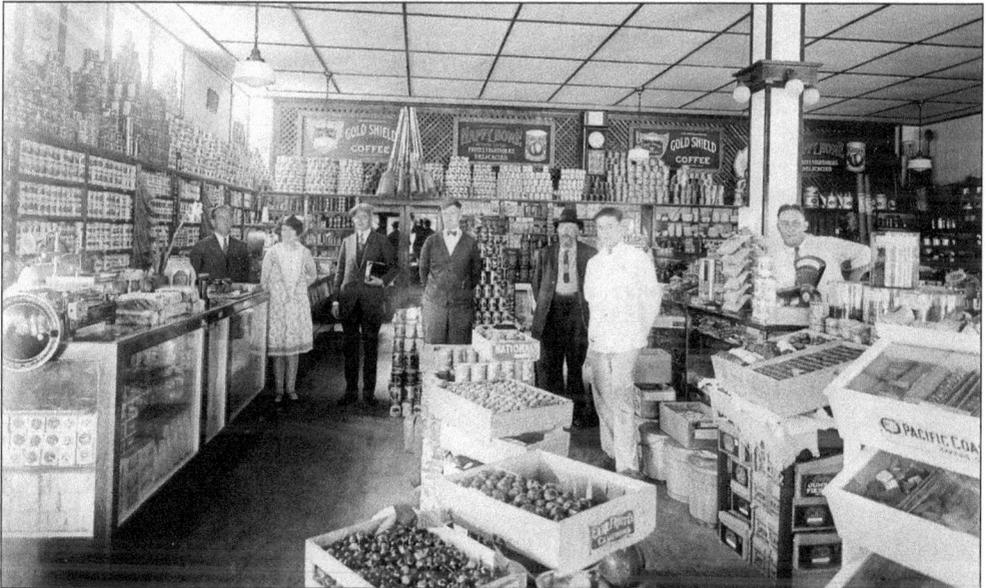

INTERIOR OF ALDRICH'S GROCERY STORE. Pictured here from left to right are unidentified, Margaret Aldrich, an unidentified salesman, Ben Aldrich, William Lammers, Phil Brown, and Bill Carder. In 1926, the Aldrich family purchased the then-vacant IOGT building. At this new location, the Aldrichs expanded their stock to included groceries, meat, hardware, paint, plumbing supplies, furniture, and appliances.

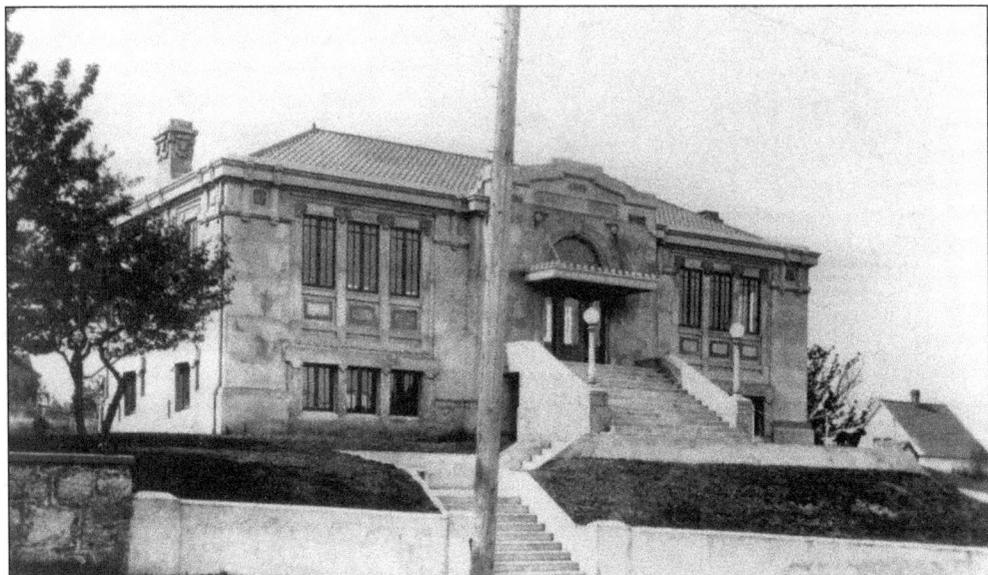

THE CARNEGIE LIBRARY ON LAWRENCE STREET. In 1898, the pioneer women of Port Townsend determined that the city was ready to absorb the cultural and educational advantages of a library. They operated it out of the Dennis-Haleman Building until moving into the new Carnegie Library on October 14, 1913. A stair climb to the entrance is a feature of all of Andrew Carnegie's libraries. He believed that people should be willing to climb to receive a library's benefits.

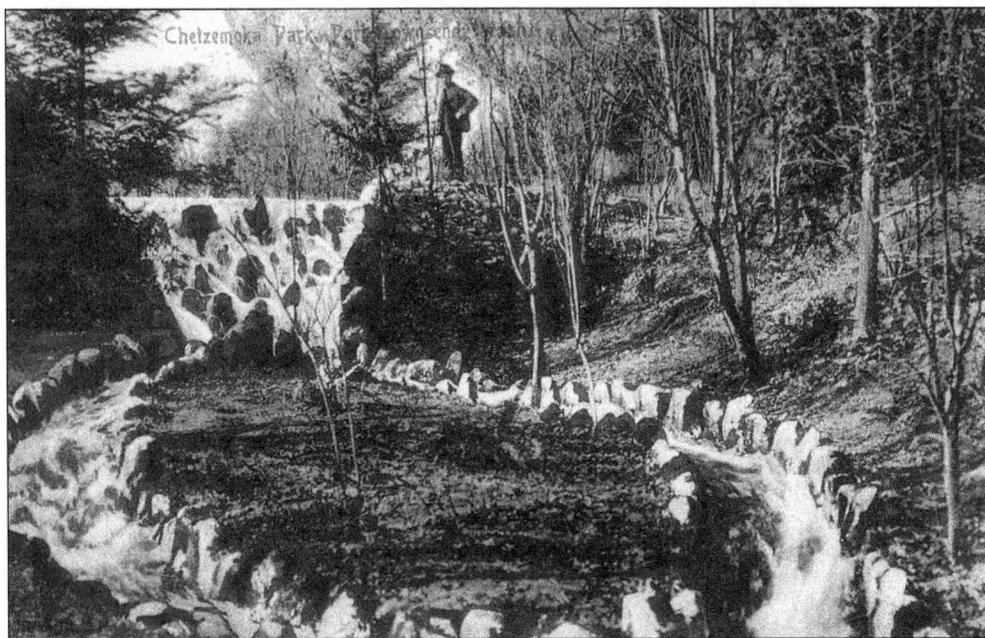

CHETZEMOKA PARK. Uptown's beautifully landscaped Chetzemoka Park sported a fountain, stream, waterfall, and gazebo. In June 1904, nearly 200 Port Townsend residents volunteered to create the city's first public park. Situated on several hillside acres overlooking Admiralty Inlet just northeast of downtown Port Townsend, it is named for Chetzemoka (c. 1808–1888), a S'Klallam Indian leader who helped keep the peace between the natives and newcomers. With views of Whidbey Island and Mount Baker, the park is a favorite setting for weddings and community events.

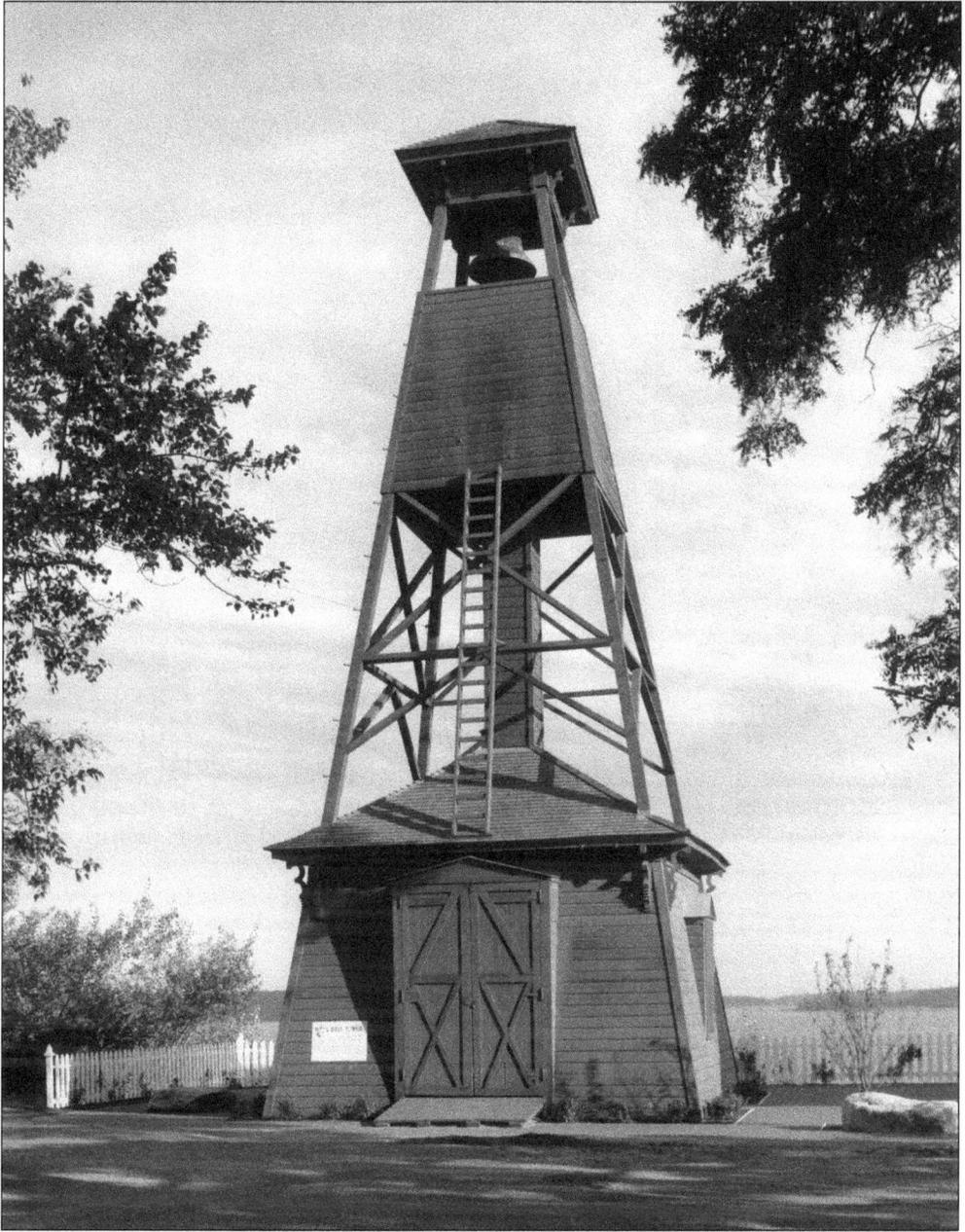

FIRE BELL TOWER. Port Townsend's Fire Bell Tower is a 75-foot-high wooden tower originally constructed in 1890 to hold a 1,500-pound brass bell. An elaborate mechanized ringing system in the tower alerted early fire department volunteers to locations of fires by tolling the bell in code. This system enabled volunteers to proceed directly to the fire instead of meeting at the downtown fire station. The Fire Bell Tower system served the community until the 1920s.

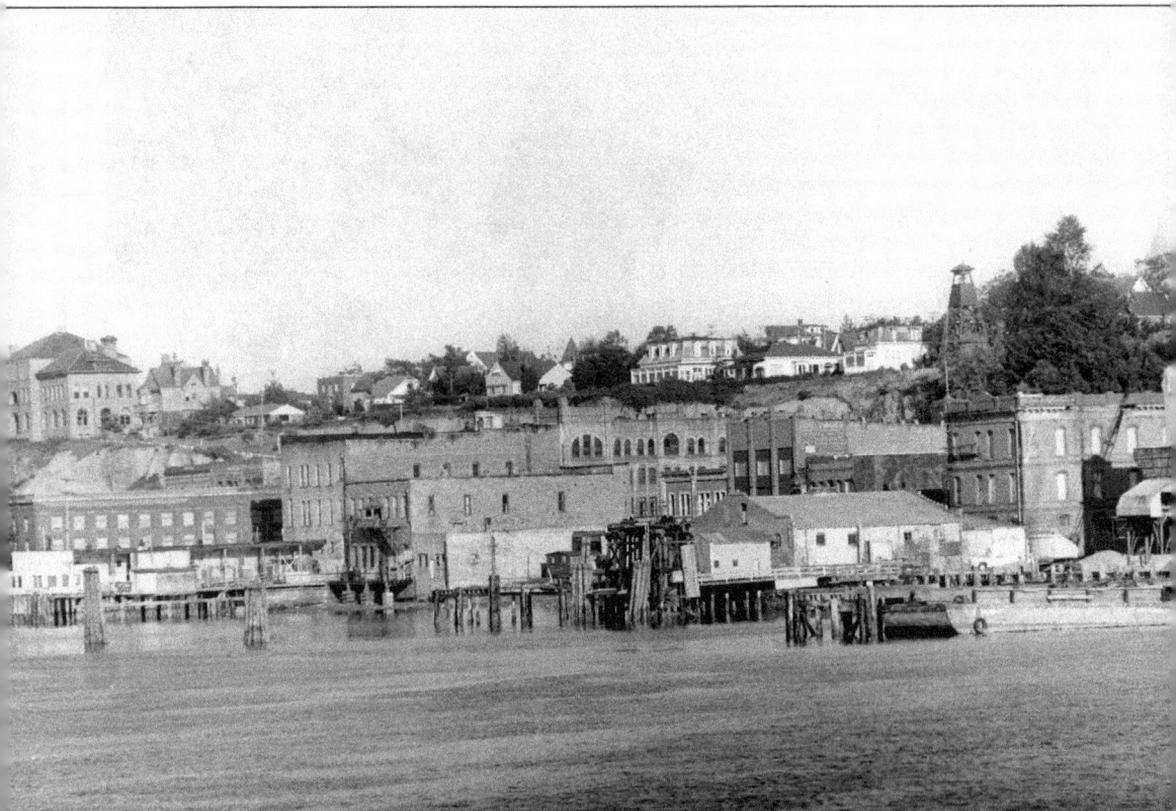

FIRE BELL TOWER. Perched on the bluff above downtown Port Townsend, the Fire Bell Tower (right) is a beloved part of the city skyline. The customs house/post office building is on the bluff at far left.

Five

AT HOME

Money earned in enterprises on the downtown waterfront found its way uptown and into the gracious homes of the entrepreneurs, government agents, and businessmen's families. During the Victorian era, elaborate rules of etiquette applied to these genteel families, including the practice of calling upon friends and acquaintances when they were "at home"—predetermined hours when one was available to accept visitors. Callers visited, appropriately attired, with calling cards in hand. The custom was to stay just long enough for a cup of tea in an elaborately decorated parlor and to then move on to the next visit.

Port Townsend's early citizens had all the pretensions of their era. Many were amazingly well traveled and everyone in this seaport had access to fashions and merchandise from all over the world. As was the style, furnishings and interior decorations were elaborate. The Victorian home was a haven and an advertisement boasting of the success of its owner. A fine home was as important to establishing respectability and professional credibility as membership in a church and lodge.

As citizens prospered, they reinvented themselves. Because everyone was relatively new in town, it was far easier to build a fine home, go to church, join a fraternal organization, and forget that one's fortune was amassed by selling whiskey, sex, smuggling, or by kidnapping sailors.

Large homes were desirable in an era of large families and, during the boom years, there was a ready supply of (often Chinese) servants. Most homes had lovely views, but the gardens on their large lots shared space with outbuildings for animals.

When the tide turned against Port Townsend's economy, the homes emptied as their occupants moved to more prosperous cities. Many fell into terrible disrepair. A number were divided into apartments and rooming houses, especially during World War I and II.

Some who stayed camped out in big drafty old mansions for a lifetime. Ambitious and tenacious preservationists were (and continue to be) the next wave of dreamers in this boom town.

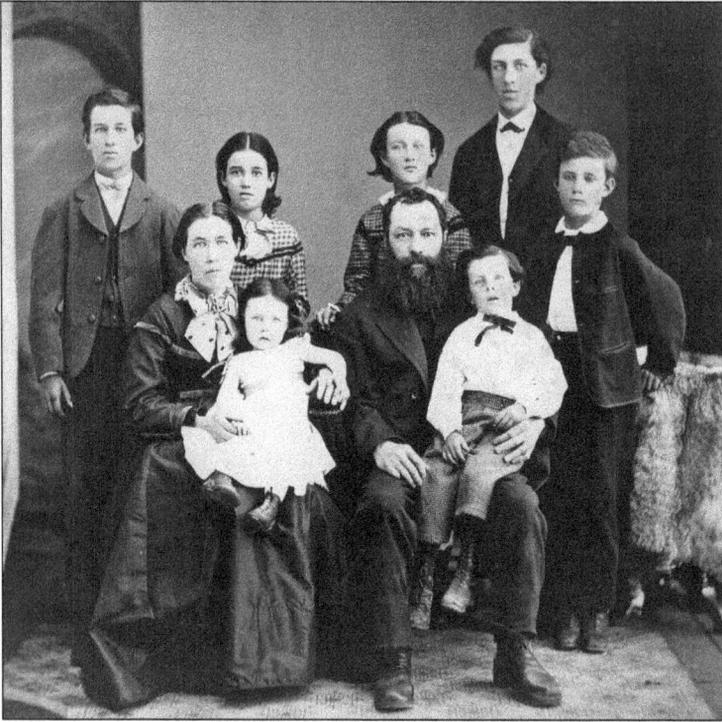

THE ALFRED A. PLUMMER FAMILY. Pictured here are, from left to right, (first row) Ann Hill Plummer, holding Anna Laura (born 1872), and Alfred Plummer, holding Frank, who died in 1874; (second row) Enoch, Ida, Mary, Alfred, and Alphonso. Alfred Plummer filed the first claim of 158 acres on Port Townsend Bay on April 24, 1851.

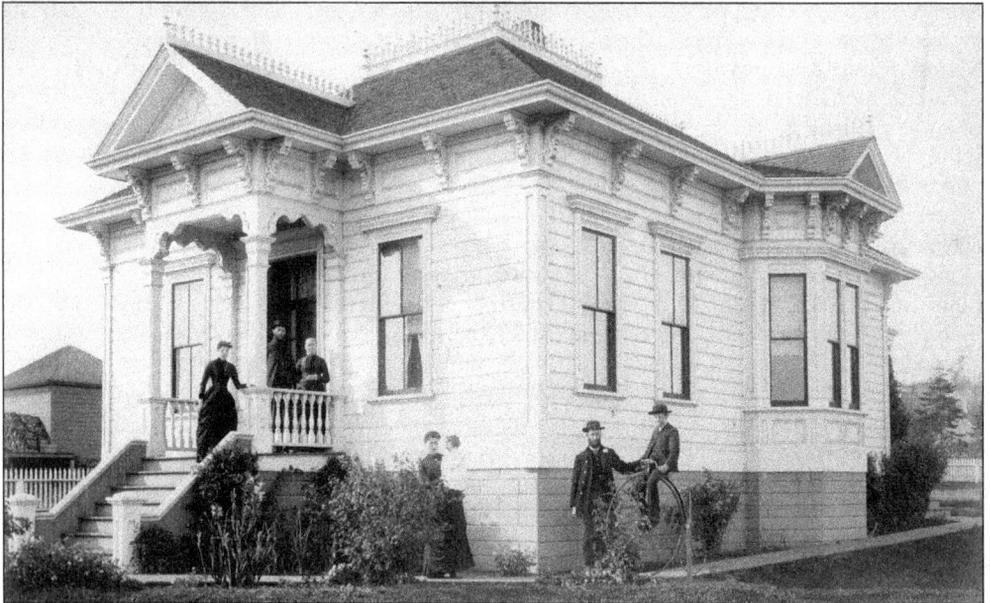

THE ALFRED A. PLUMMER HOUSE, CORNER OF CLAY AND MADISON STREETS. From left to right are Laura Plummer Marcy, A. A. Plummer, Mrs. Alfred A. Plummer, Mrs. Calhoun and her daughter Vera, Enoch Plummer, and George Plummer on the bicycle. Alfred Plummer's first house in Port Townsend was a log cabin on the sand spit downtown. There he carried his bride across the threshold, celebrating the first marriage in Port Townsend. The bride, Ann Hill from Belfast, met the Hastings family on their wagon train trip to Oregon and joined them in Port Townsend.

THE LUCINDA HASTINGS HOUSE, 514 FRANKLIN STREET.
Lucinda Hastings was the first nonnative woman to set foot
in Port Townsend. On February 23, 1852, the families of
Loren and Lucinda Hastings and Francis and Sophia
Pettygrove arrived at Port Townsend with another
family and several single men. They are the first
non–Native American families to settle in the
new town that Hastings and Pettygrove, along
with Alfred Plummer and Charles Bachelder,
founded on the Olympic Peninsula in what is
now Jefferson County.

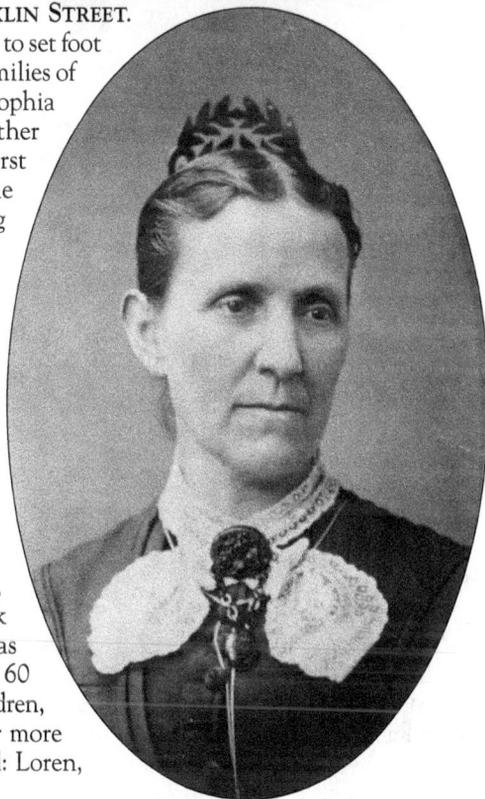

LUCINDA HASTINGS, 1858. A native of Vermont,
Lucinda married Loren Hastings in Hancock
County, Illinois. Their first child, Oregon, was
born there. They moved westward in a train of 60
wagons, reaching Portland in 1847. Two more children,
Maria and Frank, were born in Portland. Four more
Hastings children were born in Port Townsend: Loren,
Josephine, Jessie, and Warren.

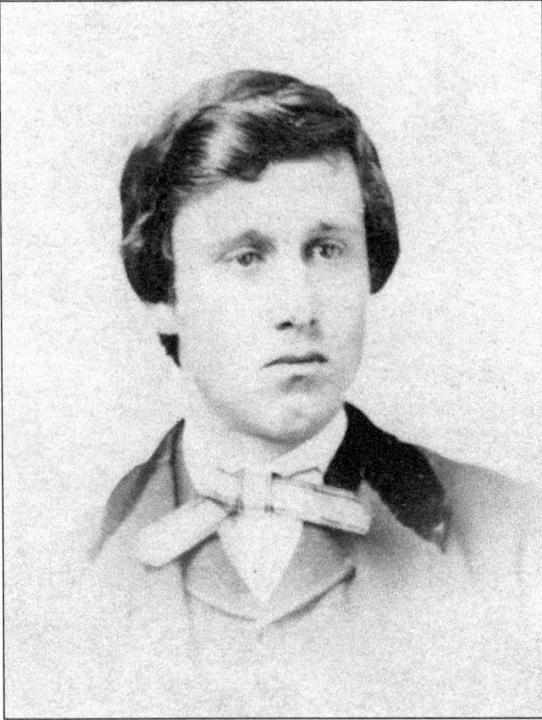

OREGON COLUMBUS HASTINGS. Oregon, the son of Loren and Lucinda Hastings, came to Port Townsend as a small child. The red-haired boy was a favorite of the Native Americans, who called him *En Squiawk*, which meant "red head."

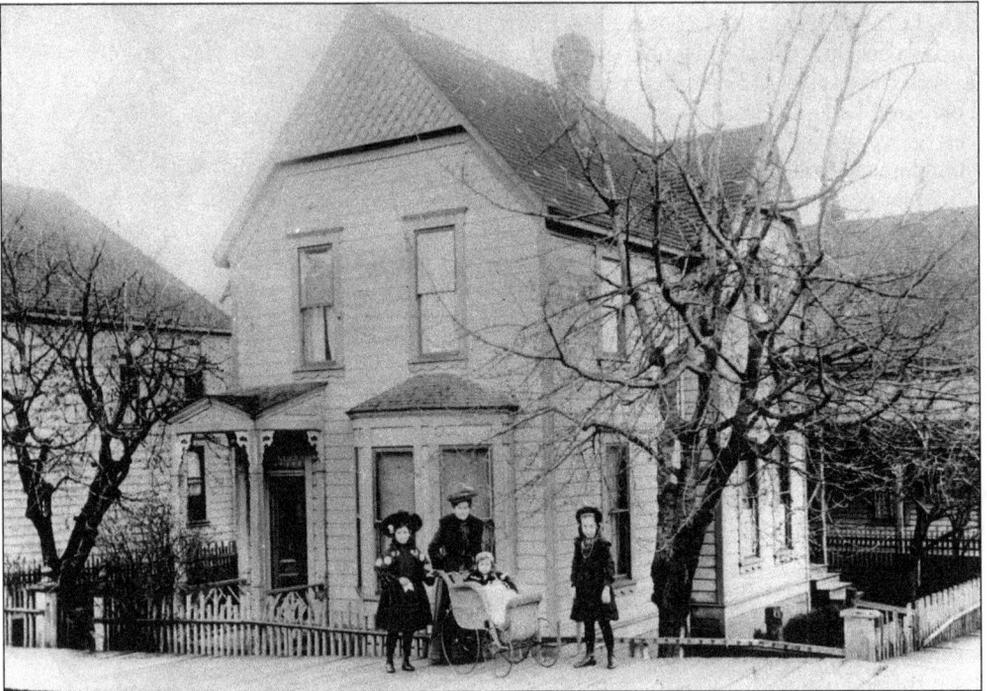

OREGON COLUMBUS HASTINGS HOUSE. The Oregon Columbus Hastings house at Lawrence and Fillmore Streets still looks very much as it did in the 1880s. He received business training at his father's store and acquired Joe Kuhn's photographic studio in 1870. He moved to Victoria, British Columbia, and continued studio work there.

PETTYGROVE HOUSE. The Pettygrove house was built in 1885 by Benjamin Pettygrove, grandson of Port Townsend (and Portland) founder Francis Pettygrove. The house was built on the site of the old family homestead at a cost of $10,000.

BENJAMIN AND ABBIE PETTYGROVE AND BABY OLIVE. Benjamin was the grandson of Port Townsend founder Francis Pettygrove. His father arrived as a child aboard the pilot boat *Mary Taylor* on February 23, 1852, with his parents and the Hastings family.

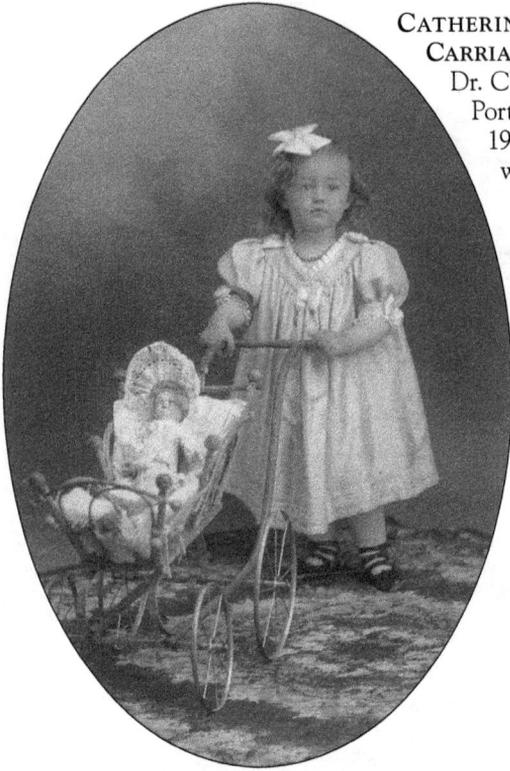

CATHERINE ELLITA MERCEREAU WITH DOLL AND CARRIAGE, C. 1906. Catherine was the eldest child of Dr. Clarence and Edith Loesner Mercereau, born in Port Townsend on June 2, 1904. Between 1890 and 1903, her father traveled throughout the Orient with Capt. Arthur Sewall in his sailing ship. Captain Sewall and his wife, Aurora, were Catherine's godparents.

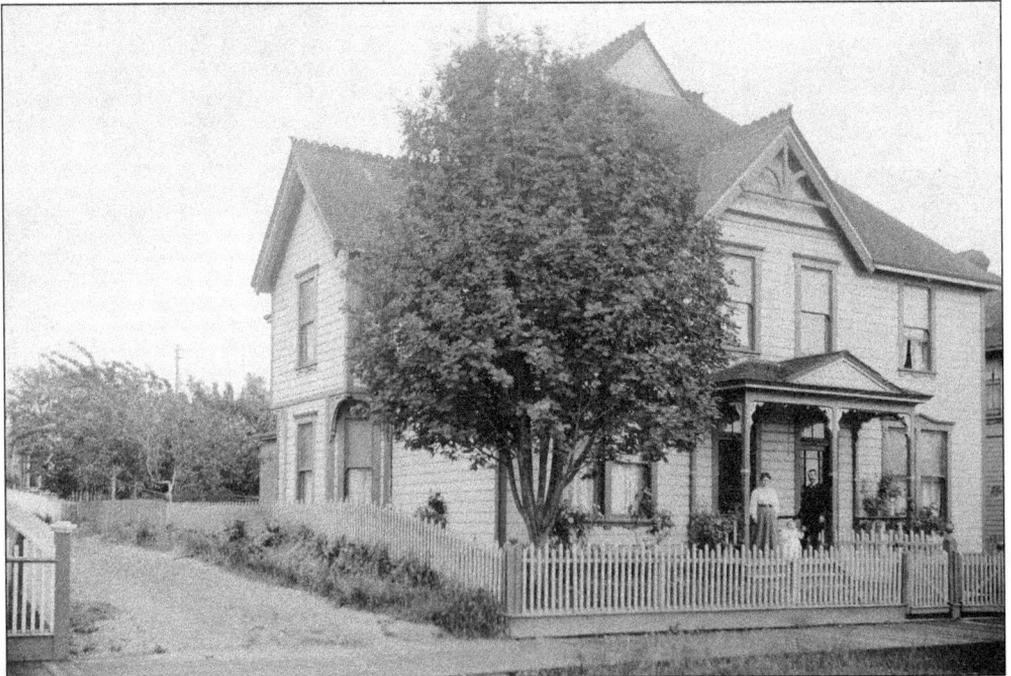

MERCEREAU HOUSE. This is the home of Dr. Clarence Mercereau. Pictured on the porch are Dr. Mercereau, his wife Edith Loesner Mercereau, and their first-born child, Catherine Ellita. The house, which looks very much the same today, is located at Taylor and Lincoln Streets.

F. C. HARPER HOUSE. The F. C. Harper house at 502 Reed Street was built in 1889 for about $2,500. The family moved to Orcas Island in the 1890s. In this 1984 photograph, the house has undergone a complete restoration.

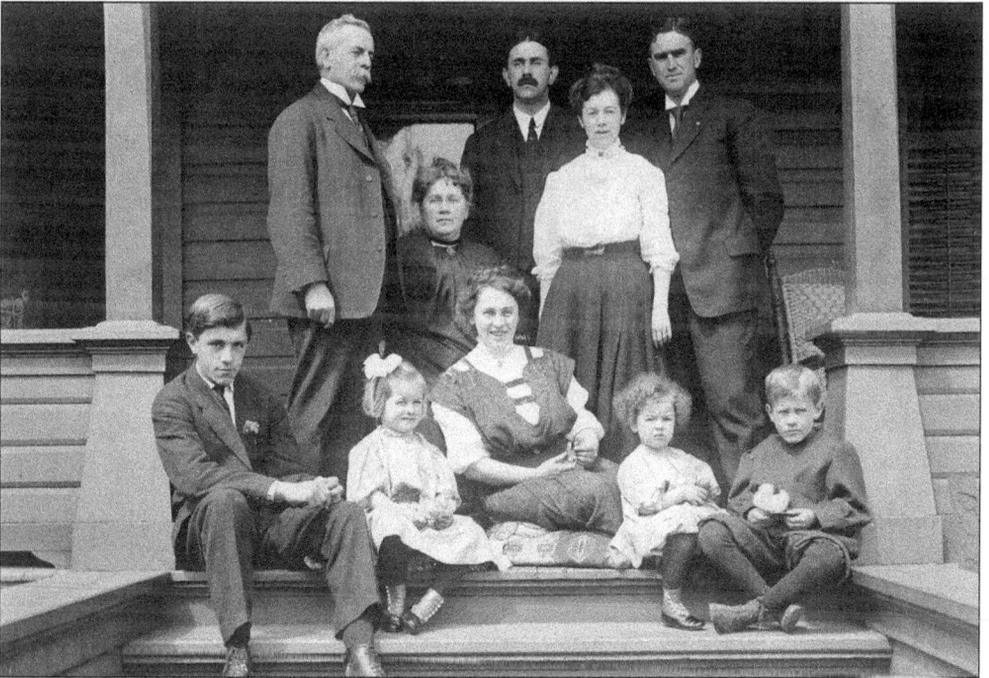

THE F. C. HARPER FAMILY. Frederick Crane Harper was a native of New Brunswick, Canada. He had a mercantile business in Port Townsend, F. C. Harper and Company. After the economic bust of the 1890s, he moved to Orcas Island.

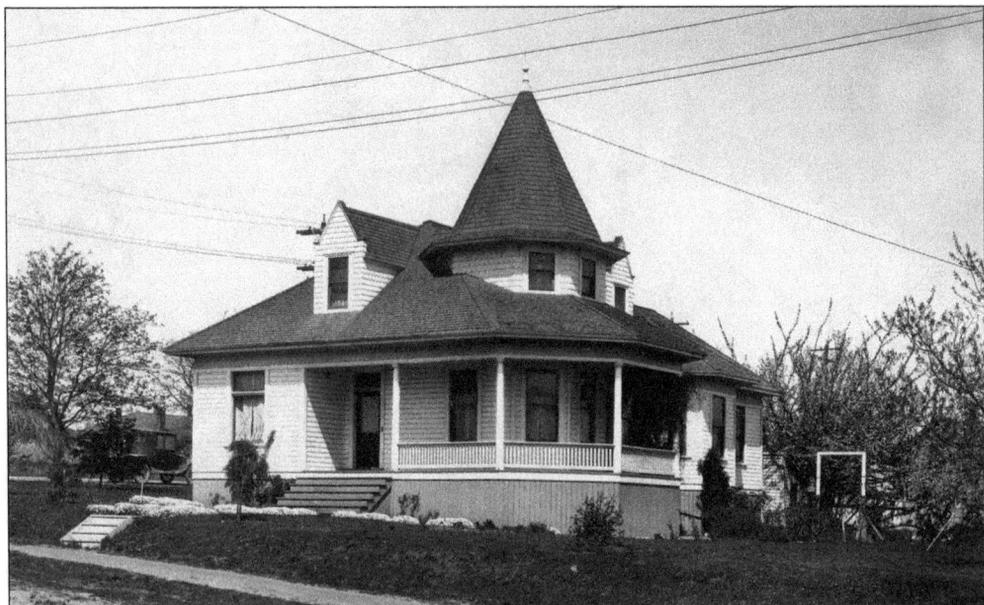

HOME OF DR. AND MRS. J. C. HOUSE. The *Port Townsend Leader* reported on August 20, 1902: "Dr. and Mrs. J. C. House are moving into the handsome cottage recently completed for them on a commanding eminence overlooking the Bay by W.A. Kuehn. The residence is one of the finest in the city and Dr. and Mrs. House are justly proud of their new home."

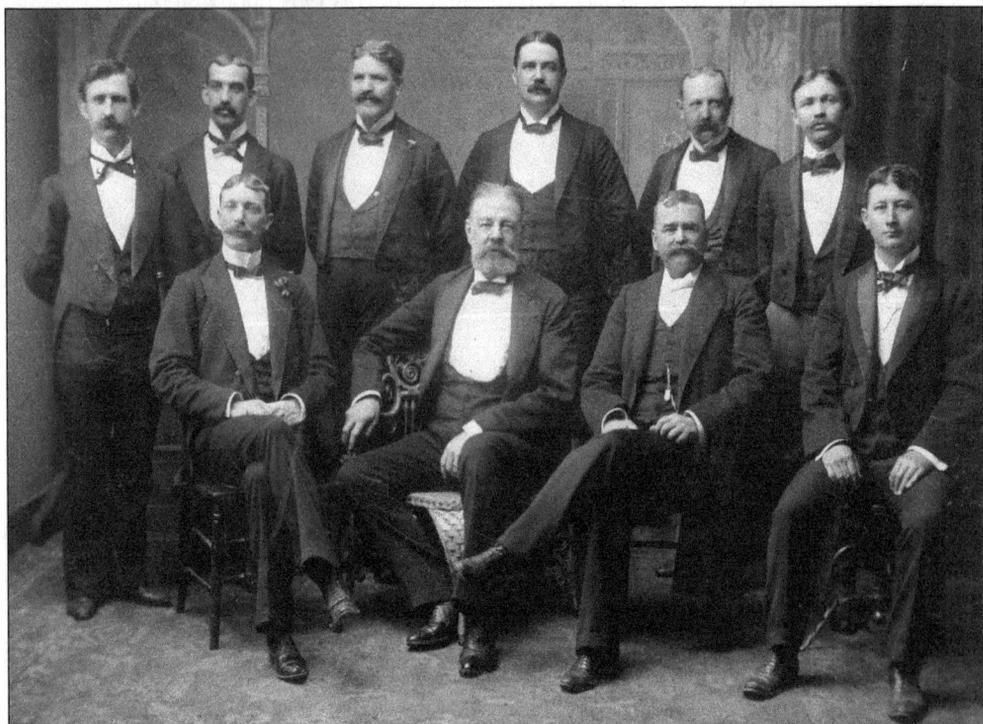

A GROUP OF PORT TOWNSEND GENTLEMEN. Dr. J. C. House, seated second from the right, came to Port Townsend in 1890 and was the city's most prominent and widely known physician, serving as a health official for both the city and county.

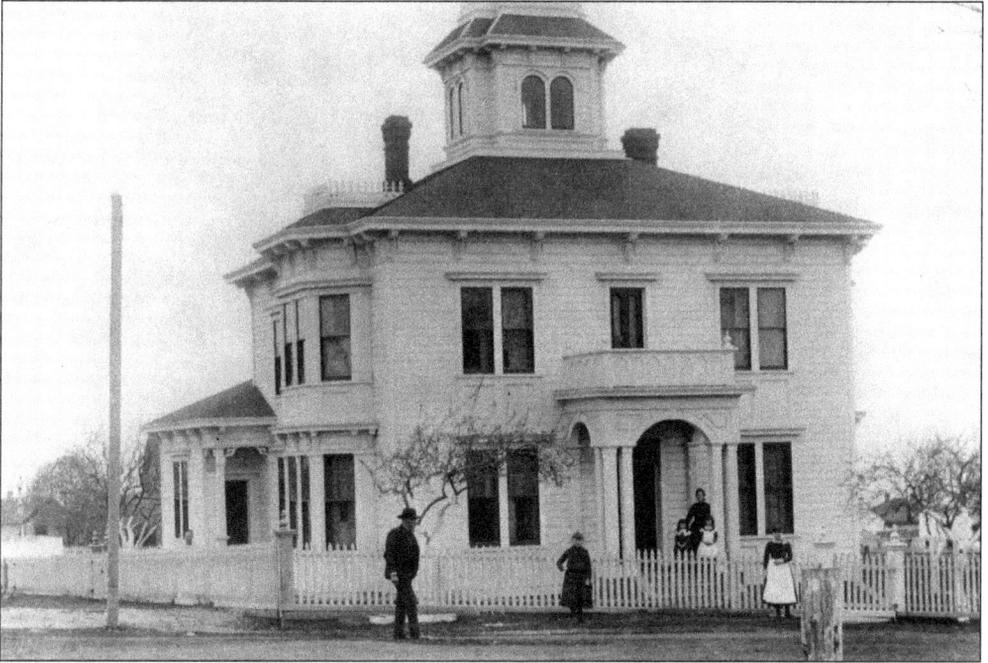

Downs House. This home, at 538 Fillmore Street, was built in 1886 by George W. Downs. The house still stands, but at some point the lofty tower was removed. It remained in the family until 1961.

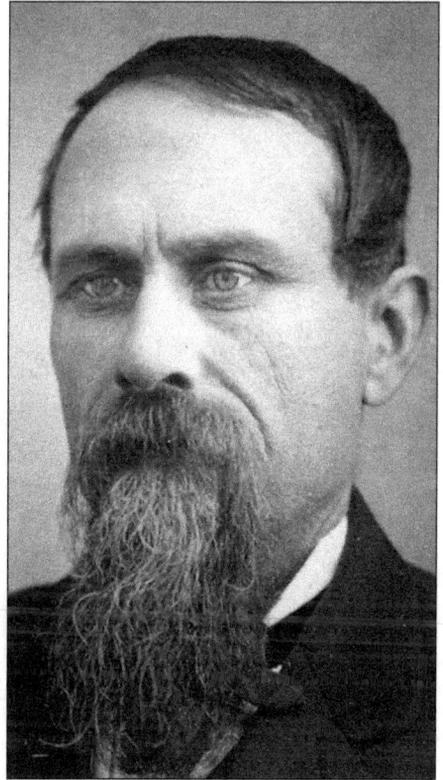

George W. Downs in 1888. Downs came to the Pacific coast in the early 1850s. He worked at the Port Discovery Mill until 1880 when he moved to Port Townsend to assume management of the Point Hudson Sawmill, a very profitable venture, especially during the boom years.

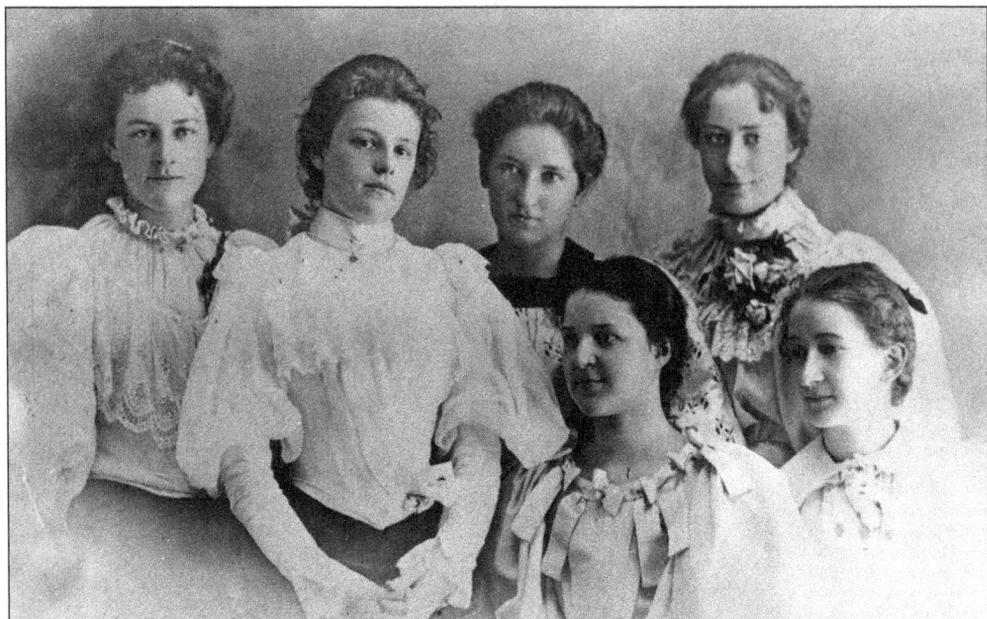

GROUP OF YOUNG LADIES IN 1895. Pictured here are, from left to right, Louise Anna Barthrop, three unidentified ladies, Inez Morris, and Louise Iffland. Louise Iffland graduated from Port Townsend High School and the University of Washington. She taught in Port Townsend schools for nine years and married Charles Barthrop.

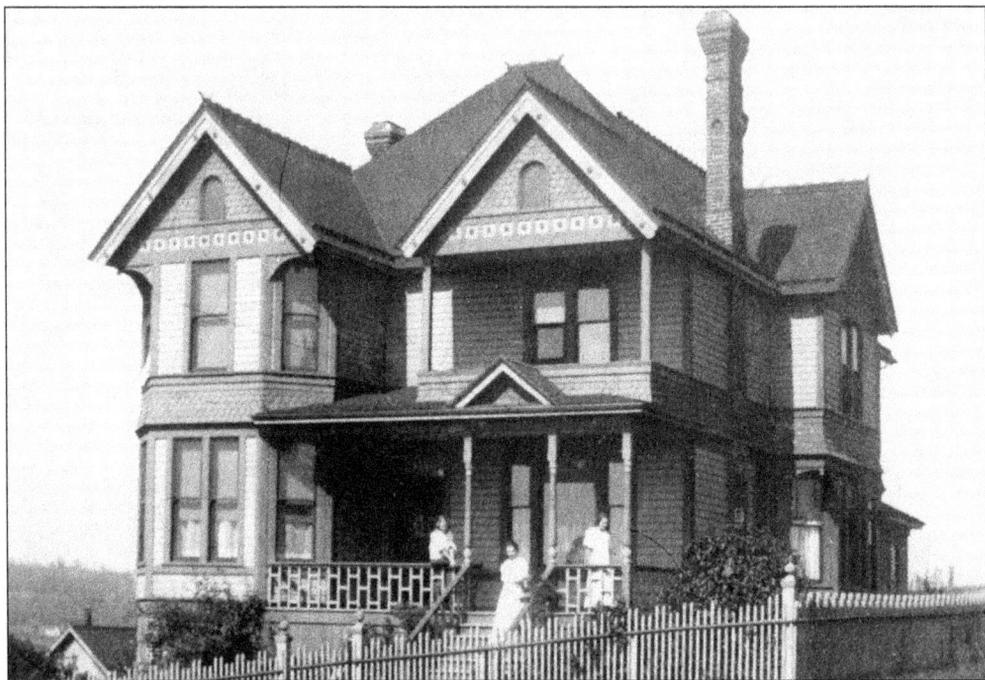

THE IFFLAND HOUSE ON JEFFERSON STREET, 1892. John Iffland was the manager of the Central Hotel. He worked his way up from dining-room waiter to management as the family moved across the country. Before emigrating from Germany, he married Lisette Lenze in 1876. They had six daughters.

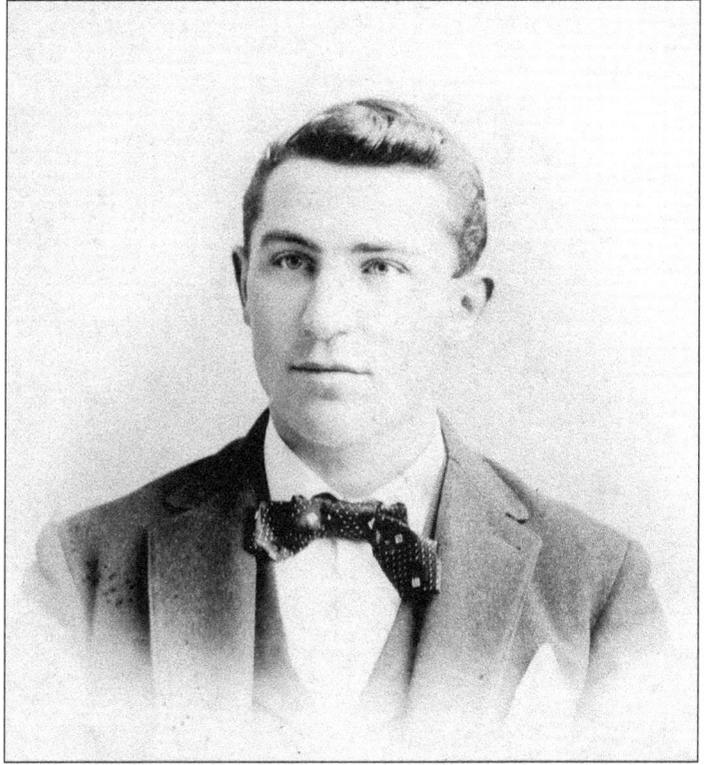

A YOUNG EDGAR SIMS. With Maxwell Levy, Edgar Sims ran the New Sailors Home, one of many such establishments on the waterfront. They provided lodging for sailors at exorbitant rates and crews (willing and unwilling) for outgoing sailing ships. Sims and Levy were notorious for supplying shanghaied crews, a practice not outlawed until 1910. Sims went on to earn a fortune with fish canneries and served in the Washington State Legislature.

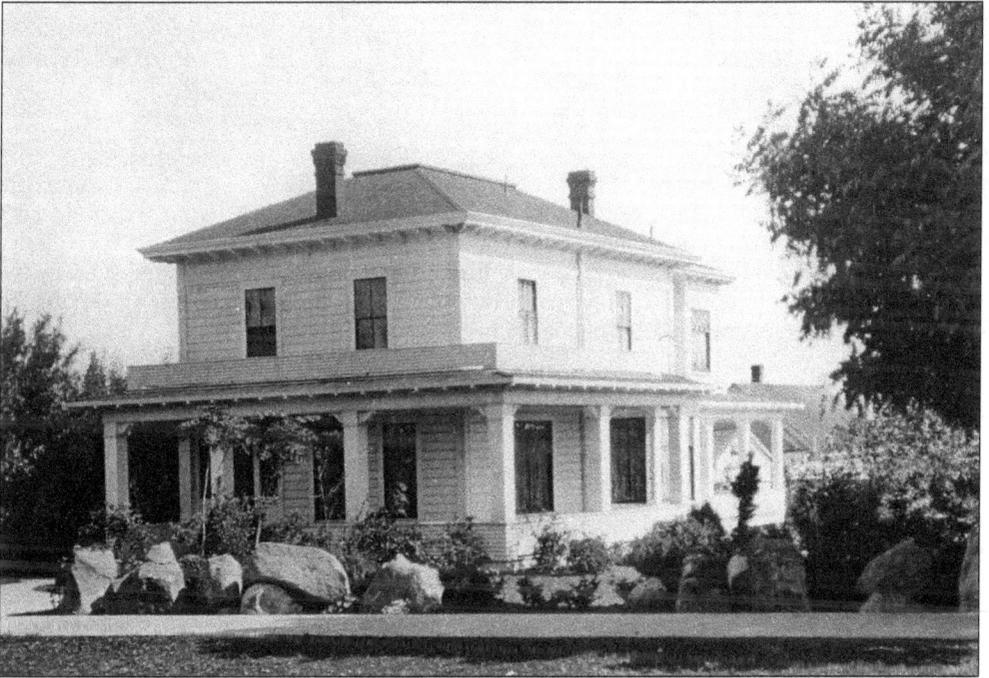

THE SIMS HOUSE AT TAYLOR AND LAWRENCE STREETS. In 1900, Edgar Sims married Harriet Eugene Postinez, the former wife of his partner, and purchased this showplace. It was beautifully landscaped with exotic plants, many of which can still be seen today.

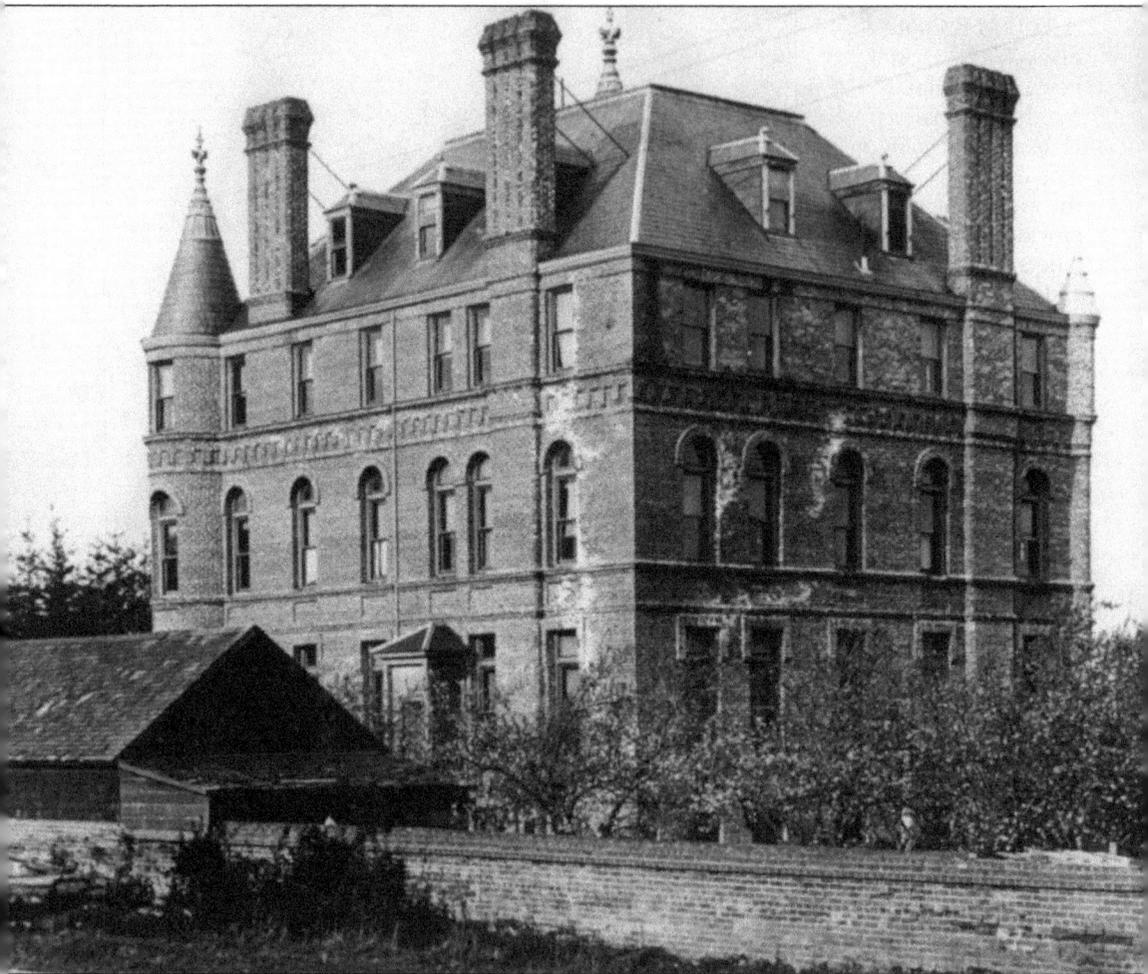

EISENBEIS HOUSE, 1892. Charles Eisenbeis was a young Prussian baker who arrived in Port Townsend in 1858. As a major holder of downtown property and a vast wooden hotel under construction on the hill above the anticipated railway terminal, Eisenbeis was hit severely by the depression of 1893. His hotel never opened. With probably the last bricks his yard produced, he built this stately house, reminiscent of ones in his homeland.

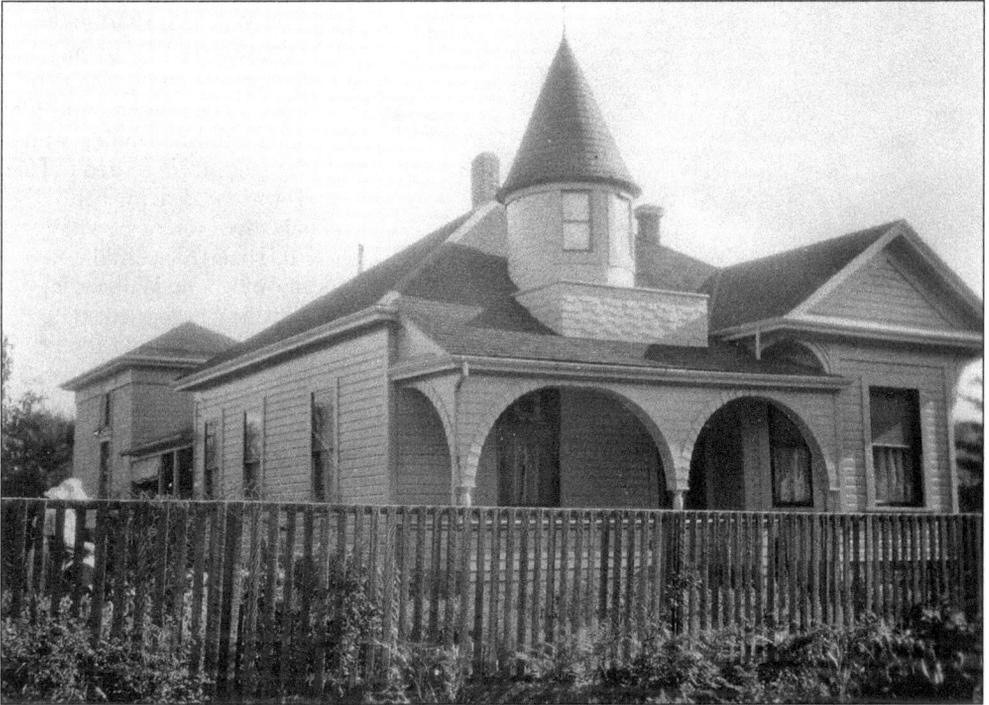

POPPENDICK HOUSE. The Poppendick house at Adams and Clay Streets was built by Captain Sewell for his wife. The house has been known as the Annapurna Inn for many years.

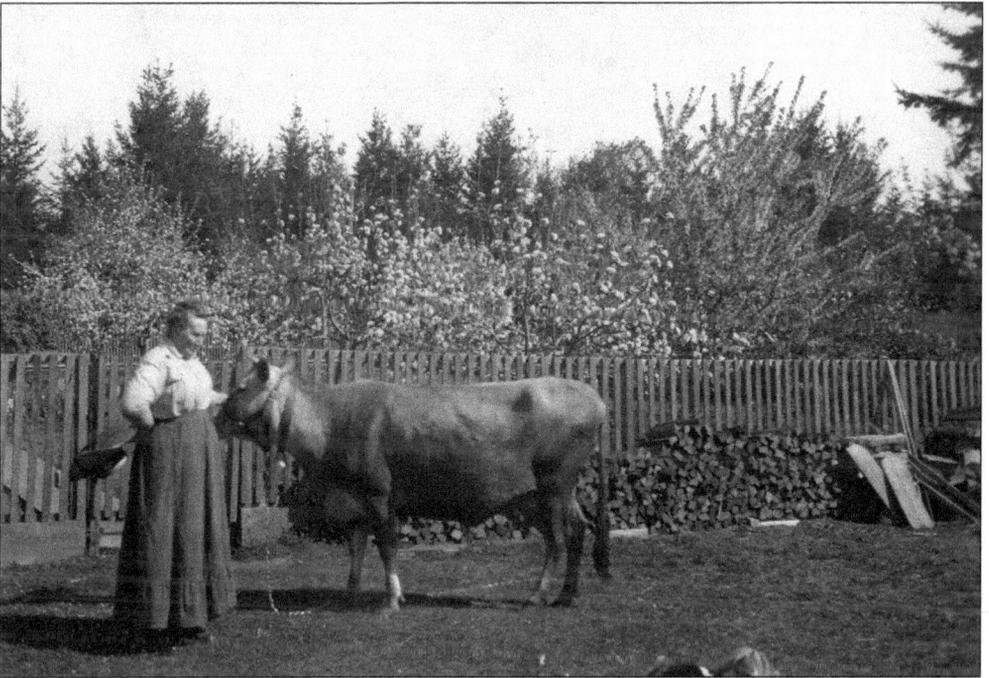

MRS. POPPENDICK WITH HER COW. Most homes uptown were surrounded by ample space for outbuildings, gardens, orchards, and animals. Additional homes have since been built in most of this open space.

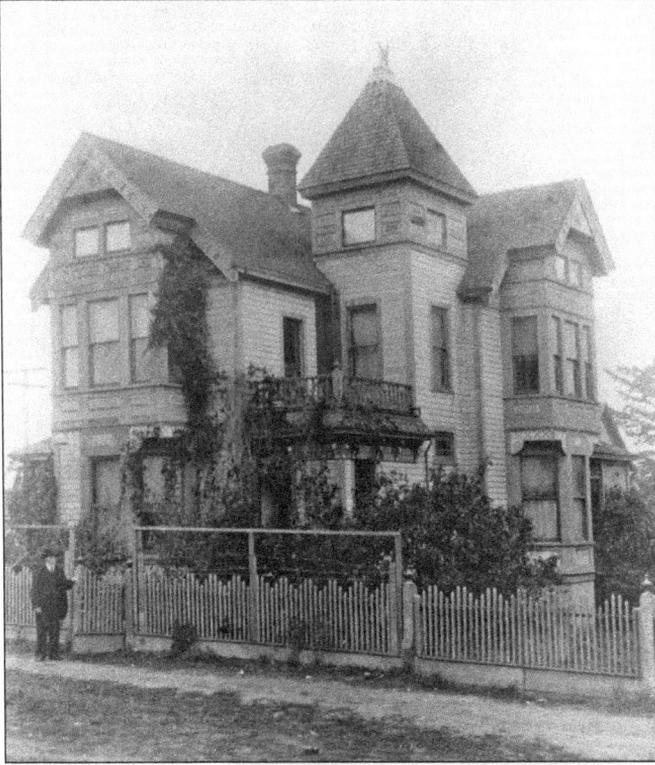

THE WILLIAM BISHOP SR. HOUSE, 1890. William Bishop was an Englishman who jumped ship around 1853 and established a successful dairy farm. He retired to Port Townsend, leaving behind a Native American wife and their three children, one of whom, William Jr., became a prominent state senator. In the mid-1860s, Bishop married a Scottish woman, Hannah (or Anna) Hutchinson. He built this house for her and their four children in 1886.

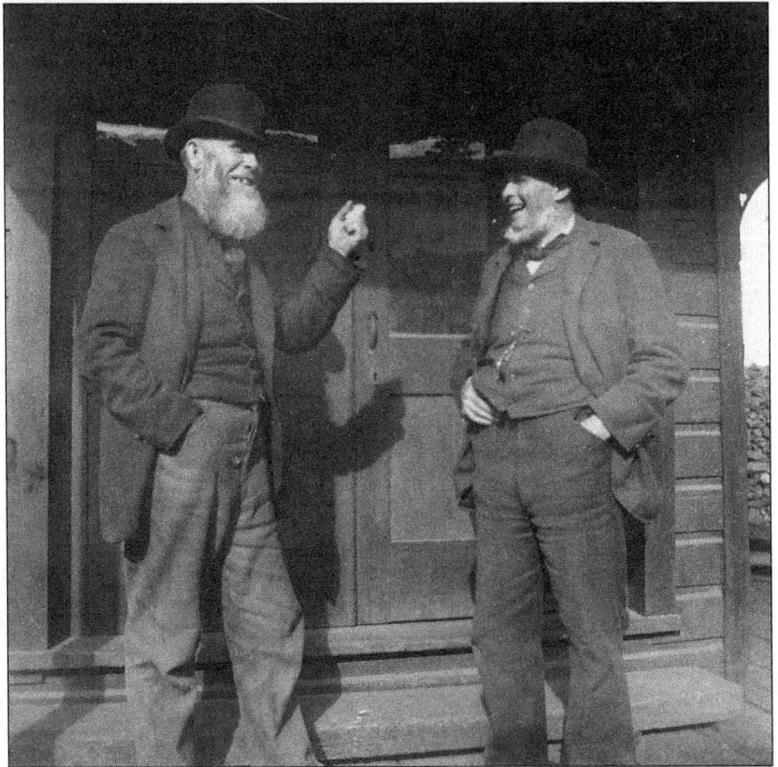

JOHN FUGE AND WILLIAM BISHOP. John Fuge (left) was a carpenter and shipbuilder. William Bishop Sr. was a dairy farmer in the Chimacum Valley, 10 miles south of Port Townsend, before moving to Port Townsend.

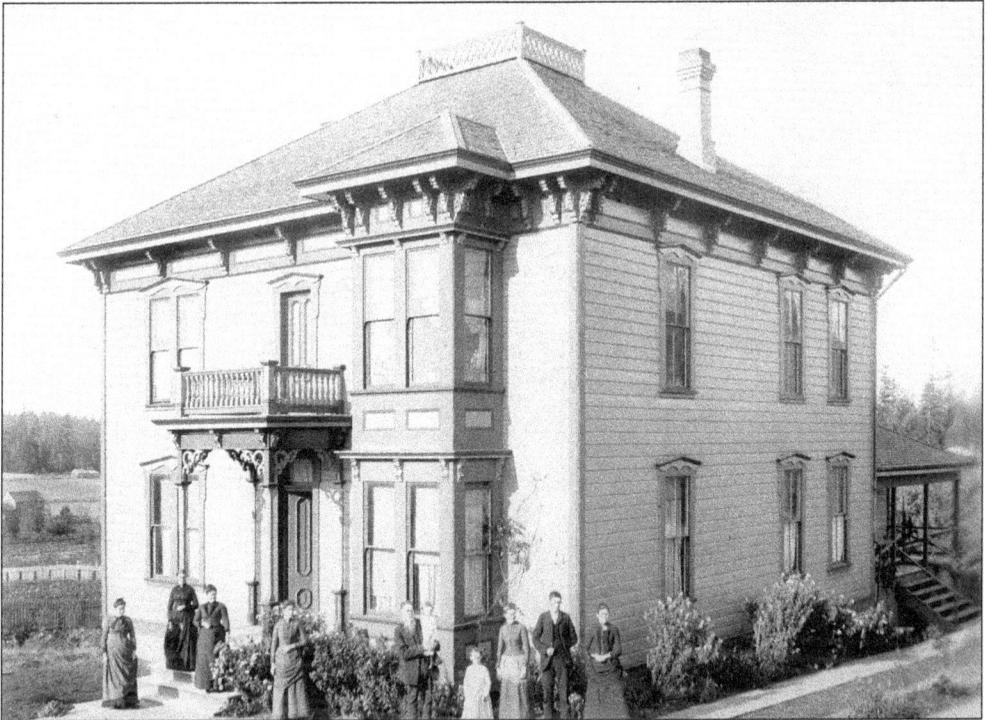

THE HENRY BASH HOUSE, C. 1890.
Built in 1885, the house stood on
one corner of an 18-acre estate that
included a tennis court. Little has
changed in the original structure of the
house. Henry Bash is at center holding
the child.

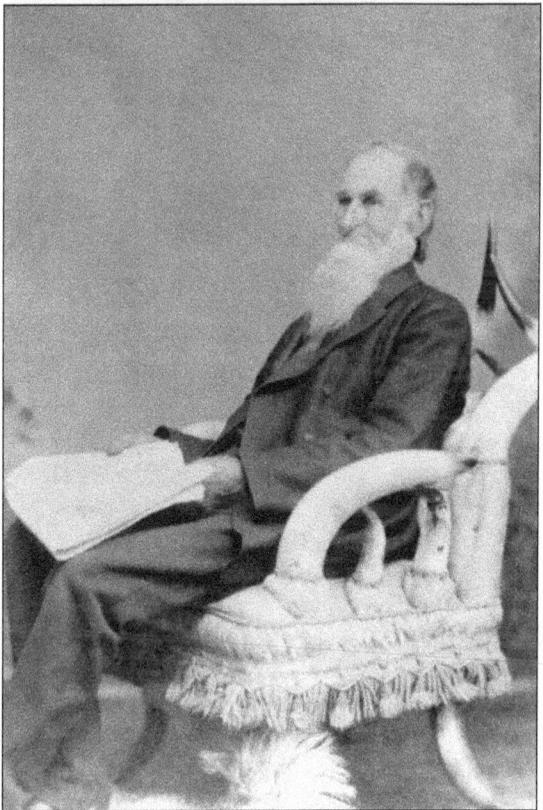

HENRY BASH. Henry Bash is seated
in the horned chair from McMurry's
Studio. Henry's son, Albert W. Bash,
served as collector of customs for the
Puget Sound District from 1881 to 1885,
during the peak of opium and Chinese
immigrant smuggling in the Pacific
Northwest. Henry Bash followed his
son to Port Townsend in 1883 and was
appointed U.S. shipping commissioner
in his son's office.

75

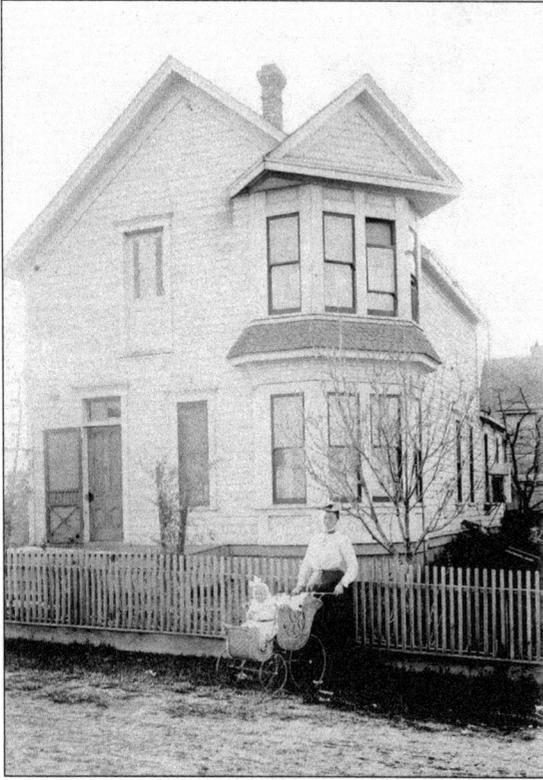

LAKE HOME. This is the Lake home at 1252 Garfield Street with Mrs. Sanford T. Lake and baby Florence in front. In 1890, at the age of 13, Sanford Lake started his career in the dry goods business with McLennan Brothers in the uptown business district. He later purchased the firm and moved it downtown to Water Street. Ann and Sanford Lake lived their entire married life in this house, celebrating their 50th wedding anniversary in 1950.

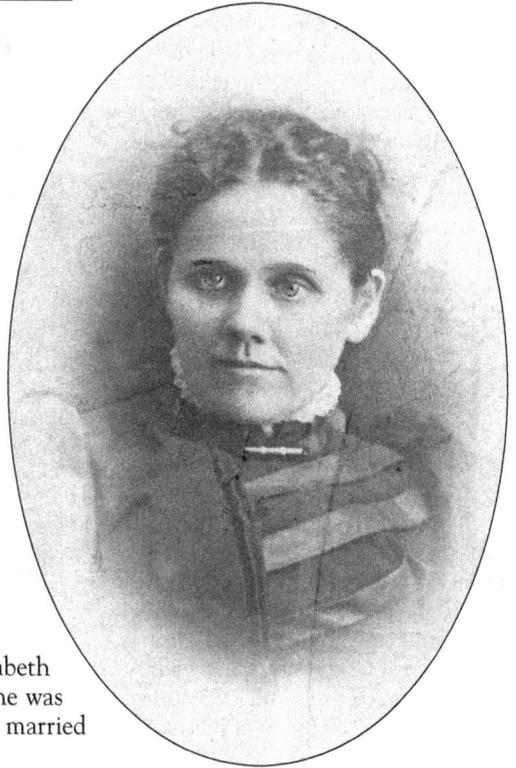

FLORENCE ELIZABETH LAKE. Florence Elizabeth Lake was born in Port Townsend in 1903. She was the only child of Ann and Sanford Lake and married C. R. Willis of La Mesa, California.

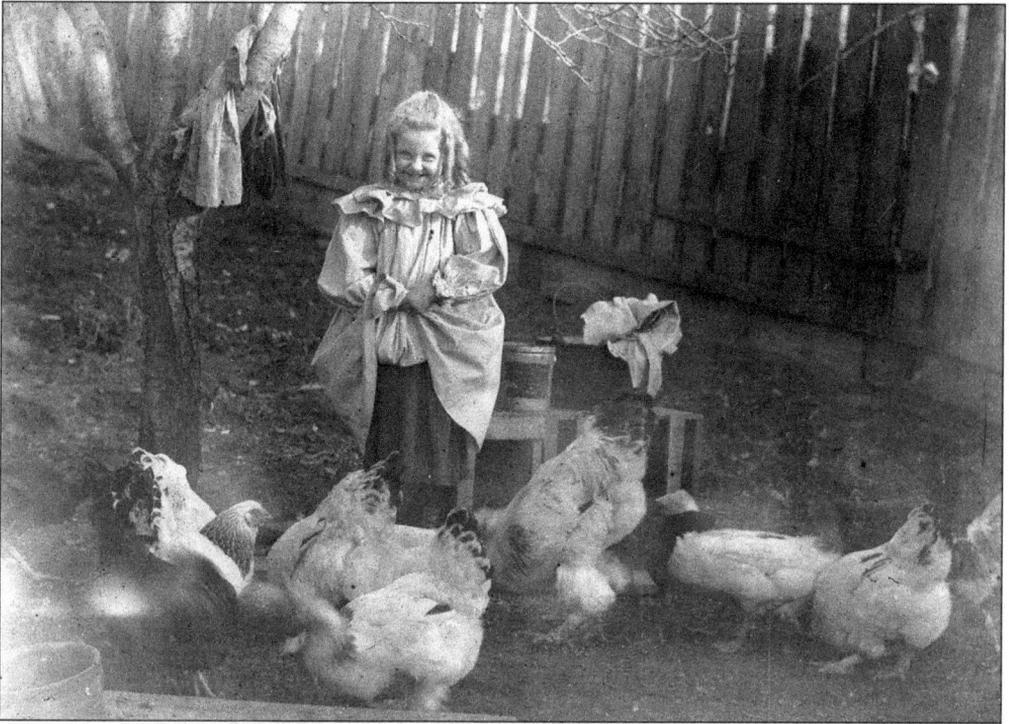

ROSETTA KLOCKER FEEDING A FLOCK OF BACKYARD CHICKENS. Rosetta was the only child of Oscar Klocker and local girl Kathlynne Pink. He was the son of a wealthy Norwegian family and sailed into Port Townsend as an apprentice, learning his family's shipping trade. He stayed for the rest of his life, at various times serving as vice consul for England, Chile, and Norway.

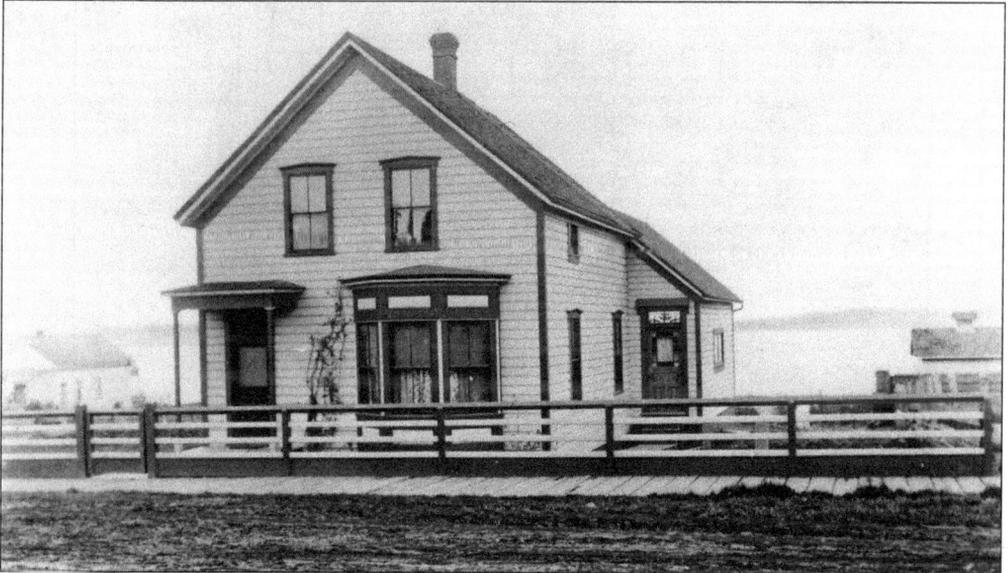

THE KLOCKER HOUSE. The Klockers were active in the Port Townsend social scene. Oscar was a member of the chamber of commerce, Elks, and Odd Fellows. At their home, they hosted sea captains and officials from England, Chile, and Norway. Oscar was knighted in 1912 to the Order of St. Olaf by the king of Norway for services to his homeland.

77

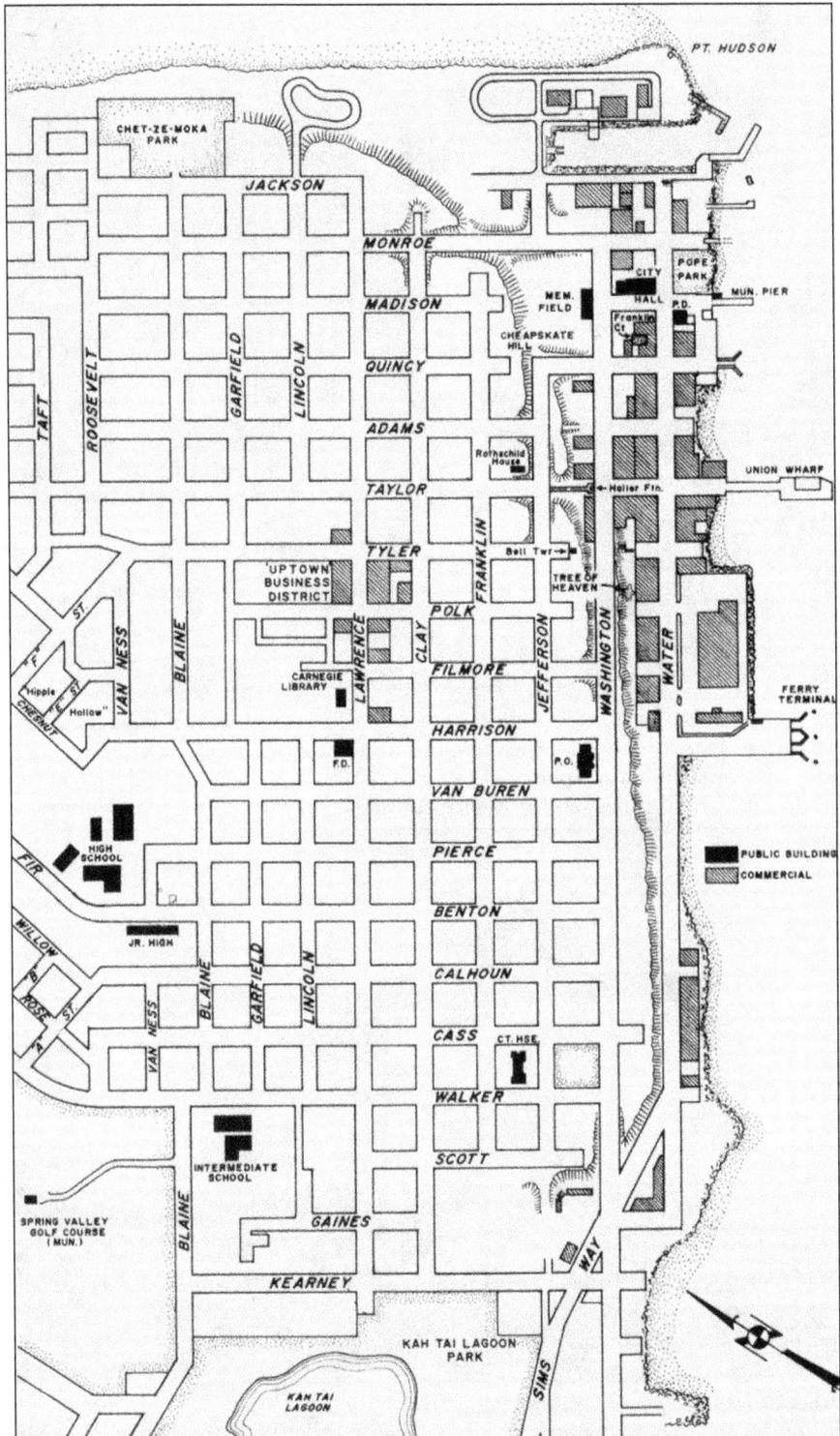

MAP OF PORT TOWNSEND. This street map of Port Townsend is from the book *City of Dreams: A Guide to Port Townsend.*

Six

AMUSEMENTS

Port Townsend residents have always been eager for entertainment. Surrounded on three sides by water, they enjoyed sailing, picnics and cookouts on the beach, canoeing, fishing, beachcombing—and for the hearty—swimming. Of course, one need not travel far to go hiking, mountain climbing, hunting, or camping in the wilderness of the Olympic Mountains.

There was a very active motorboat club. Bicycling and tennis were hugely popular. There were book clubs, glee clubs, a garden club, a yacht club, a pen club for aspiring writers, and even a goat club. Many ladies took art classes from accomplished local instructors. The Science, Literature, and Arts Club organized lectures on lofty topics. Locals enjoyed dances, card parties, masquerades, musicals, amateur theatricals, visiting entertainers, magic shows, storytellers, and as soon as possible, movies. The lodges of the Red Men, Odd Fellows, Good Templars, and Masons served for community meetings, dance classes, plays, and school graduations. Church groups hosted picnics and wedding parties. Baseball and football teams organized and, as transportation improved, lively competition resulted. Early Port Townsend teams played against teams from Chimacum, Port Hadlock, Port Ludlow, and Seabeck.

As early as 1874, the Fowler Building hosted theatrical productions. The Standard Variety Theater, located in the rear of the Cotton Building on Water Street, was in use by 1888 and featured a stage, box seats, and a small orchestra pit. In 1887, at the height of economic optimism and speculation, postmaster A. H. Learned built the Learned Opera House on Washington Street next door to the Bishop Block.

There were, of course, "uptown" and "downtown" amusements. Downtown entertainments included imbibing alcohol, dog fights, horse racing, gambling, and partaking of the services of women at the many brothels or, as they were represented on Sanborn Fire Maps, Female Boarding Houses.

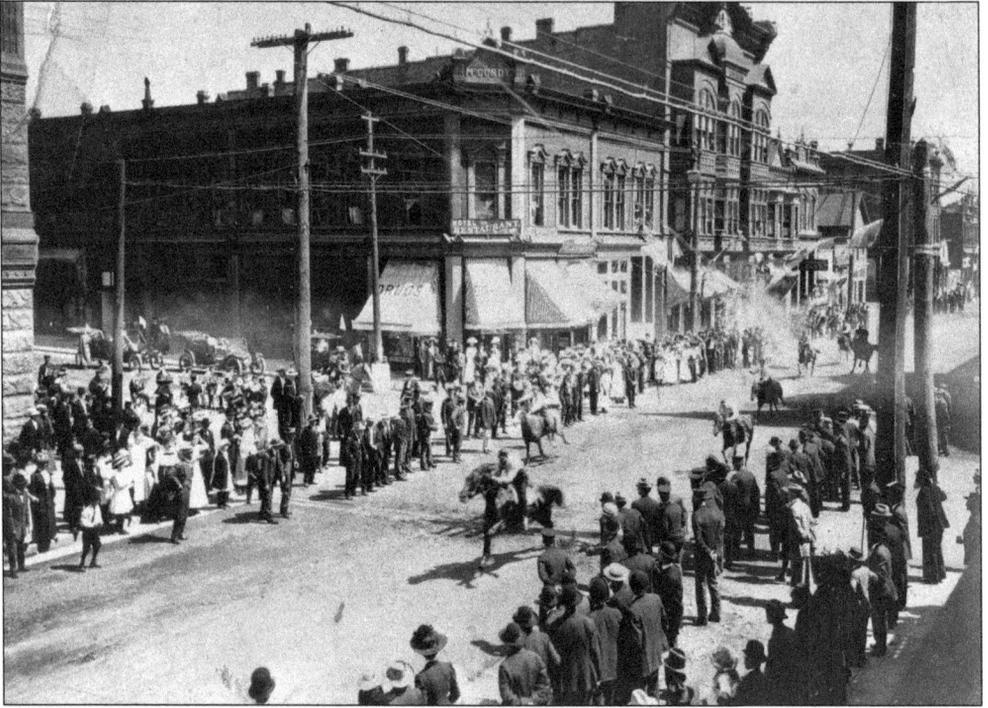

HORSE RACE. This horse race took place on Water Street in 1920 at the corner of Water and Taylor Streets. The McCurdy Building with Delmonico's Saloon is on the corner with the taller Eisenbeis Building next door.

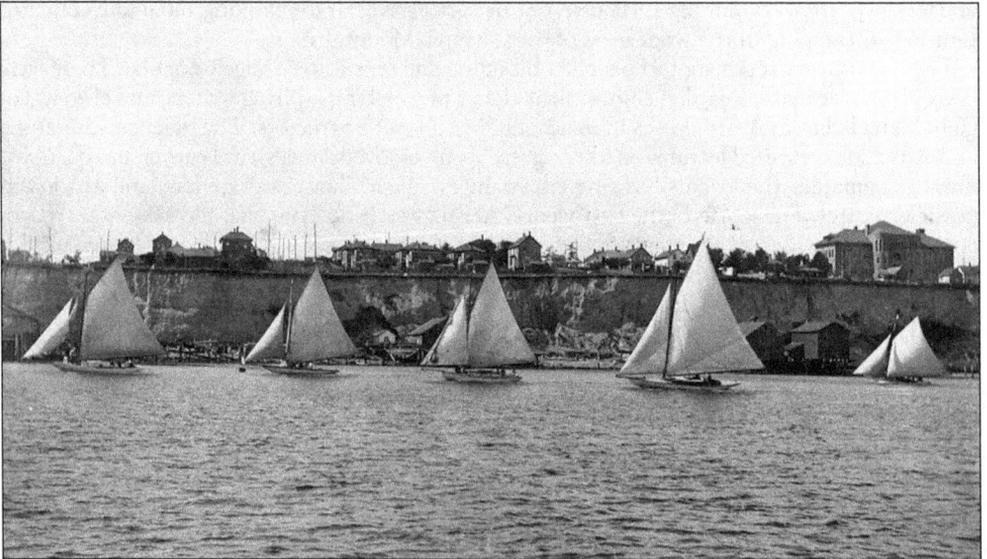

YACHT RACING. Yacht racing has been a part of Port Townsend's waterfront scene from the earliest days. Traditionally, racing enthusiasm climaxed during the annual Fourth of July celebrations. The sport became formally organized when a group of citizens formed the first Port Townsend Yacht Club on July 23, 1892, and engaged F. R. Perrott of Port Townsend to build a 36-foot racing sloop. The beautiful craft, built in eight weeks for $1,600, was christened *Francel* after the 16-year-old daughter of Capt. Loren B. Hastings, a prominent Port Townsend citizen.

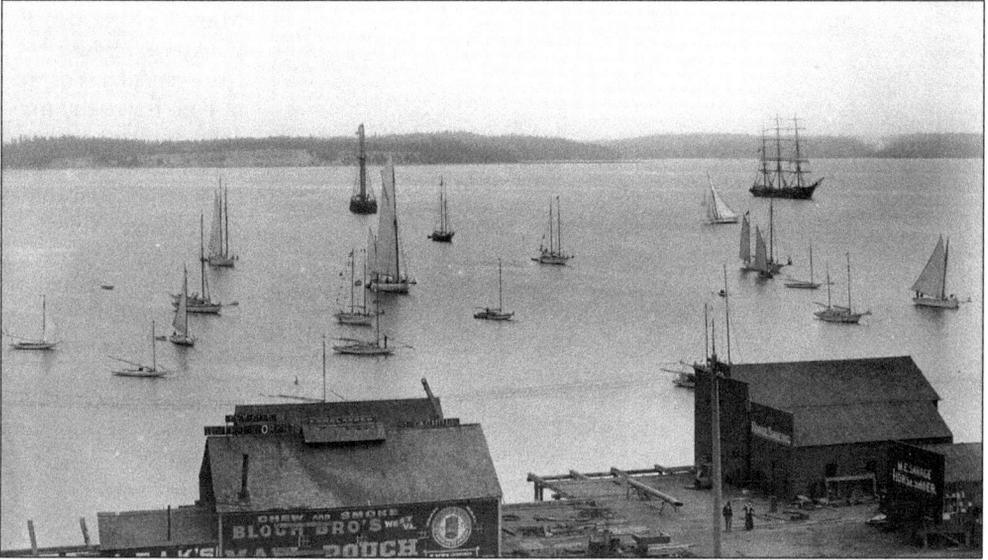

REGATTA. In this view from downtown, sailboats compete in the 1901 regatta of the Northwest International Regatta Association (NIRA). That year, the even was a great success, with 20 yachts from throughout Puget Sound competing. The *Bonita* of the Seattle Yacht Club won the coveted Key City Trophy and kept it for three more years.

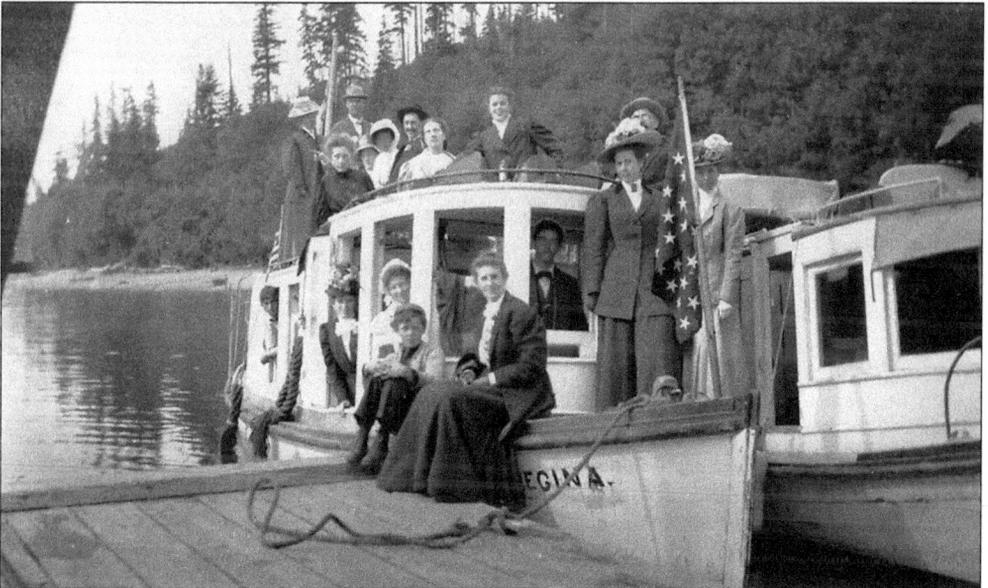

THE REGINA. Members of the Rothschild family are seen here aboard the *Regina* before setting off for a picnic in honor of the Bash family on June 25, 1909.

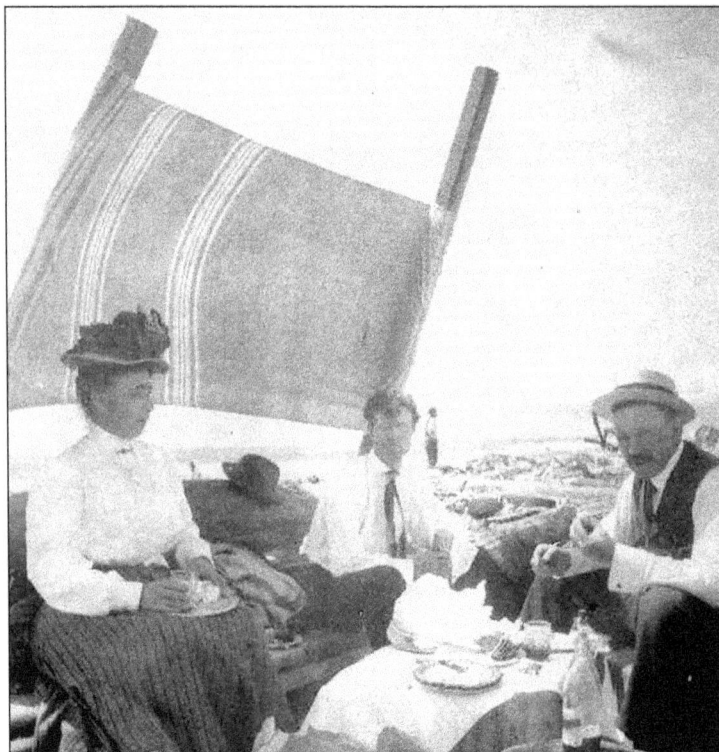

MABEL, DON, AND E. C. ADAMS. Edward Crossett Adams came to Port Townsend in 1888. By 1890, he had gone into business with his brother Alva and T. J. Nolton to create Nolton and Adams Hardware. Eventually, Edward and Alva bought out Nolton and the business became Adams Brothers Hardware and Ship Chandlery. Edward's wife, Lily Bryant Adams, was the secretary in the business. They sold Adams Brothers Hardware in 1907, and it became Olympic Hardware. They then moved to Seattle.

MABEL ADAMS POSED ON A PIECE OF DRIFTWOOD. Mabel was Edward and Lily Adams only child. She attended the Port Townsend Central School and graduated in 1904. Mabel was an active member of the Port Townsend Presbyterian Church and a charter member of the Port Townsend chapter of the Eastern Star. In a time when women normally did not go to college, she attended the University of Washington and graduated with a bachelor of arts in Latin and Greek in 1909.

HORACE MCCURDY. Horace McCurdy is pictured on a beach dressed in short pants and a straw hat. He is holding a model ship.

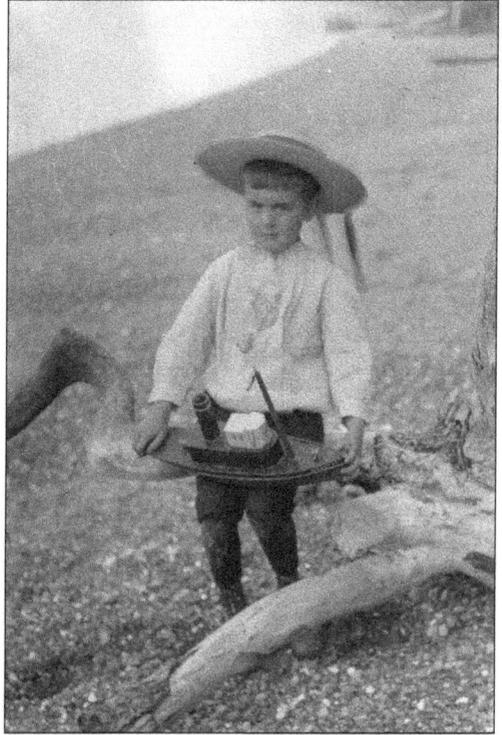

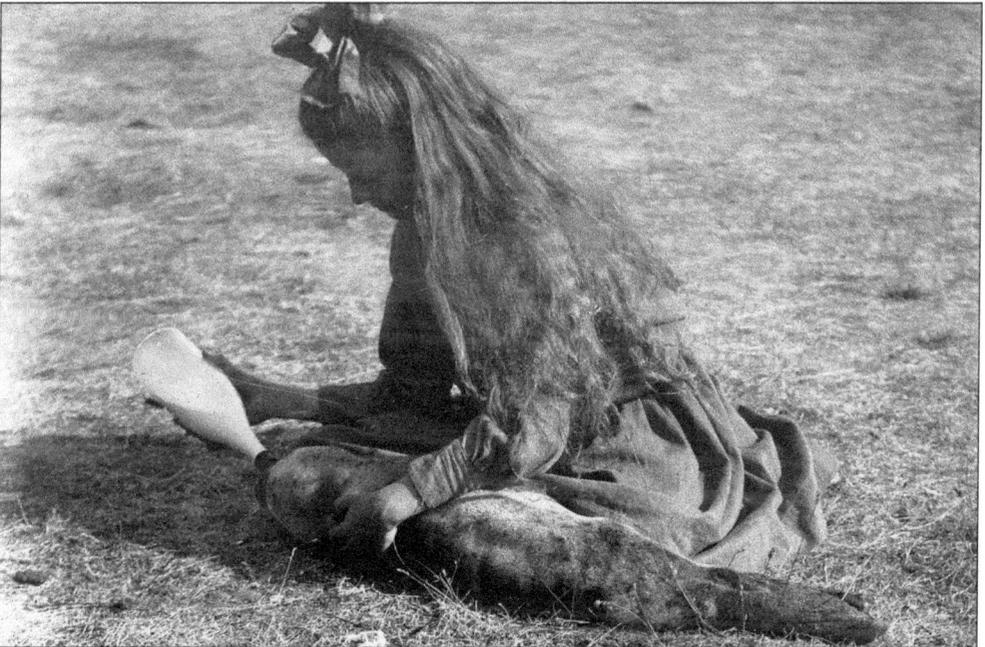

A LITTLE GIRL BOTTLE FEEDS A BABY SEAL. Today this would be a violation of the Federal Marine Mammal Protection Act. Baby seals are often left on the beach while their mothers hunt. It is against the law to hunt, capture, kill, harass, or otherwise disturb seals or any other marine mammal. From 1947 to 1960, there was a bounty on seals because fishermen didn't like their competition. During that time, an estimated 17,000 seals were killed.

83

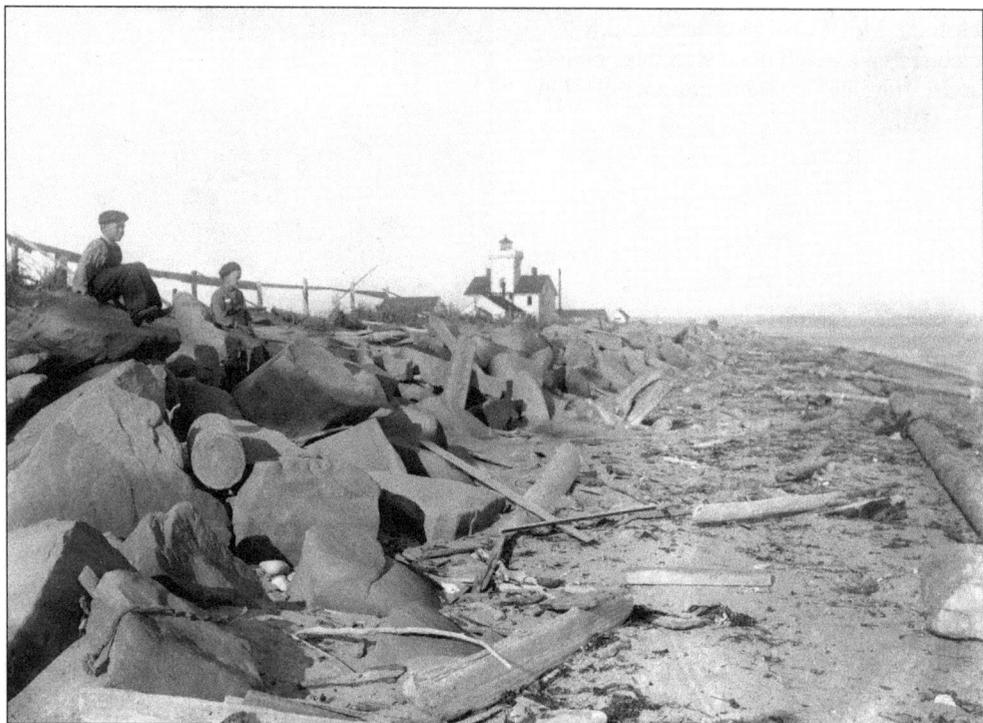

ON THE BEACH. Boys sit on the beach with the Point Wilson Lighthouse in the distance. The lighthouse was built in 1879 by the federal government to help seafarers avoid this dangerous point of land at the northwest entrance to Port Townsend Bay. The lighthouse still stands as an important aid to navigation.

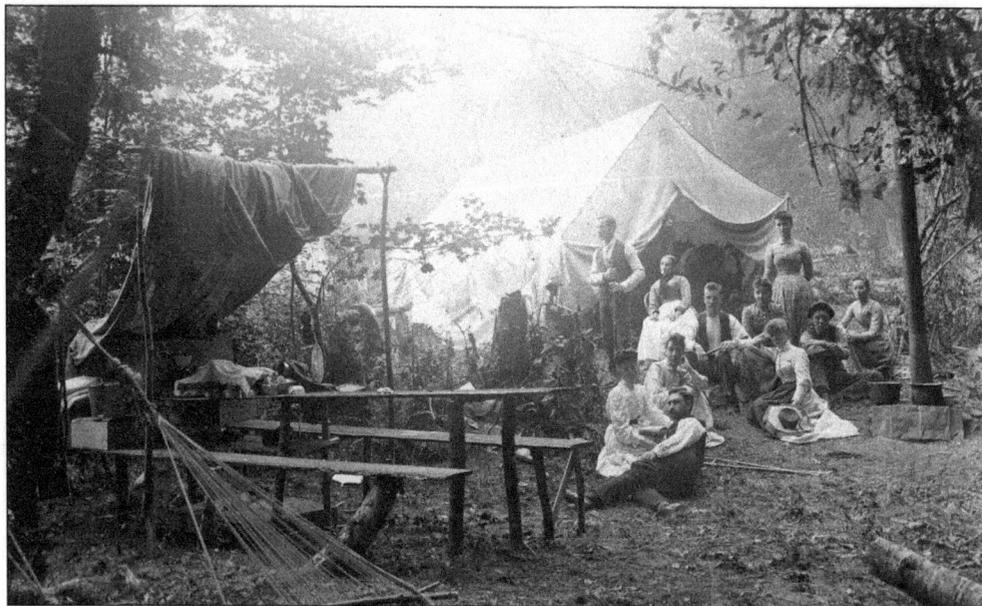

CAMPERS. Residents of Port Townsend also had vacation cabins in the woods and on the nearby beaches. The Olympic Mountains provide ample nearby opportunities to get out into the woods. Glen Cove, the site of the current paper mill, was a favorite spot for informal gatherings.

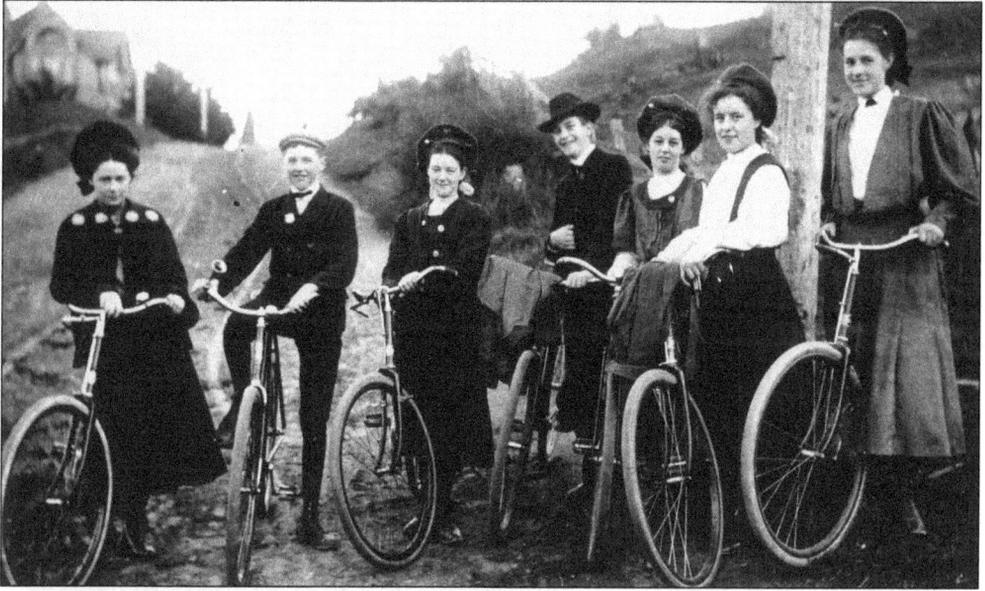

EARLY BICYCLISTS ON LEARNED STREET. In a letter dated April 29, 1900, Anna Green describes a long bicycle ride and an upcoming bicycle race planned by local boys challenging the girls. In 1899, there was a "Bicycle Road Fund" authorized by the city council's finance committee and payment for labor on bicycle paths. In 1899, W. E. Davis was paid by the city for his service as "Special Bicycle Police." On May 9, 1903, a warrant was issued for the arrest of Dr. Charles Trumbull for riding a bicycle on a Port Townsend sidewalk. Pictured in 1910, Jessie Richardson is the third from left. The others are unidentified.

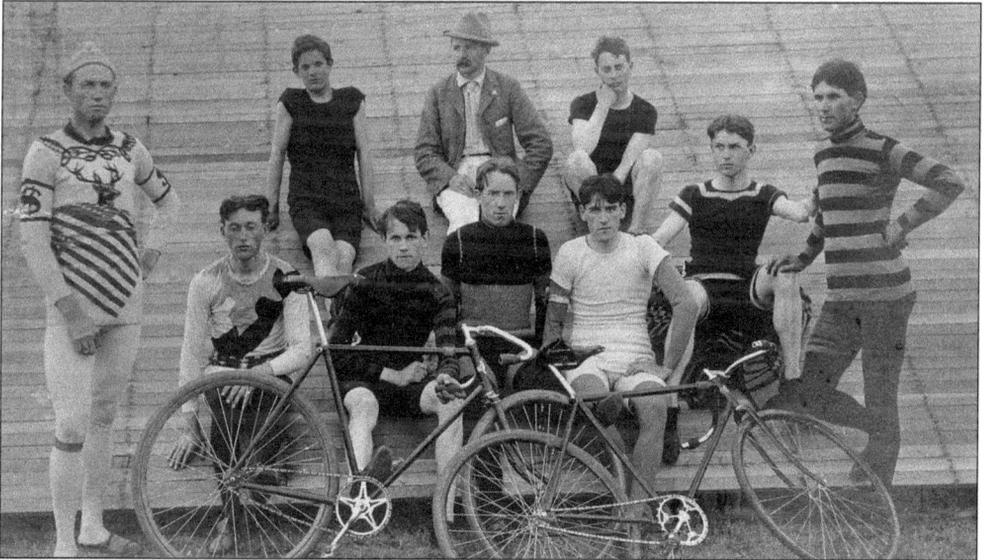

CYCLISTS AT THE CYCLODROME. On May 21, 1901, a Seattle firm incorporated and built a local cyclodrome, a banked, wooden, racing track. It was to be a moneymaking venture with both local and out-of-town teams competing. The first race took place June 15, 1901, with cyclists entering from as far away as Idaho and Oregon. It was located at the southwest corner of the current golf course. Eventually, the abandoned tracks were placed upright to act as part of the fence around the field.

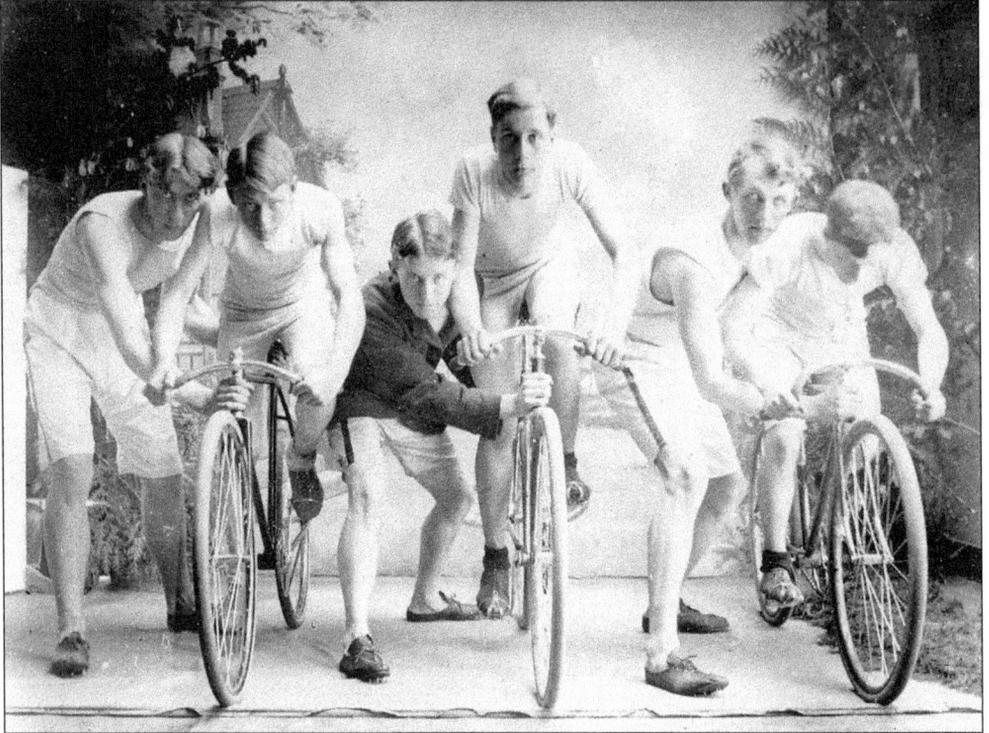

CYCLODROME PARTICIPANTS, C. 1900. Pictured are, from left to right, Earl Sturrock, Charles Schnath (on bicycle), Maurice Tibbals, Ernest Palmer (on bicycle), Will Sturrock, and Clyde Terry (on bicycle).

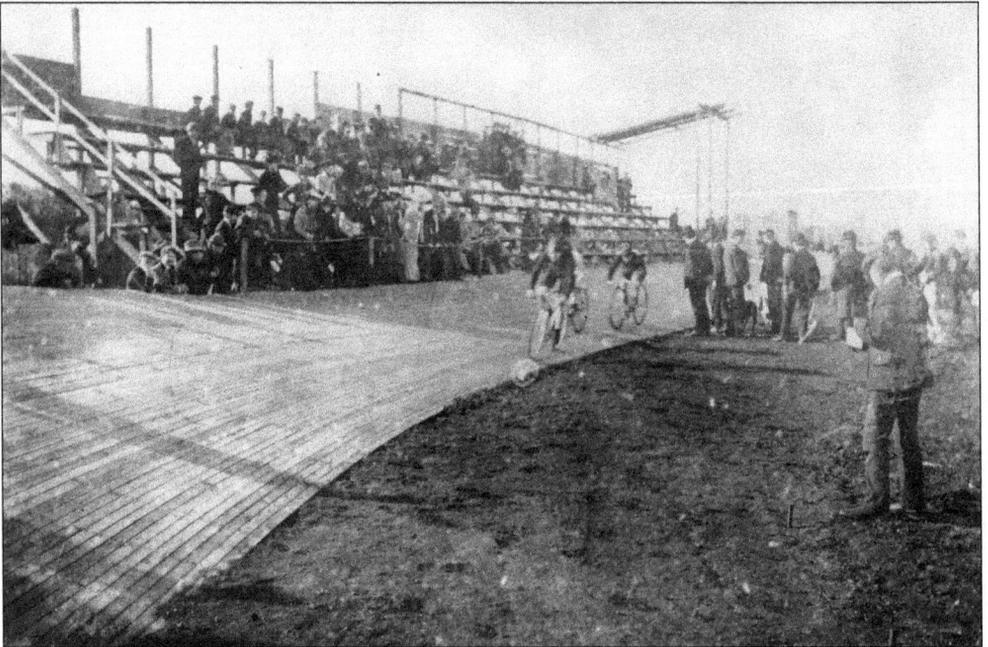

A PORT TOWNSEND BICYCLE RACE. Despite its hilly terrain, Port Townsend residents have been fond of bicycles since rubber tires and brakes made their popularity soar in the 1880s.

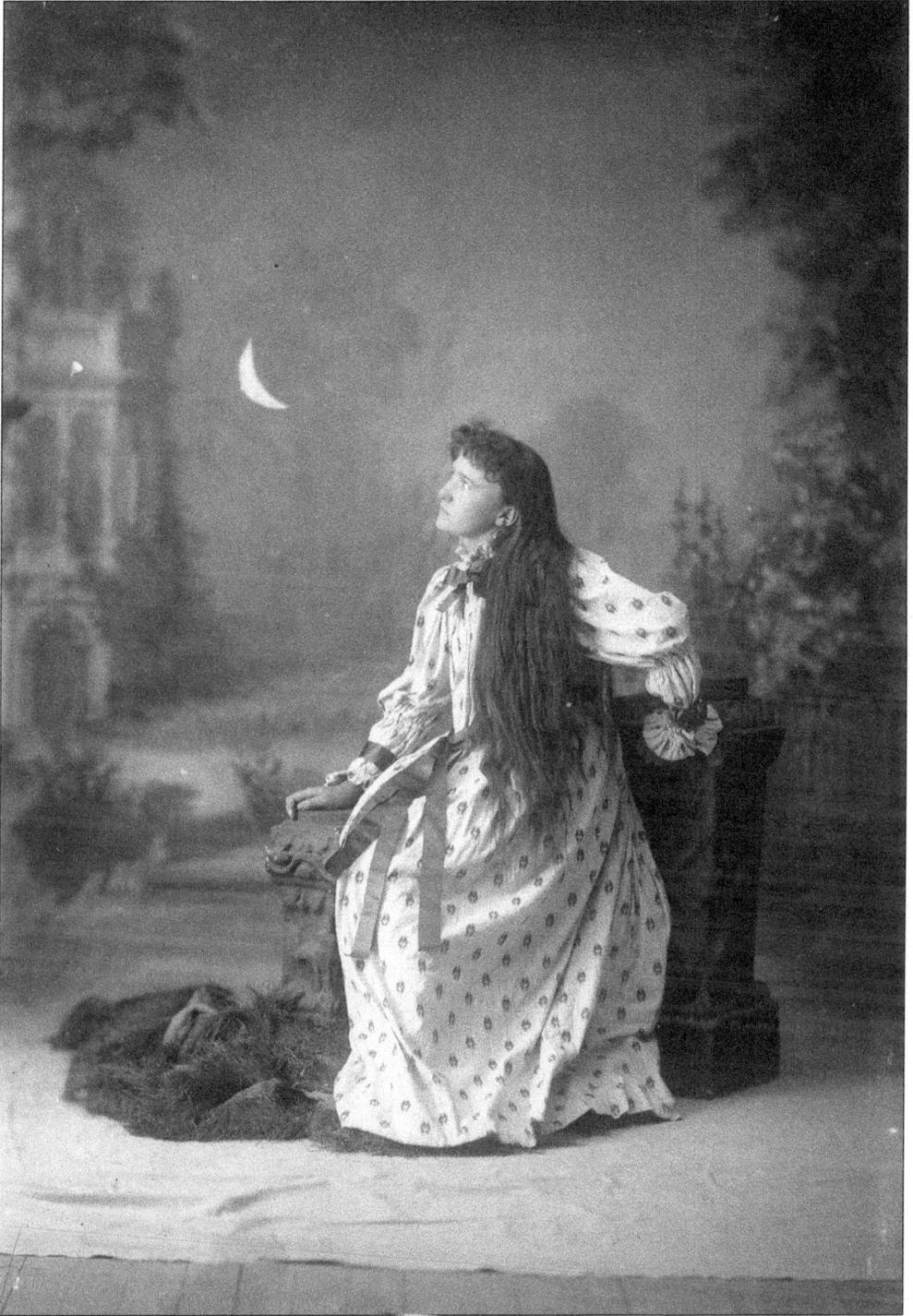

ANNA LAURSEN MCCURDY. Anna Laursen McCurdy is seen here in a theatrical tableau where she gazes at the moon. Anna was the wife of photographer and businessman James G. McCurdy and mother of Horace McCurdy.

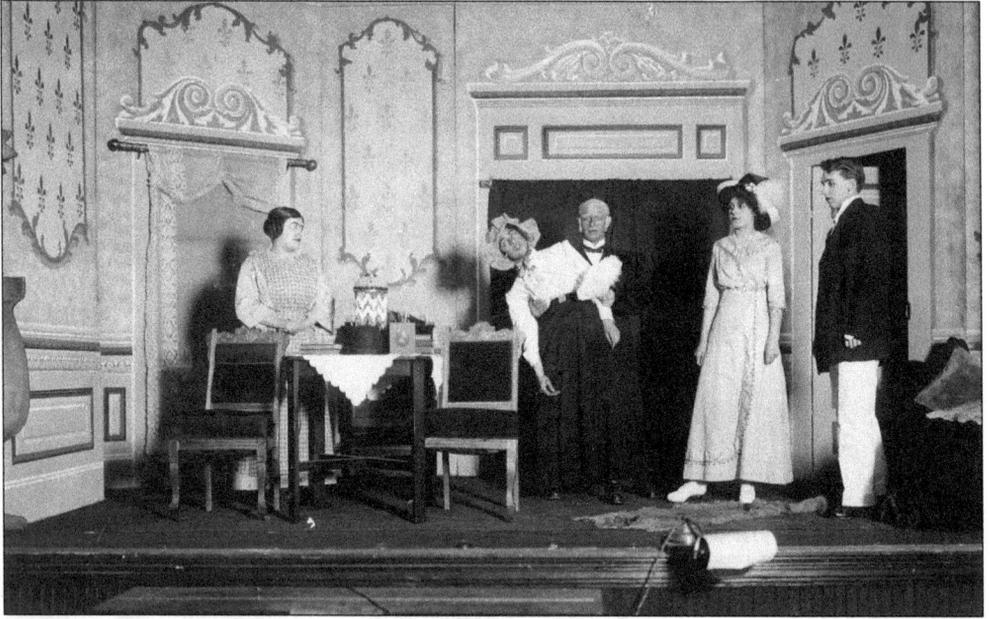

ROSE THEATRE. *Whose Baby are You?* was playing on stage at the Rose Theatre on Taylor Street in 1913. The cast of characters included Dan Gillespie, "a good fellow," played by J. K. Metzger; Jorkins Jobson, "his gardner [sic]," played by M. Deleo; Deacon Smith, "Dan's uncle," played by O. D. Cummings; Sally, "Dan's good-hearted little cook," played by Daisy Levera; Miss Camson, "his housekeeper," played by Emma Metzger; and Louisiana, "a dark brunette, on the war path," played by Hazel Kirk.

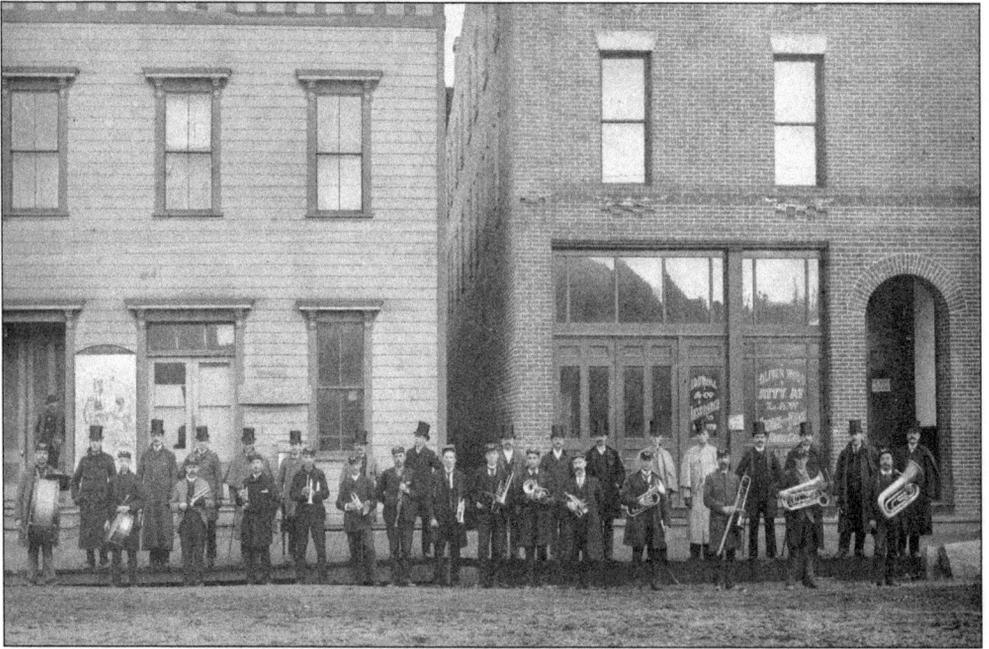

BISHOP HOTEL AND LEARNED OPERA HOUSE. A band poses in front of the Learned Opera House (left) and the Bishop Hotel on Washington Street. The opera house was destroyed by fire on April 6, 1923. The beautifully restored Bishop Hotel still stands.

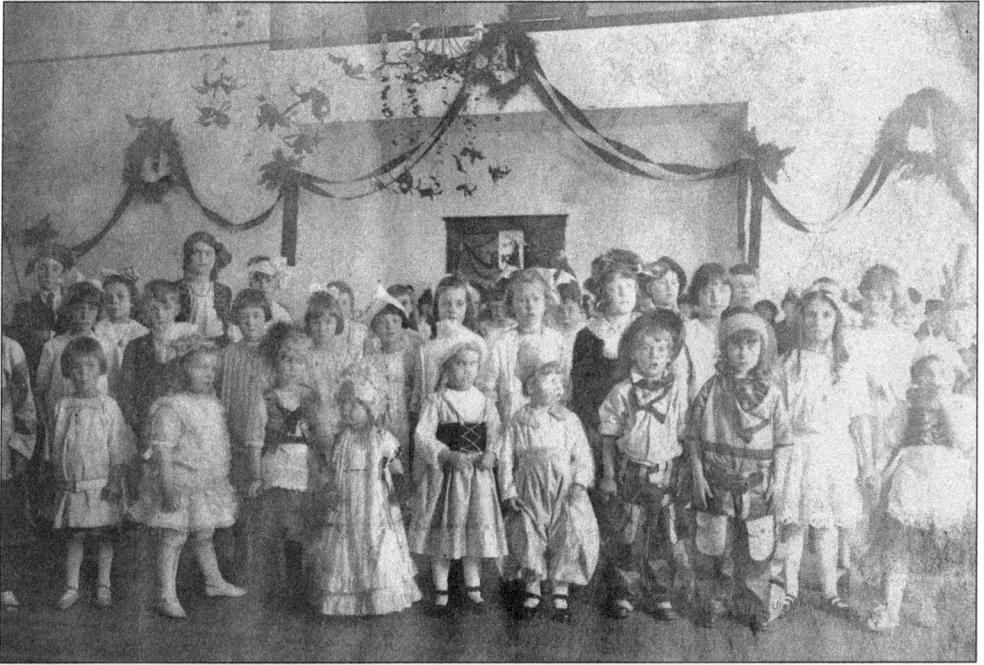

A CHILDREN'S MASQUERADE. The two cowboys in front are Harry Hart and Johanetta Maas Arneson. Osceola House, second from left in front row, and Frances Hayden, second from right in the front row, are also pictured. Behind Harry Hart is Francel Hastings.

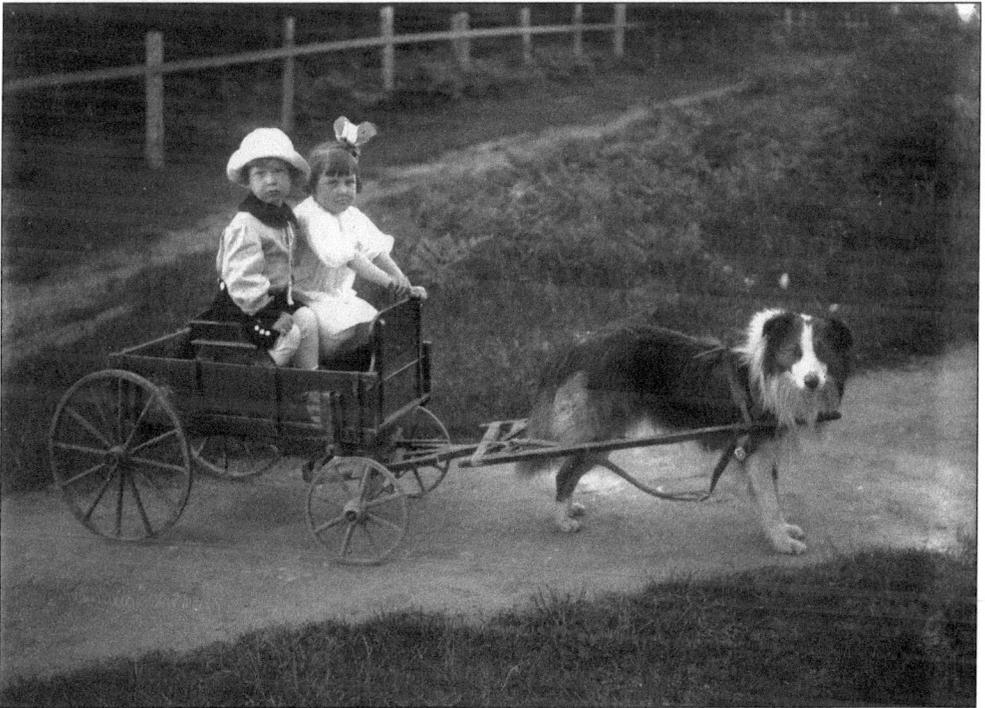

DOG CART. A dog provides horsepower for this cart ridden by two small children.

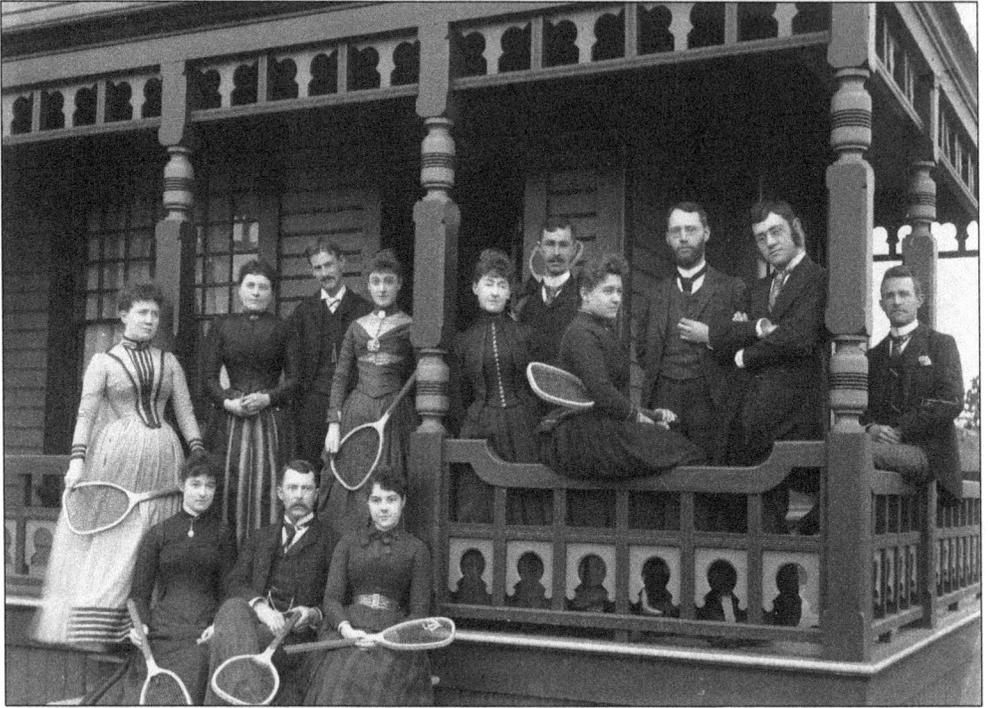

TENNIS, ANYONE? A group of young men and women, probably members of the Townsend Tennis Club, are seated on the porch and steps of the J. B. Hogg House at 932 Pierce Street. Littlefield's Field at Taylor and Lincoln Streets was an excellent tennis court in the heart of residential uptown.

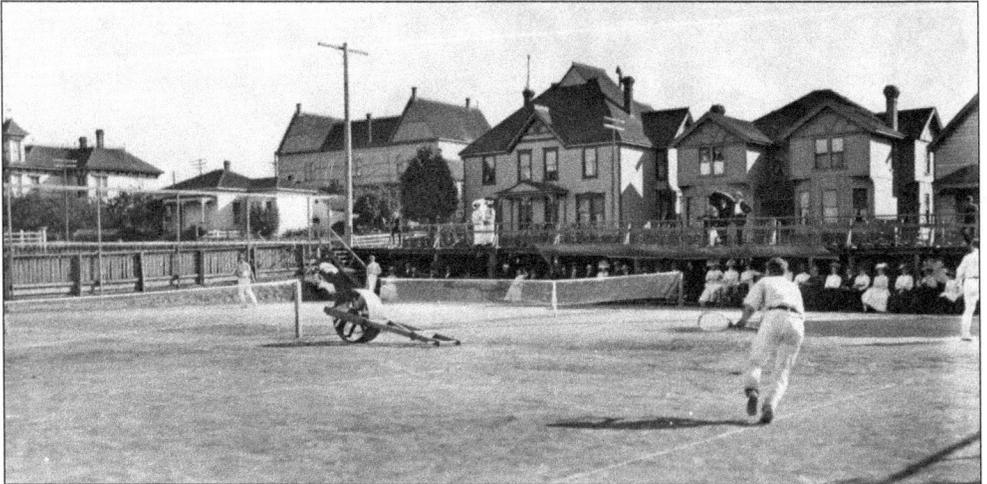

THE TENNIS CLUB. Pictured here is the Tennis Club at Littlefield's Field at the corner of Taylor and Lincoln Streets. The Central School is at far left.

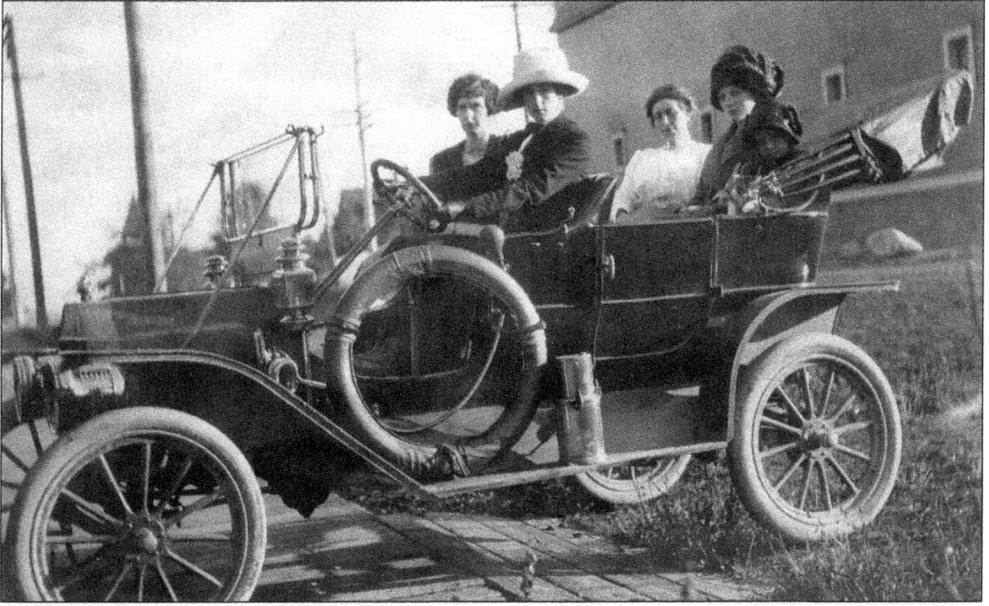

SORGE FAMILY. This is the Sorge family car with Vera (left) and Ella Sorge in the front seat and Hazel Sorge (left) and family friend, Lizette Korter, with her daughter Irene in the back seat in 1911. Motoring was a recreational pursuit well before automobiles became a reliable form of transportation. This photograph was taken in the delivery driveway of Sorge's Bakery and Grocery Store at 1030 Lawrence Street. The family had an apartment above the store. The Odd Fellows Hall is in the background.

PARADE FOR SPANISH AMERICAN WAR VETERANS IN 1912. From left to right are Louis P. Mutty, Mayor Oscar C. Klocker, unidentified, Hazel Dick, Rosetta Klocker, and Florence Pink. They are in place under a peace arch erected at the corner of Water and Taylor Streets.

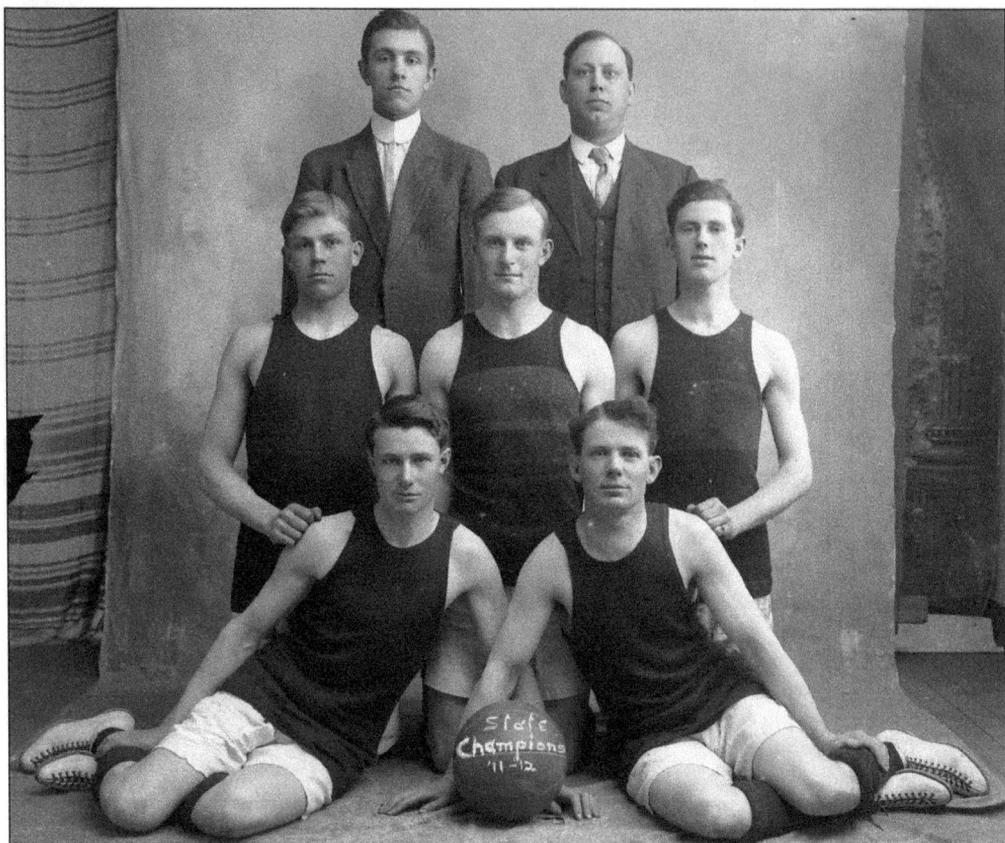

THE CHAMPS. This Port Townsend High School basketball team won the state championship in 1911–1912.

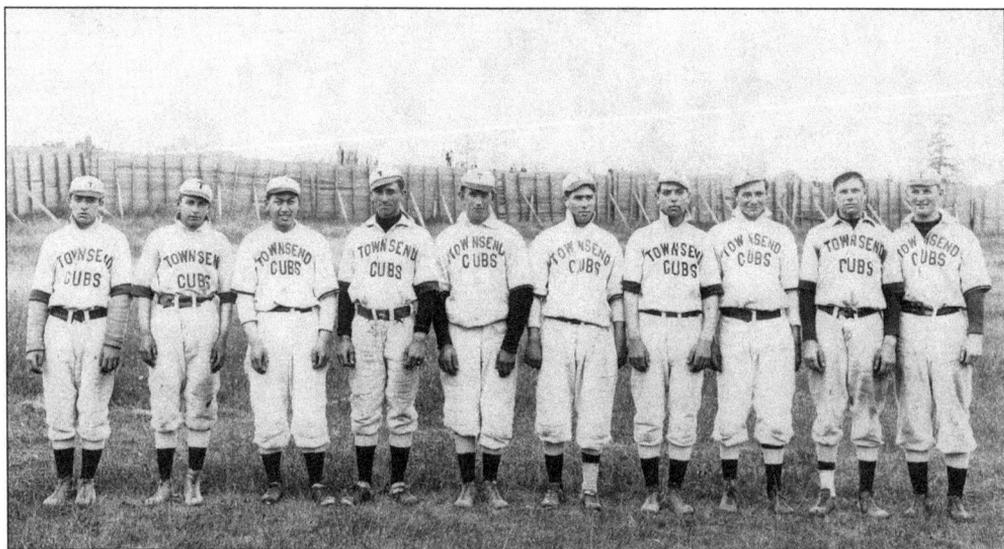

TOWNSEND CUBS BASEBALL CLUB. Baseball became popular following the Civil War and most of the sawmills and many of the saloons on Puget Sound sponsored teams. Betting on the games expanded interest beyond the team members and sponsors.

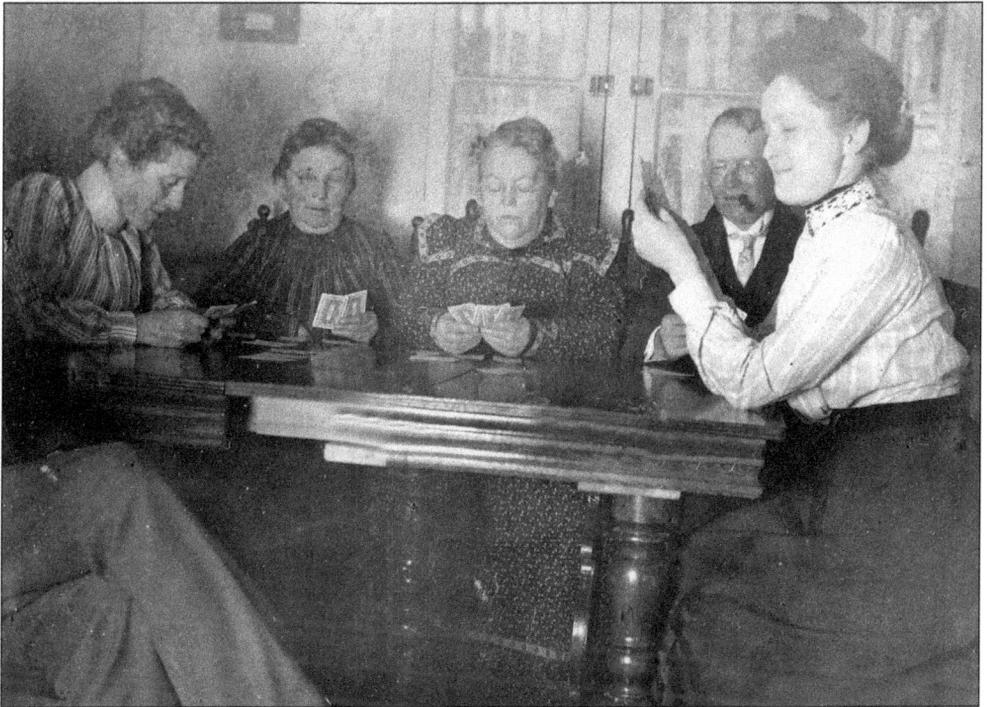

ROTHSCHILD FAMILY. The Rothschild family plays cards at a card party. Pictured from left to right are Emilie Rothschild, Dorette Rothschild, Mrs. Smith, Uncle John, and Helen.

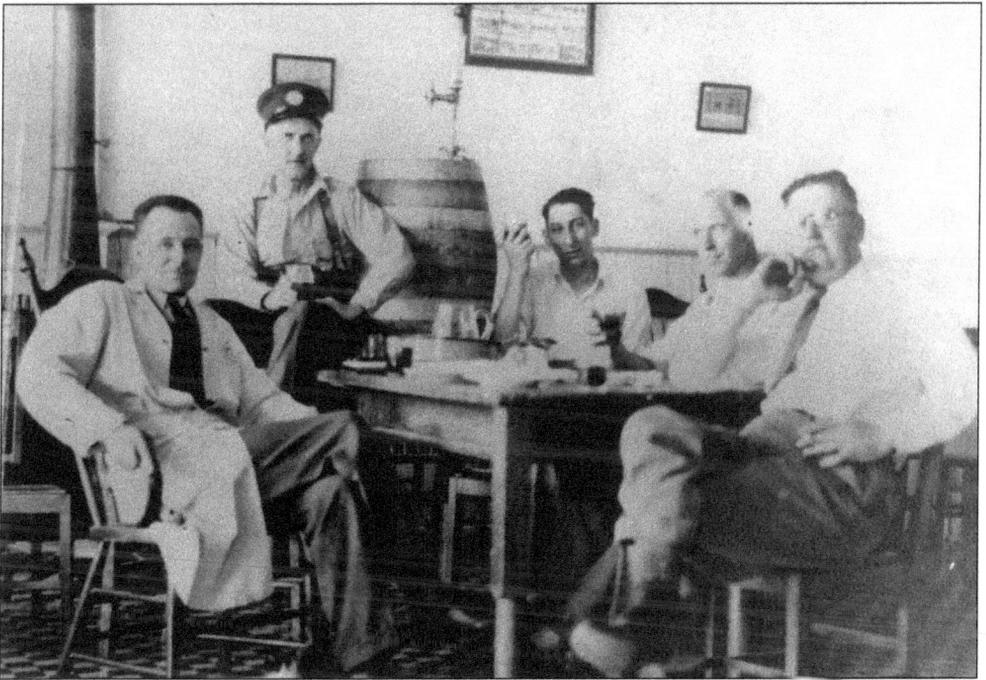

FIREMEN. These firemen are having a beer party at the fire department, which was located in the city hall building. From left to right are John Siebenbaum, Ray Seavey, Harold Quigley, Wayne Albright, and John Lafferty.

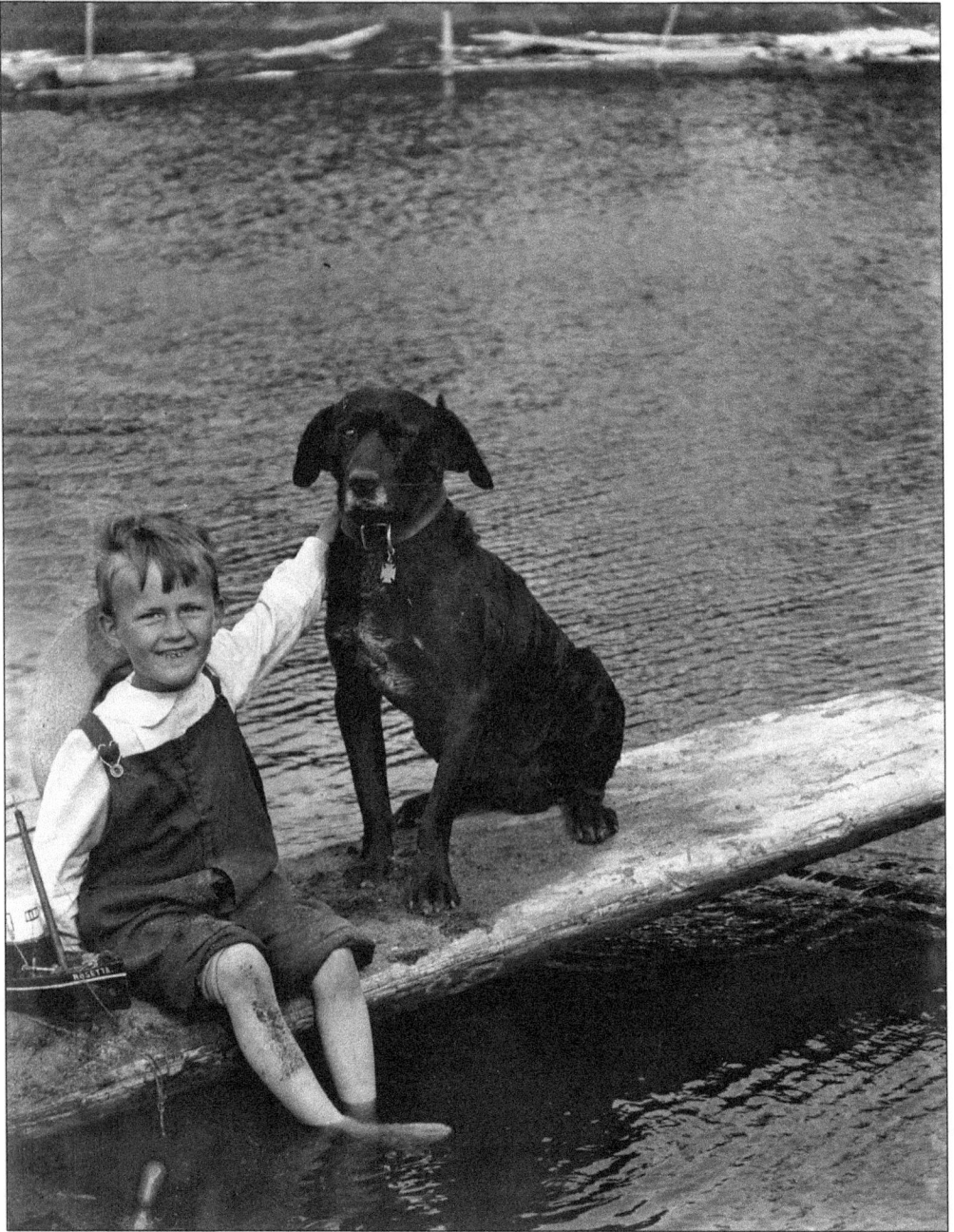

HORACE MCCURDY AND JUMBO. Pictured here with a toy sailboat, Horaace was the son and favorite subject of the photographs of James G. McCurdy. Horace grew up to be a builder of ships and the world's first floating bridge. He owned and operated what would become the Lockheed Shipyard in Seattle.

Seven

YOU'RE IN THE
ARMY NOW

In 1896, the federal government began constructing Fort Worden on the high bluffs north of Port Townsend. Activated in May 1902, the imposing fortification was one of three major coast artillery forts built to protect critical naval installations and shipyards in Puget Sound. Along with Fort Casey at Admiralty Head and Fort Flagler on Marrowstone Island just south of Port Townsend, the three forts formed a "triangle of fire" armed with huge guns that could stop any enemy ship that attempted to enter Admiralty Inlet.

Construction of a compound of barracks, administrative buildings, and gun emplacements continued at Fort Worden until 1911, providing a boost to the sagging local economy. For decades afterward, the town's population fluctuated with mobilizations at the fort. During World War I, building and training efforts intensified at the forts. During World War II, thousands of soldiers were trained at the forts and at the Coast Guard training facility at Hudson Point. Many of Port Townsend's old buildings, vacant for 50 years, were modified into apartments to house the overflow of military families.

The defense system worked beautifully, and there was never a shot fired in anger. In June 1953, the Harbor Defense Command was deactivated; the fort was closed and put up for sale. On July 1, 1957, Fort Worden was purchased by the State of Washington for $127,533 for use as a diagnostic and treatment center for troubled youths. When the state closed the juvenile treatment center, the Washington State Parks and Recreation Commission acquired most of the fort's grounds on September 30, 1971. The 433.53-acre Fort Worden State Park and Conference Center was opened and dedicated on August 18, 1973. It is now a National Historic Landmark District, serving as the home of several arts, education, recreation, and cultural organizations that draw visitors from all over the world.

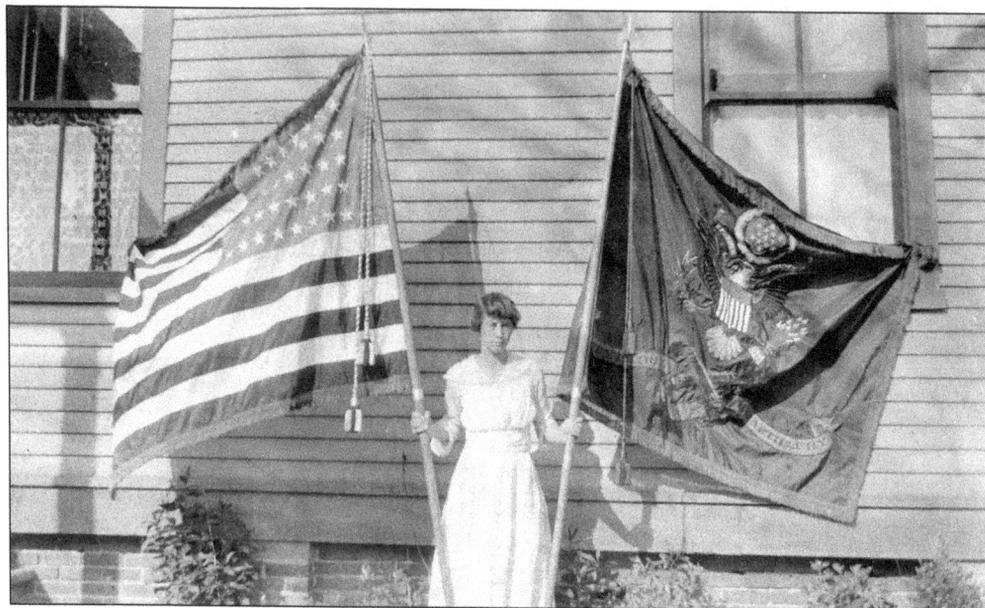

CHAPLAIN EASTERBROOK'S DAUGHTER. Pictured here is Gladys E. Easterbrook, Coast Artillary chaplain Easterbrook's daughter, holding both the U.S. and regimental flags. Soldiers and their families swelled the depleted population of Port Townsend and were welcome members of the community, adding military dash to parades and balls.

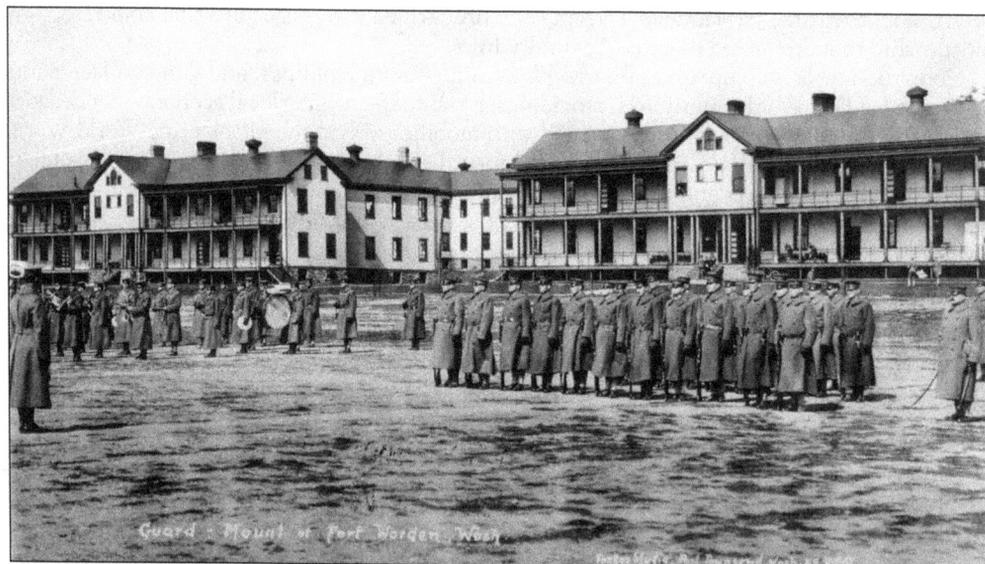

FORT WORDEN BAND. With barracks in the background, soldiers stand at attention on the parade ground while the Fort Worden band practices.

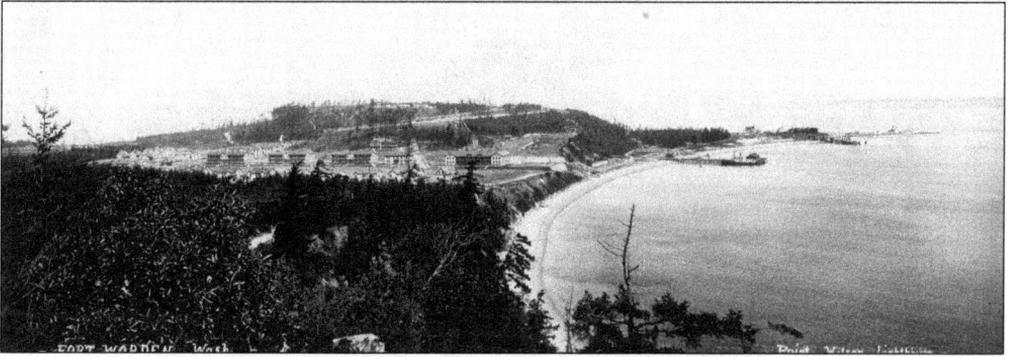

FORT WORDEN. This view of the Fort Worden beach was taken from Morgan Hill in Port Townsend. The Point Wilson Lighthouse is on the point of land at the far right.

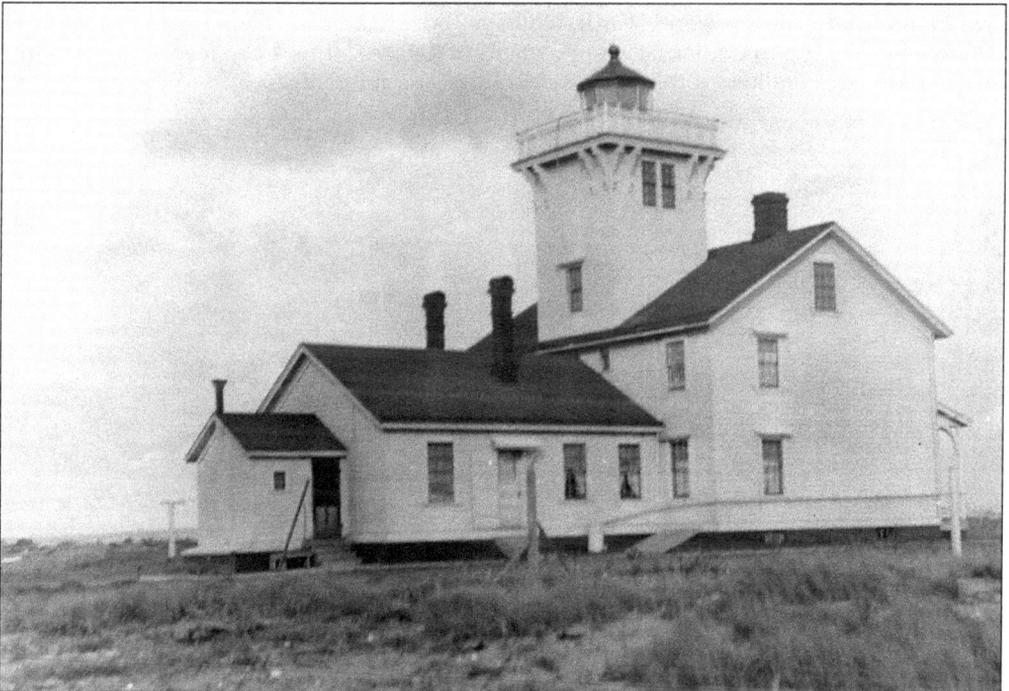

POINT WILSON LIGHTHOUSE. Frequent and persistent fogs prompted the Lighthouse Board to install a steam fog whistle in the 1870s, which was later upstaged by a diaphragm horn. On the evening of December 15, 1879, the tower's oil lamp was put into service for the first time. A fourth-order Fresnel lens focused the light, visible from any point along a sweeping 270 degrees of horizon.

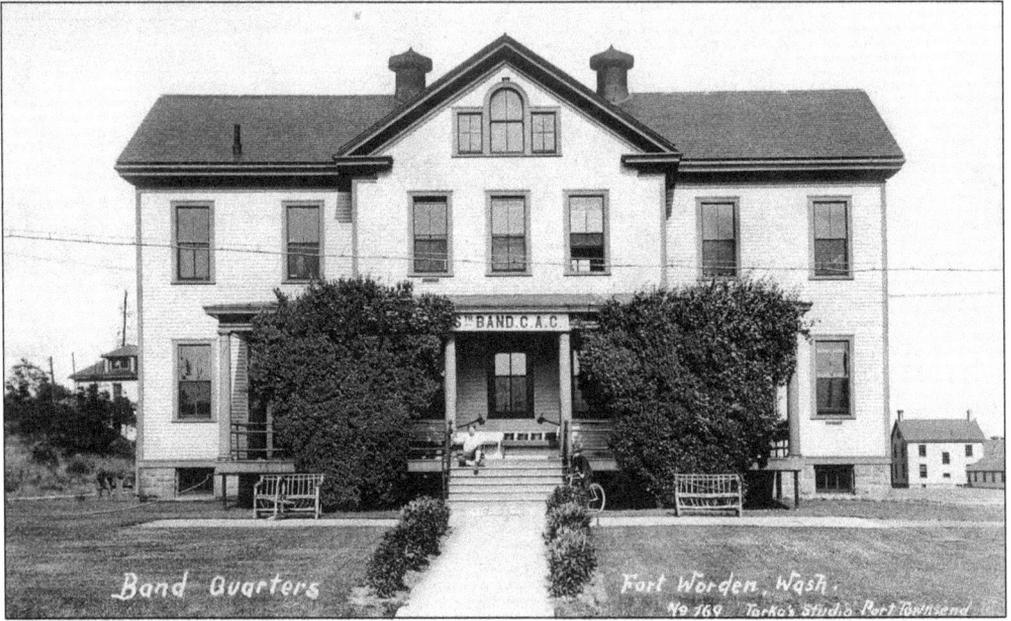

FORT WORDEN POSTCARD. This is a postcard of 6th Coast Artillery Corps Band Headquarters building at Fort Worden. The Torka brothers, German immigrants, built a photography studio in Port Townsend in 1909. They took hundreds of photographs of the local forts and Port Townsend area for postcards. During World War II, William Torka was arrested as a spy in Seattle as he set out on a sales trip to California with postcards of the forts. It took two months to prove the images revealed no military secrets and to clear himself of the charges.

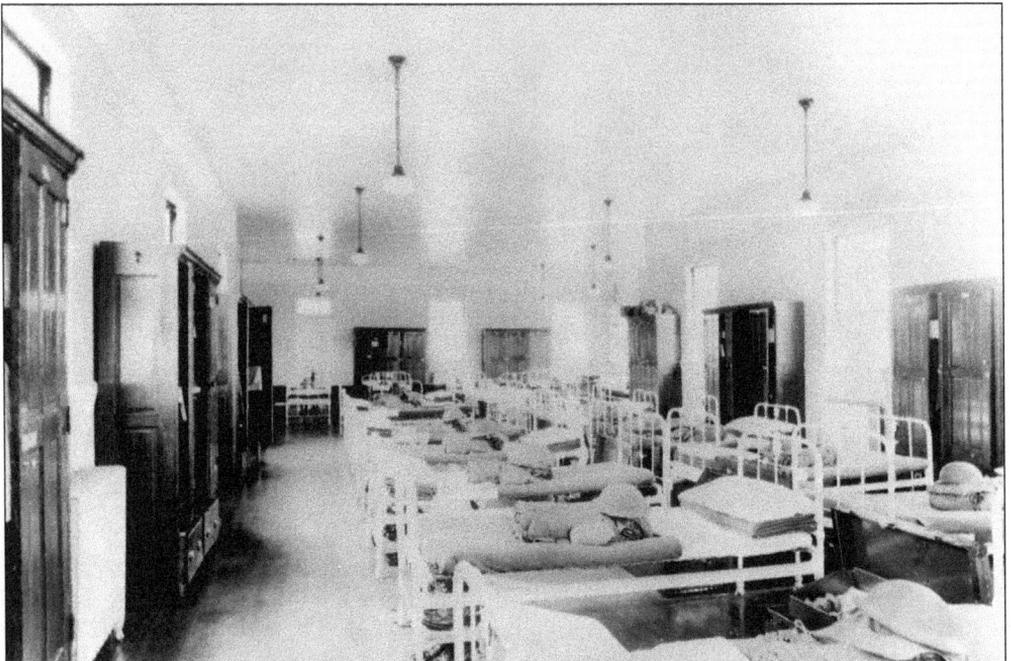

FORT WORDEN SQUAD ROOM. This scene is of the Fort Worden squad room during an inspection of Battery G, 14th Coast Artillery Corps in 1937.

FORT WORDEN BATTERY. Two unidentified men are seen standing with battery ammunition. While huge guns were designed to shoot these mortars out 9 miles, it was up to the ingenuity of men using muscle, leverage, animals, and crude machinery to get the ammunition into position.

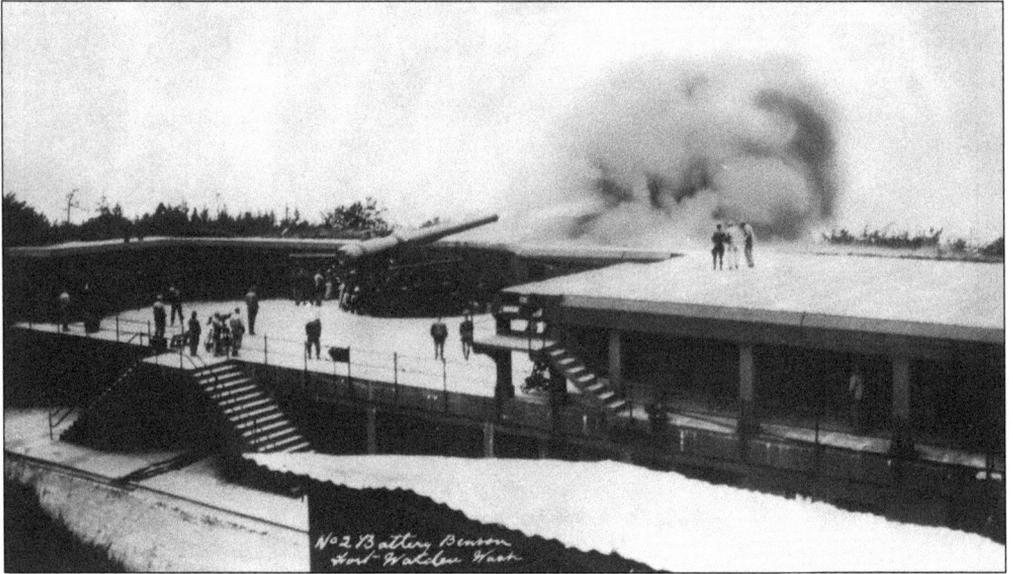

BATTERY BENSON. Pictured here is the Battery Benson gun during test firing. The artillery shells were aimed at targets in the strait.

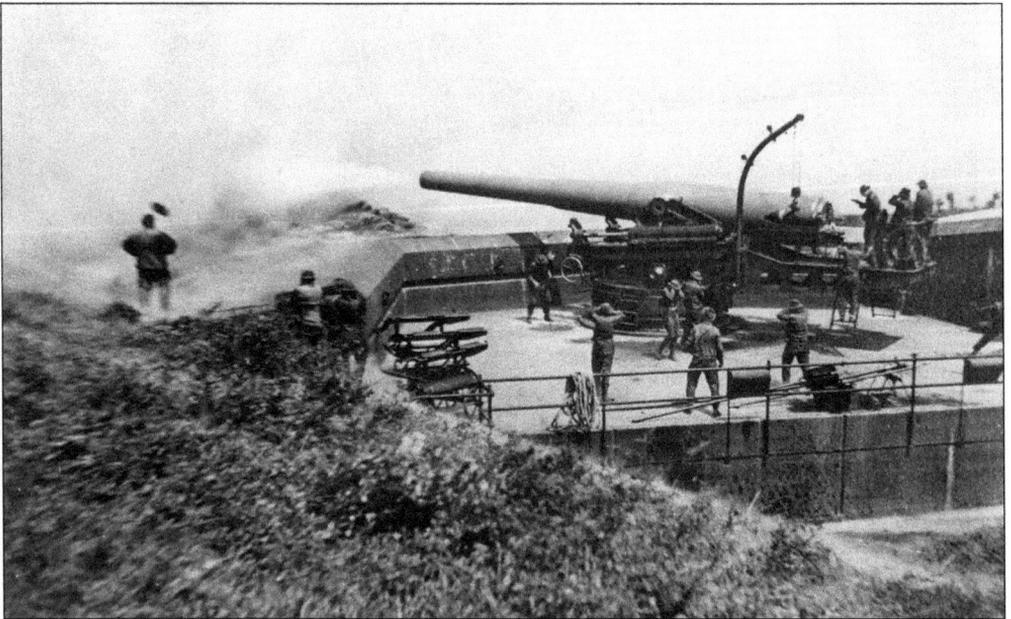

GUN ON SCISSORS MOUNT. Smoke still issues from the muzzle as some in the gun crew hold their ears. Blasts from guns firing at Fort Flagler could shatter windows across the bay in Port Townsend. This complication was accommodated by opening windows on practice days.

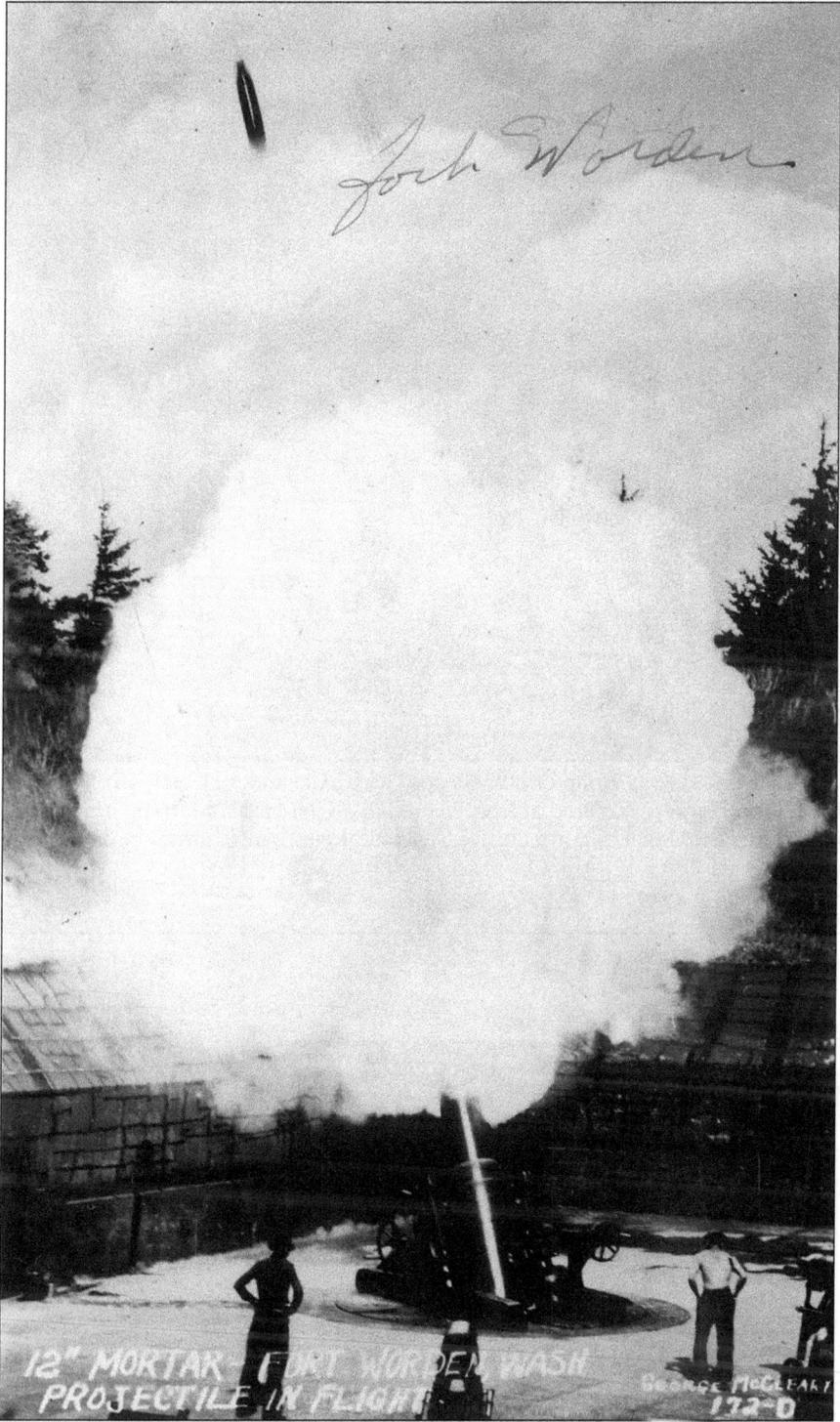

FIRING A 12-INCH MORTAR. Fort Worden's initial armaments included four 3-inch guns, two 5-inch guns, eight 6-inch guns, seven 10-inch guns, four 12-inch guns, and sixteen 12-inch mortars. A 12-inch rifled mortar, weighing 29,000 pounds, could hurl a 700-pound projectile 9 miles.

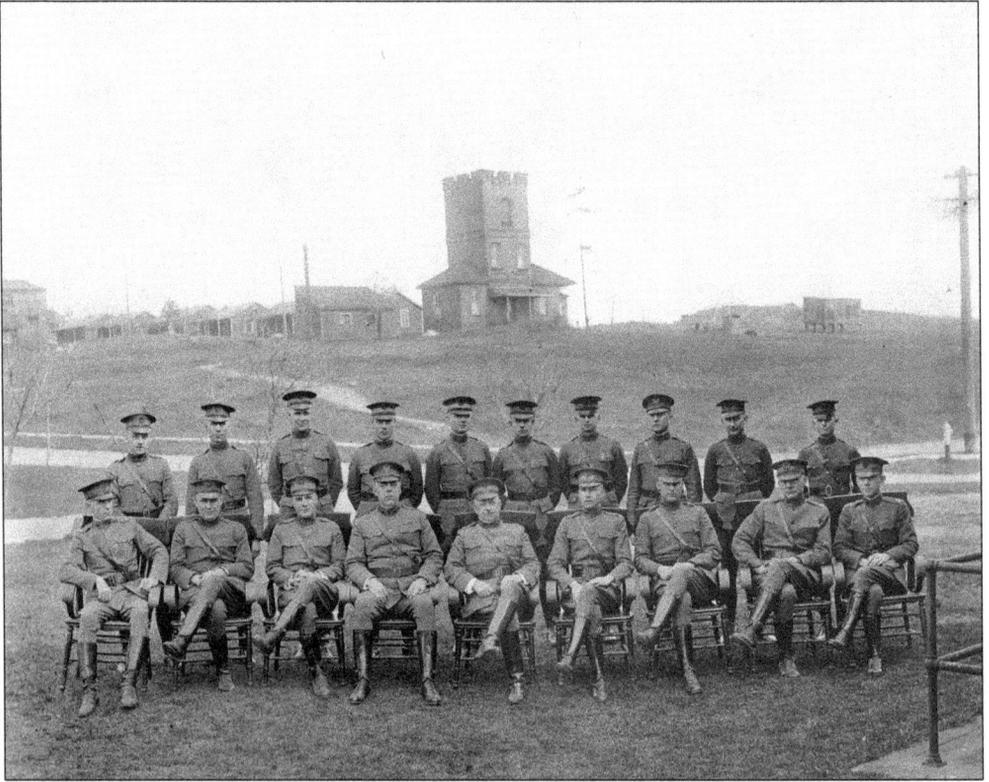

ALEXANDER'S CASTLE. A group of officers pose with Alexander's Castle in the background. Brig. Gen. John Hayden, pictured at front center, and Col. H. M. Merriam are the only men identified. John B. Alexander, a rector of St. Paul's Episcopal Church, built the whimsical Alexander's Castle.

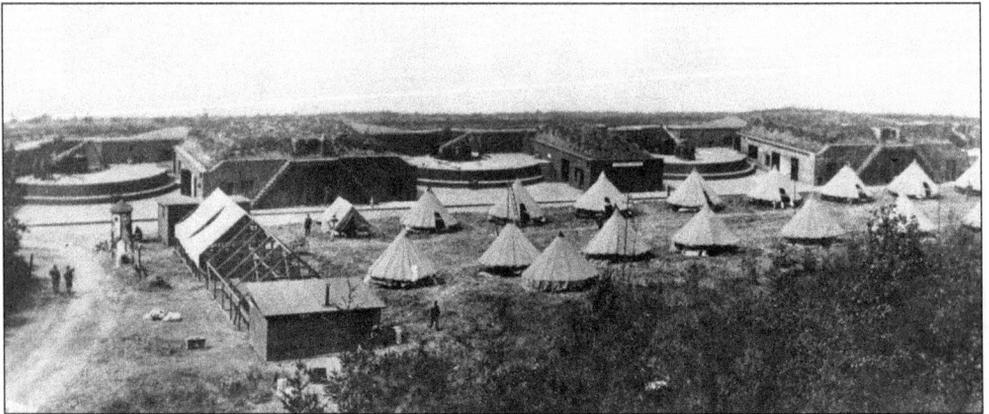

AN ENCAMPMENT AT BATTERY TOLLES. Batteries at Fort Worden were named for fallen Civil War heroes. Col. Cornelius Tolles died near Newton, Virginia, on October 16, 1864. Reinforced concrete formed the base and protective walls for guns mounted on disappearing carriages and barbettes (platforms). These battery emplacements were massive yet simple in design, flowing into the landscape. Abandoned more than half a century ago, they are still in place, minus the guns.

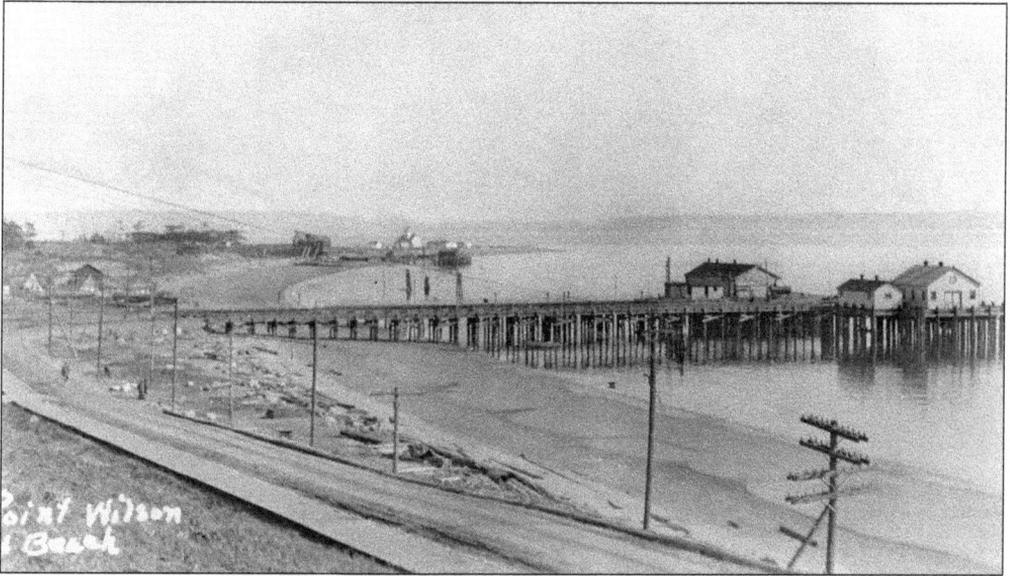

THE DOCK AT FORT WORDEN. Pictured here is the dock at Fort Worden, looking toward Point Wilson. The heavy guns required a solid footing of concrete. Sand, gravel, and water were within reach. Cement was shipped in from Belgium. Beginning in 1898, British ships began arriving laden with thousands of 400-pound barrels of cement. Gravel from nearby pits was loaded on scows, towed by the steamers, unloaded at the dock, and hoisted to the level of the concrete mixer.

HARD BOILED EGG. George Gradwohl Jr. is pictured sitting on the boat *Hard Boiled Egg* in 1917. A native of Walla Walla, Washington, George volunteered for the army at the start of World War I. He was assigned to the Coast Artillery, serving at both Fort Worden and Fort Flagler. He was a trombone player in the band. He wound up in France, where band members served as stretcher bearers. He returned to Walla Walla after the war to become a successful businessman and civic leader.

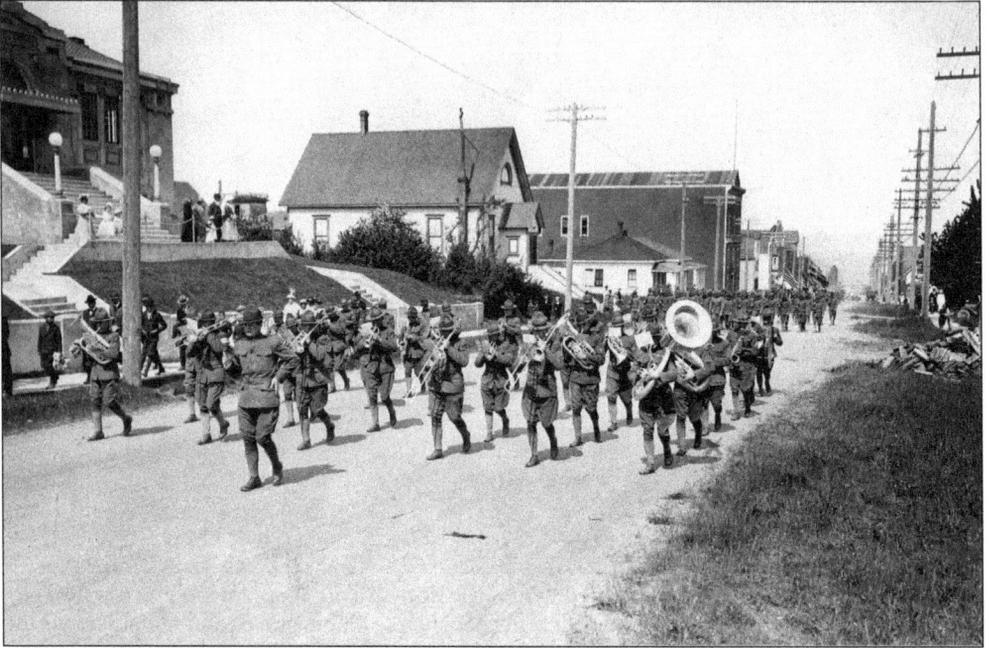

FORT WORDEN BAND. Fort Worden's 6th Coast Artillery Corps Band parades past the Port Townsend city library in May 1919.

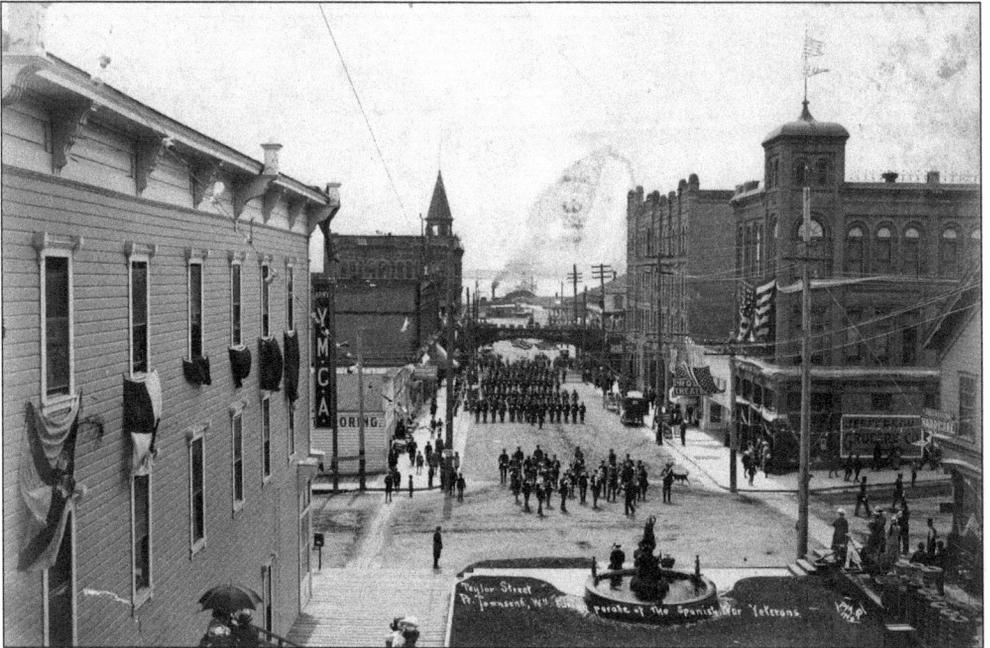

FORT WORDEN SOLDIERS. Fort Worden soldiers march in the Rhody Parade in 1950. The Second World War was good for Port Townsend's economy, and by the late 1940s, the town was looking to a new era. The Memorial Field sports stadium was built in honor of the men and women of Jefferson County who served in the wars. The post–World War II cold war kept Fort Worden open, and by 1950, the population of Port Townsend had grown to 6,888, with half dependent upon continuing fort operations and the other half upon paper mill wages.

Eight

REMOTE VILLAGE

In the early 1900s, Port Townsend's commercial buildings on the waterfront and stately homes on the bluff were still fairly new and the town looked prosperous despite its lethargic economy. The removal of the customs house to Seattle in 1913 was a terrible blow. Post–World War I doldrums brought the failure of local businesses as local fruit, vegetable, and fish canneries closed down. During the 1920s, most men worked in logging, farming, or fishing.

In 1924, the county sheriff invited teachers and ministers to witness a "grand smashing" of moonshine stills that had been collected on the courthouse lawn. Prohibition caused the failure of the Port Townsend Brewery. In 1925, the town's water system began to fail, and the future of Port Townsend looked grim.

While the rest of the country drifted into the most severe depression in its history, Port Townsend received a welcome reprieve. The Crown Zellerbach Corporation built a $7 million pulp and paper mill in the once-lovely Glen Cove, just outside town. In 1928, the new mill hired 275 workers at about 60¢ an hour. It kept the county seat alive and, in an agreement between the corporation and the city, helped finance Port Townsend's water system. The new pipeline brought in 14 million gallons of fresh water daily from the Quilcene River for use by the mill and the domestic, commercial, and fire protection of Port Townsend's citizens, as well as Forts Worden and Flagler.

The new industry stimulated the local economy and changed Port Townsend's landscape. Mill workers needed modest new houses. In a flurry of construction not seen since the boom of the late 1880s, a land bridge was built to fill in the seaward side of Kah Tai lagoon, creating a direct route into town. In 1929, shoppers flocked to the new JCPenney store on Water Street, and by 1937, a Safeway store made the abandoned backwater feel like mainstream America.

When the army pulled out of Fort Worden in 1953, half of the town's jobs went with it. Port Townsend was left a remote mill town.

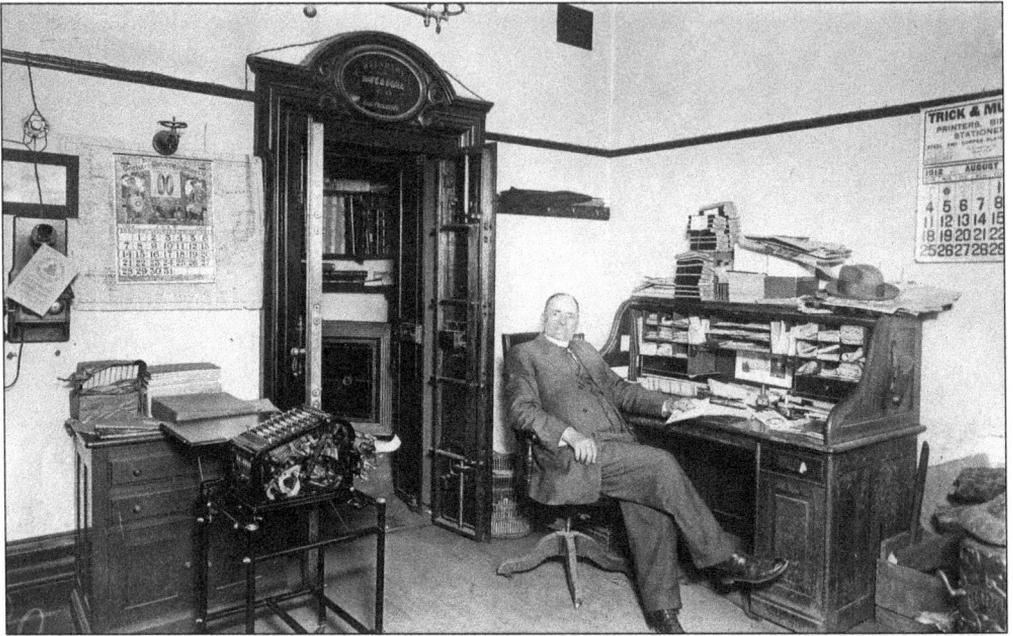

CITY TREASURER. C. L. Intermela, the city treasurer, sits in his office in city hall on August 16, 1912. This office, now part of the Jefferson County Historical Society, has a beautifully decorated walk-in safe.

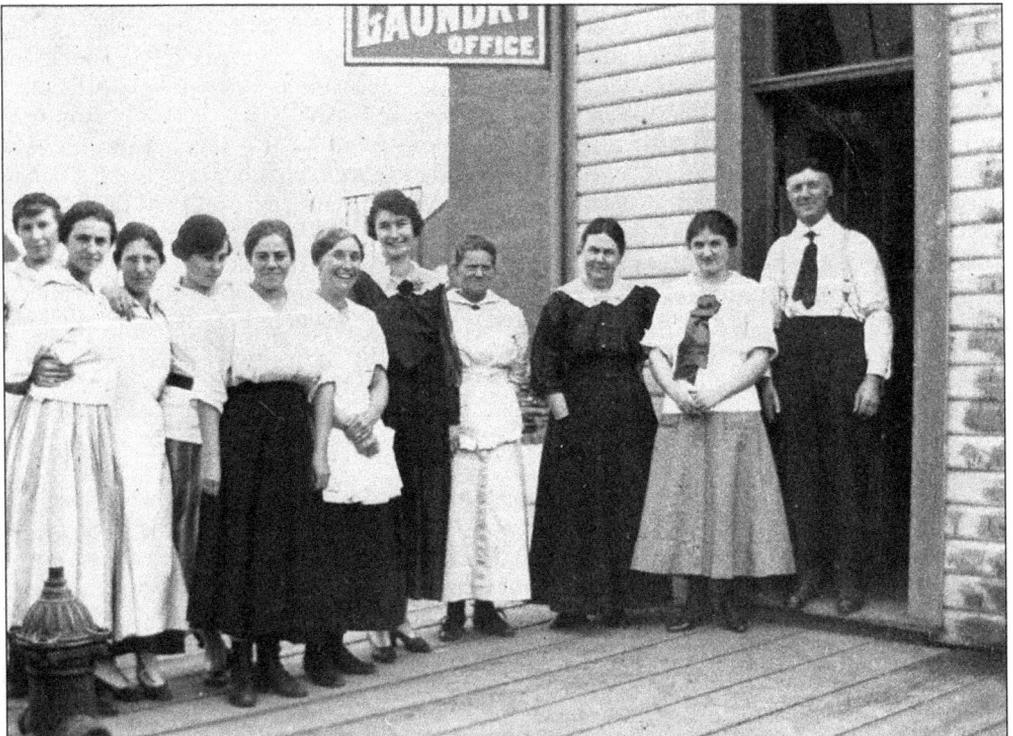

STEAM LAUNDRY. Employees of the Port Townsend Steam Laundry, which was located at 603 Washington Street, take a break from work to pose for this photograph.

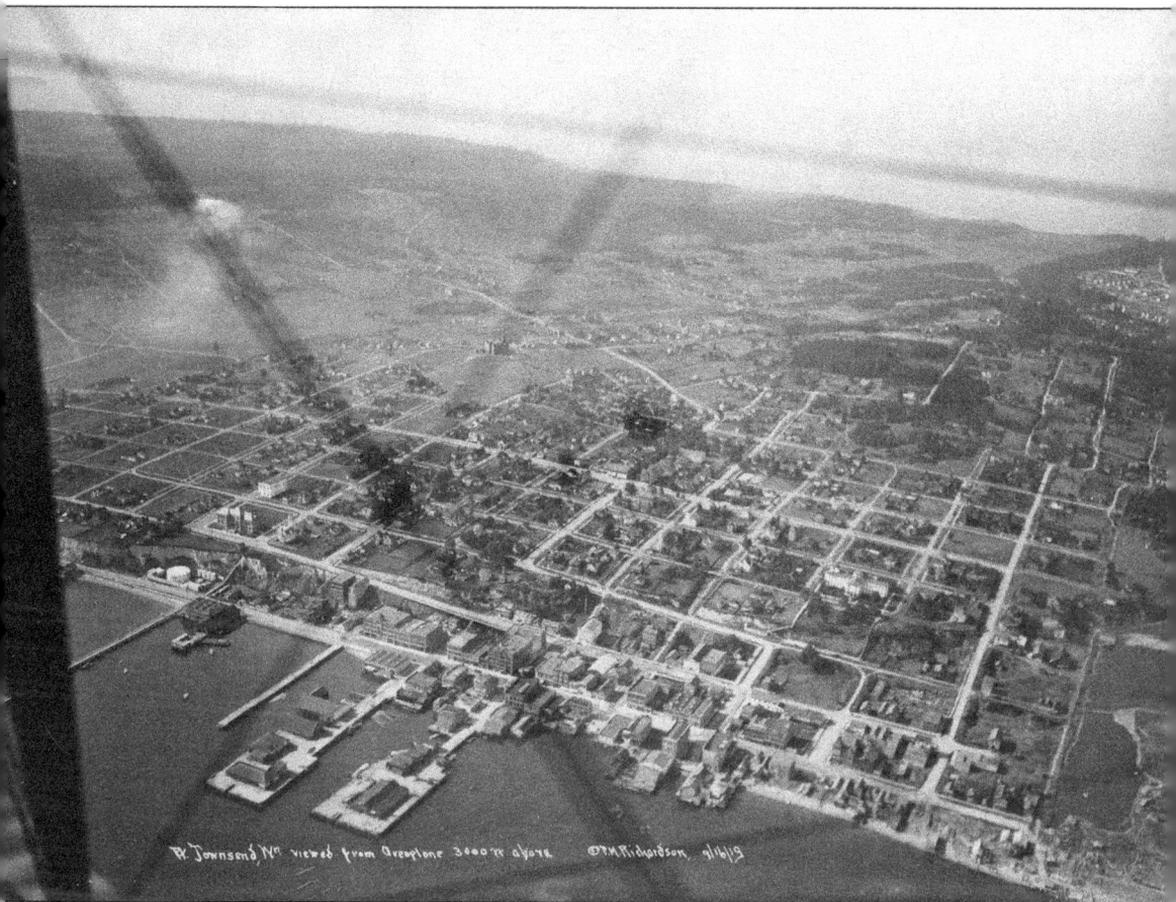

AERIAL VIEW. This aerial view of Port Townsend was taken from 3,000 feet in 1919. The large Union and Tyler Street wharves are apparent as are the neatly platted business and residential districts. The Strait of Juan De Fuca and the Olympic Mountains are in the background.

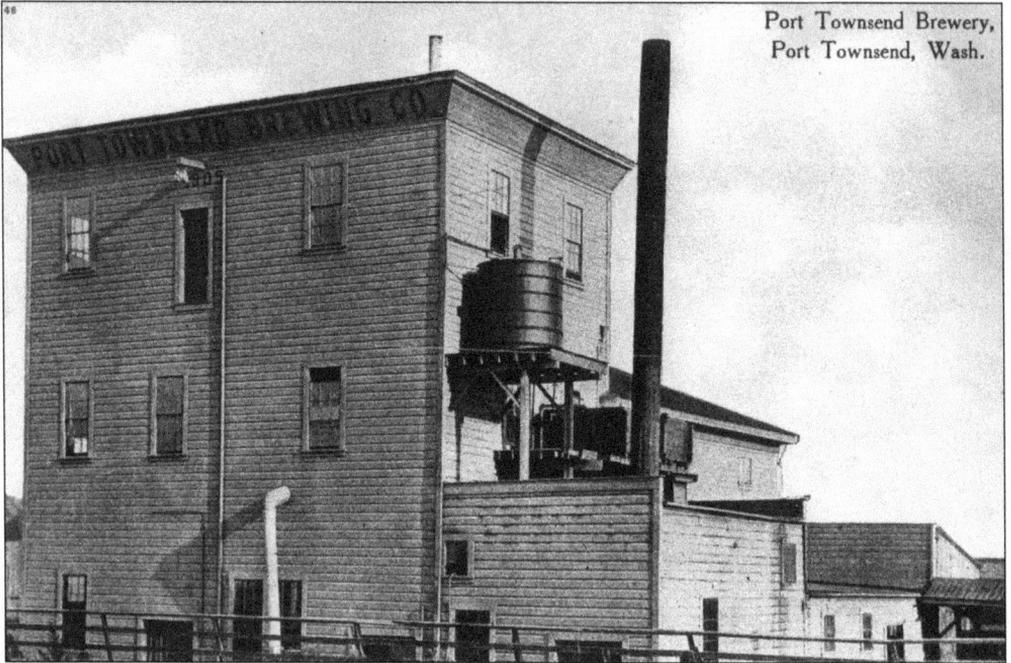

PORT TOWNSEND BREWING COMPANY. The Port Townsend Brewing Company was established on the site of the old Eisenbeis brewery on the west side of Monroe Street between Water and Washington Streets. The inaugural brew was released on June 9, 1906. The following day, the newspaper had glowing words for the new enterprise: "Home-Made Beverage Finds Favor With the Public—SPARKLING, PURE AND HEALTHFUL." In January 1916, the brewery closed thanks to Washington voters who passed a statewide Prohibition initiative. The Port Townsend Brewing Company continued with a line of nonalcoholic beverages, but closed a short time later.

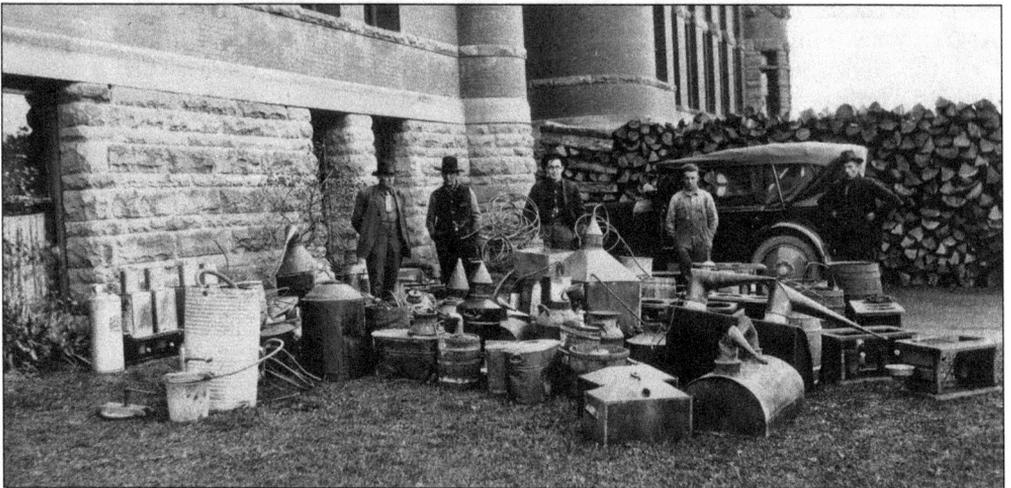

PROHIBITION. On the lawn next to the Jefferson County Courthouse sits a pile of confiscated illegal stills. Reportedly, Prohibition did not inhibit Port Townsend's drinkers very much—moonshine stills sprang up throughout the county. Rob Gow remembered that bootleggers "hid booze under the wooden sidewalks." Dr. Plut was often called to the Rhododendron Dance Hall where he saw, "loud dances . . . fights and car wrecks coming and going. I spent half the night sewing up eyebrows and lips."

108

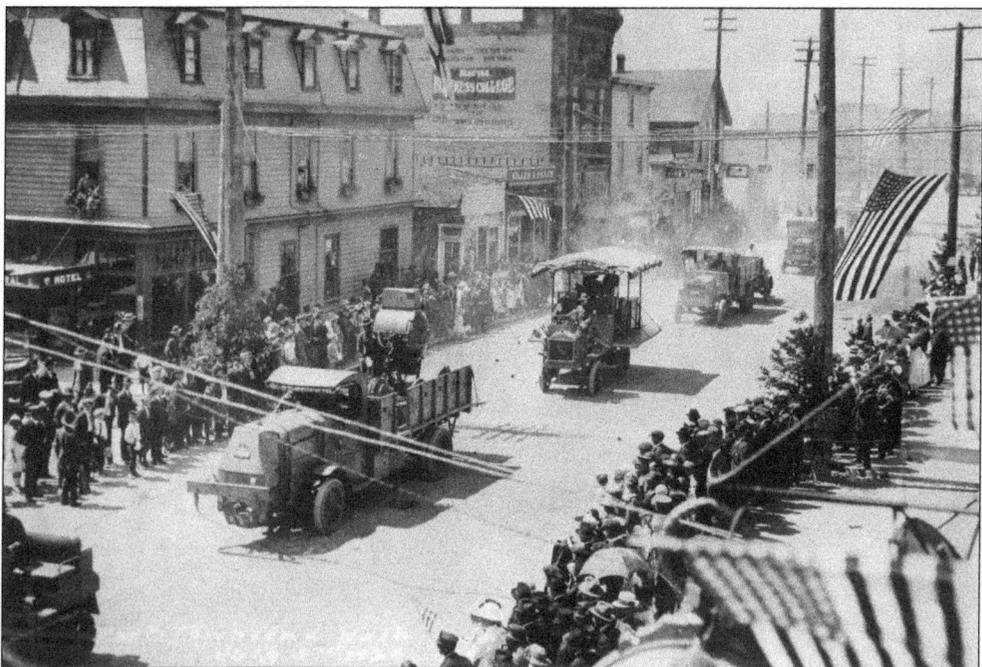

PARADE. This parade downtown at Water and Taylor Streets took place on July 3, 1920. The Central Hotel is the three-story building at left.

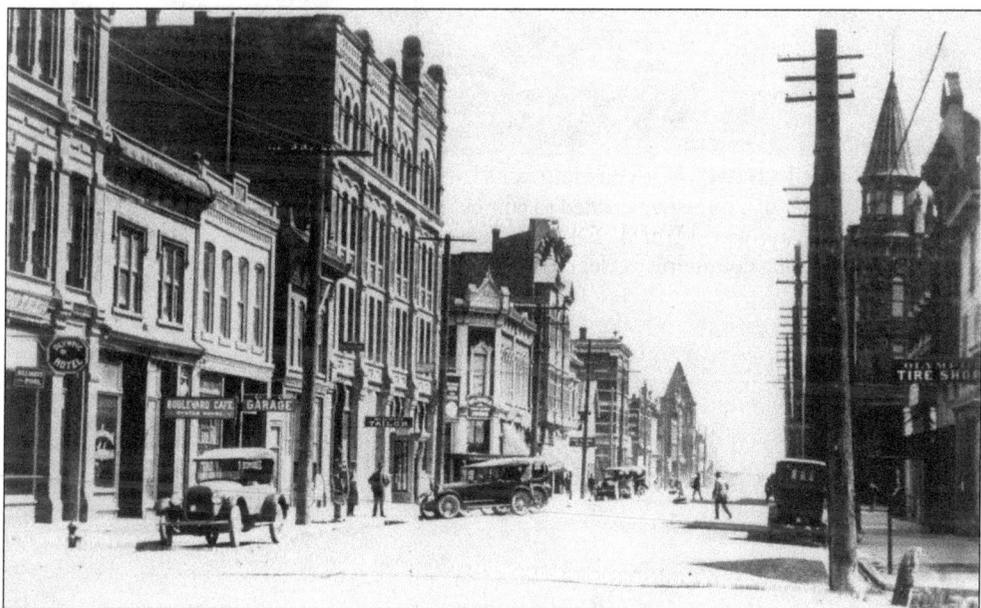

WATER STREET. This view of Water Street in Port Townsend shows the west side of the street facing north c. 1920, shortly before the Hastings Building on the right lost its conical tower.

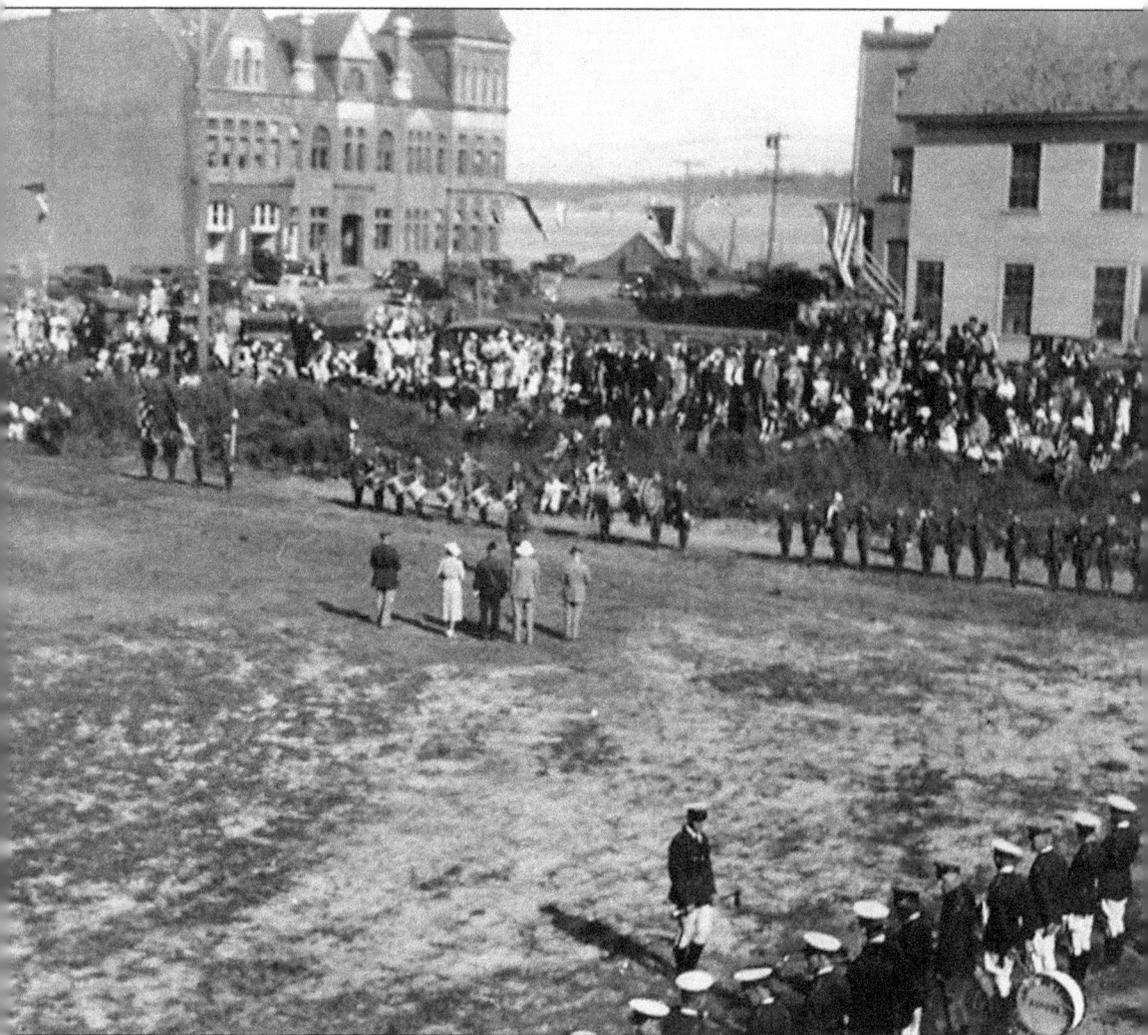

Rhododendron Festival. With city hall as its backdrop, the first Rhododendron Festival was held on May 28, 1936. The festival, timed to coincide with the blooming of wild rhododendrons, was suspended during World War II (1942–1945), but was resumed in 1946. It has grown over the years into a weeklong community celebration.

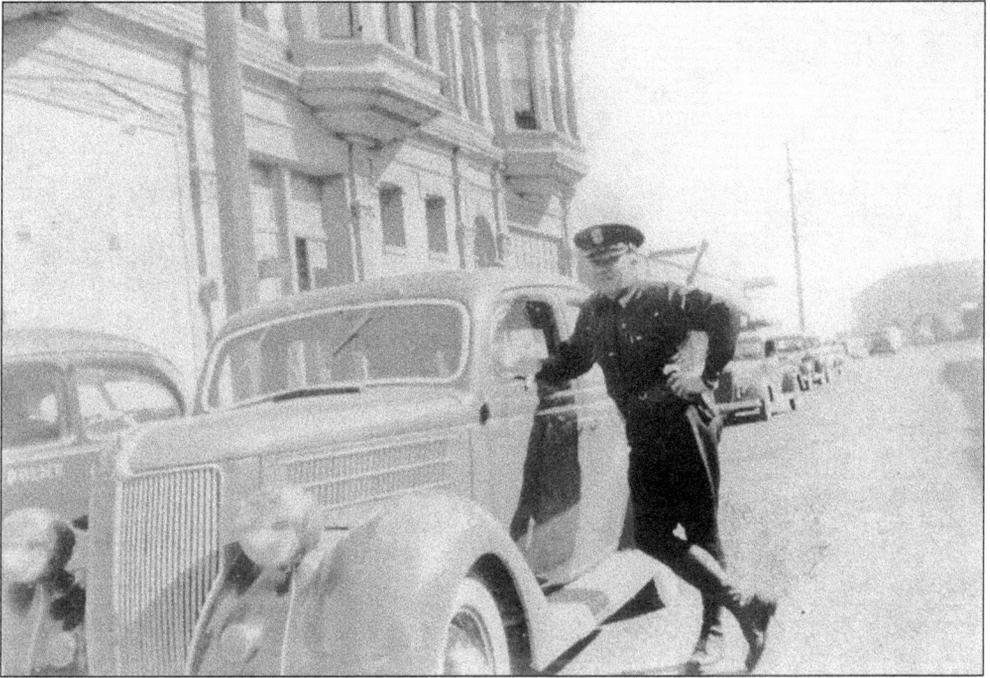

GEORGE WILLISTAFF. George Willistaff, of the Port Townsend Police Department, is talking to a motorist at the corner of Taylor and Water Streets in 1938.

FIRE TRUCK AT CITY HALL, 1946. The Port Townsend City Hall was designed as a multipurpose building to house the police and fire departments, firemen's quarters, municipal courtroom, jail, council chambers, and city offices, including that of the mayor and the delinquent tax collector.

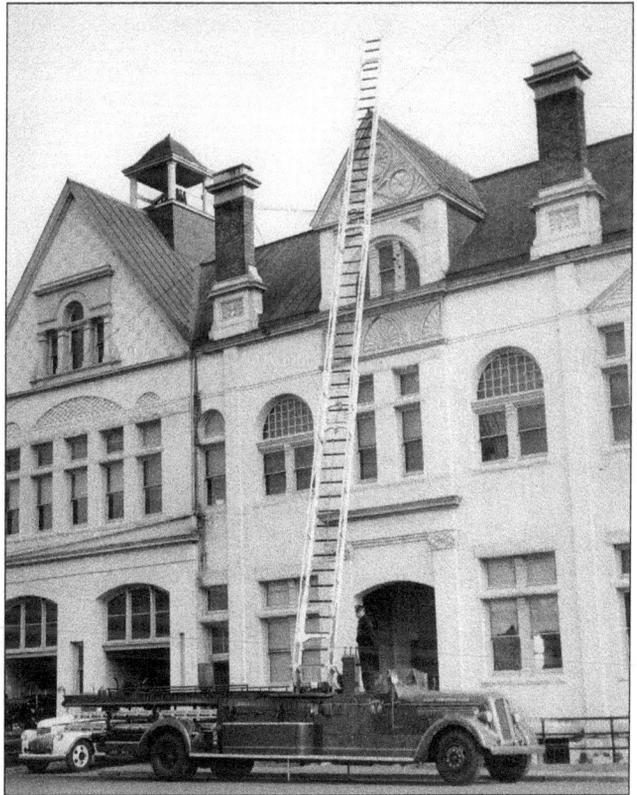

HALLER FOUNTAIN. Minna Hastings Hilton, daughter of pioneer L. B. Hastings, is seated on the edge of Haller Fountain during the time it was a planter with a sadly tilting goddess.

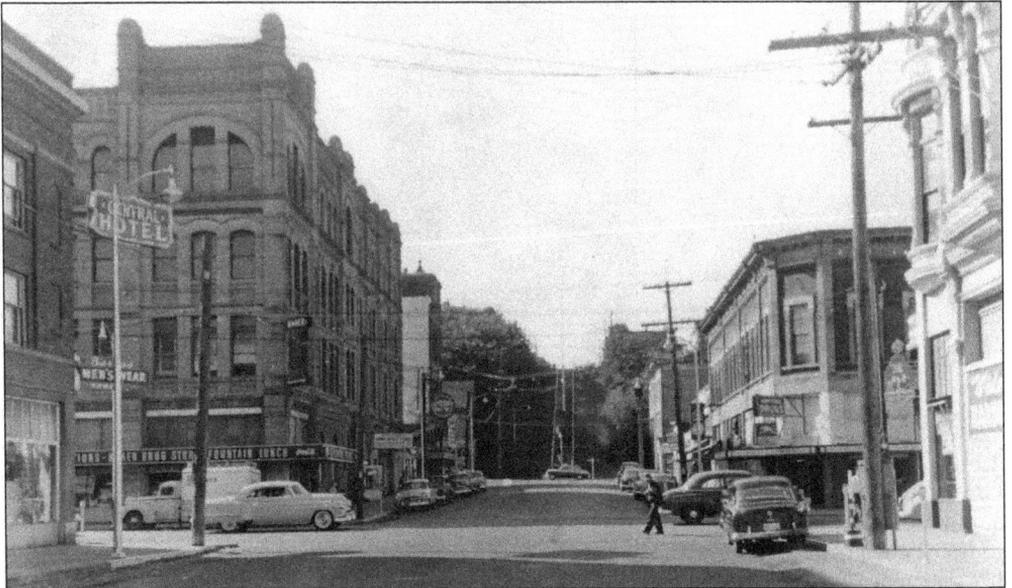

DOWNTOWN PORT TOWNSEND, 1950. This view of downtown Port Townsend at Water and Taylor Streets, looking toward the Haller Fountain, was taken in 1950. The brick version of the Central Hotel (far left) was built in 1928 following a kitchen fire that was fanned by a severe windstorm on November 11, 1927. The Mount Baker Block, across the street, looks much the same today, as does the McCurdy Building on the right and the Hastings Building at far right.

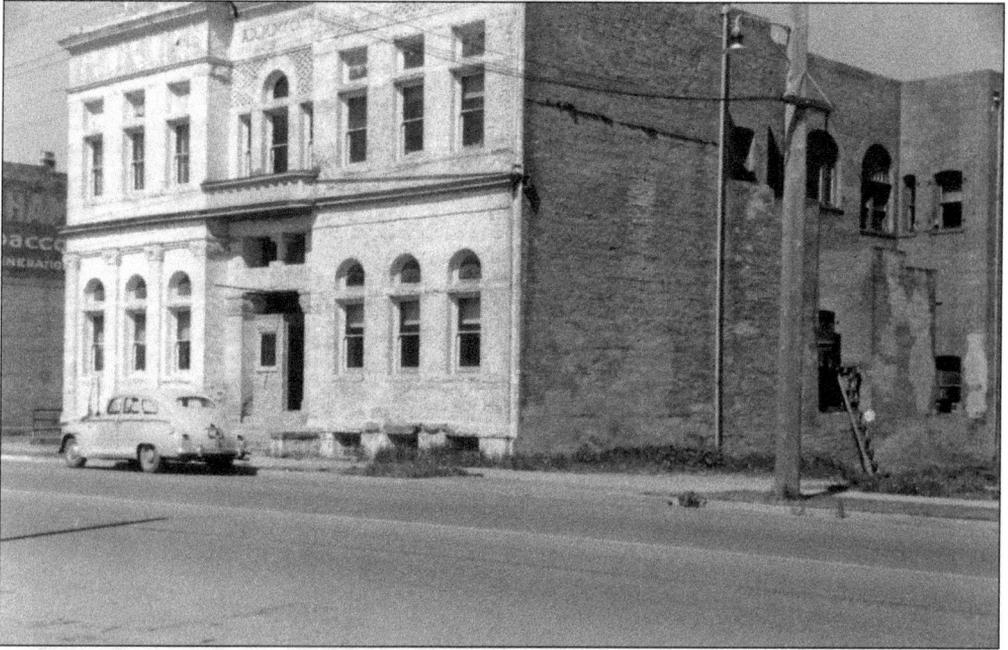

CITY HALL IN A VERY SAD STATE, C. 1958. Benign neglect preserved much of Port Townsend's Victorian architecture. Sad exceptions are the ornate towers on the Kuhn Building, Lincoln School, city hall, and Aldrich's Grocery uptown. To save the cost of maintaining the elaborate roofs, these buildings were modernized to suit a new style that favored flat-roofed box shapes.

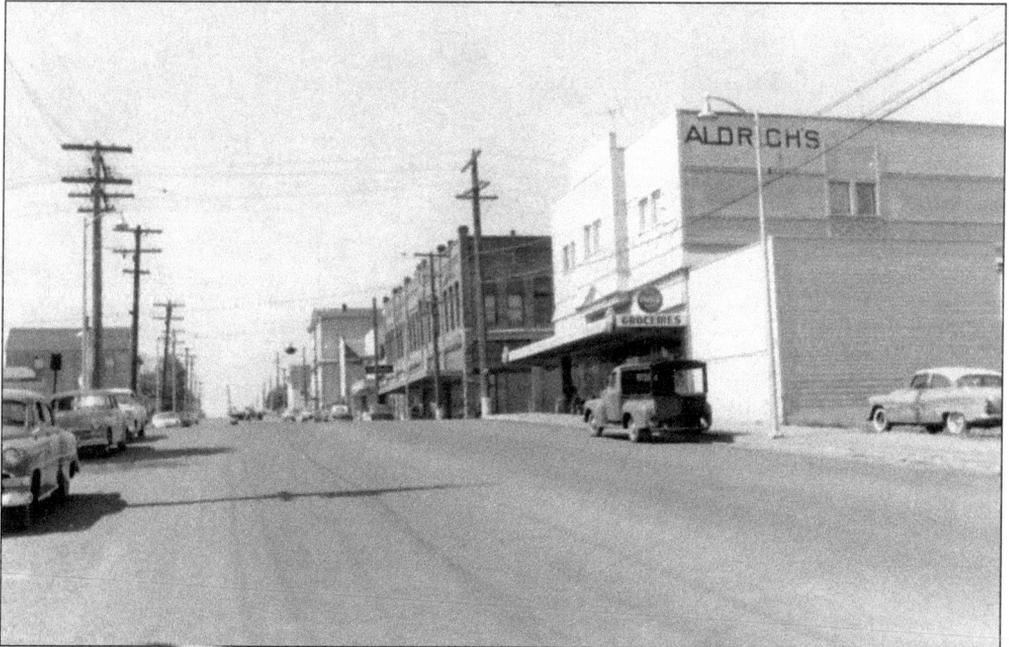

UPTOWN BUSINESS DISTRICT. This scene of the uptown business district on Lawrence Street shows Aldrich's store, the McLennen Building, and the Odd Fellows Hall. In the late 1930s and early 1940s, the Aldrichs remodeled the building. At that time, the Gothic roof was removed and windows boarded over "to make it look more reasonable," as Clark Aldrich Jr. explained.

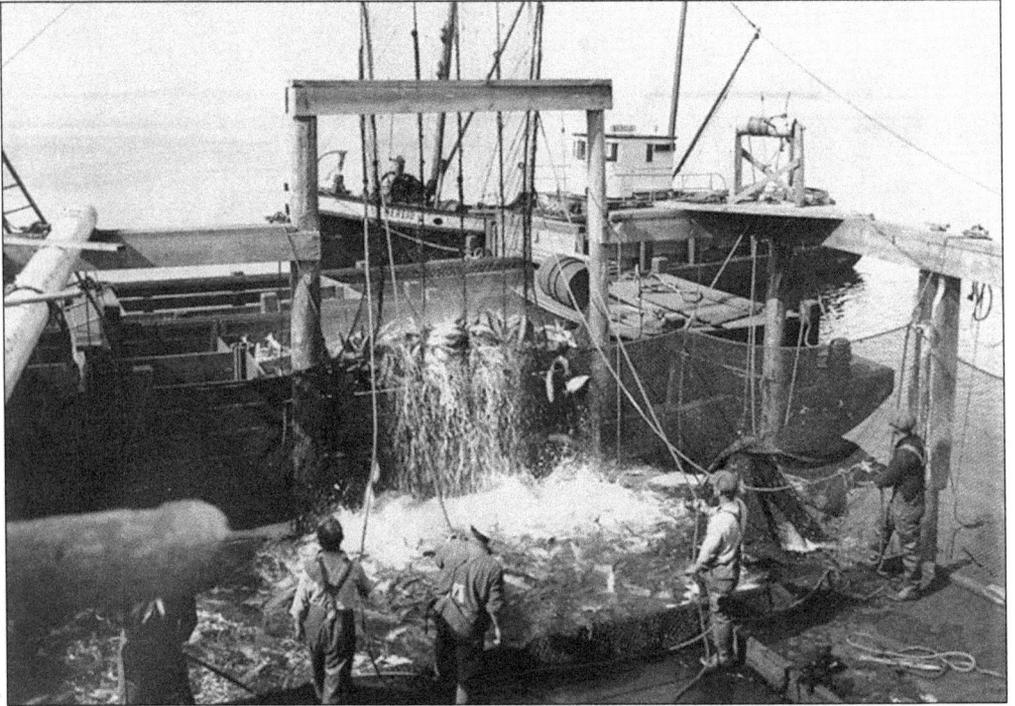

BRAILING FISH. Fish are hoisted by brail from a fish trap to a scow to be towed to a processing plant at the Sims Cannery.

CANNERY. Pictured here is an interior view of a cannery with two Chinese workers. E. A. Sims operated several large canneries on Puget Sound and in Alaska. Two of them were in Port Townsend. He converted an old sailing ship, *Glory of the Seas*, into a floating canning plant.

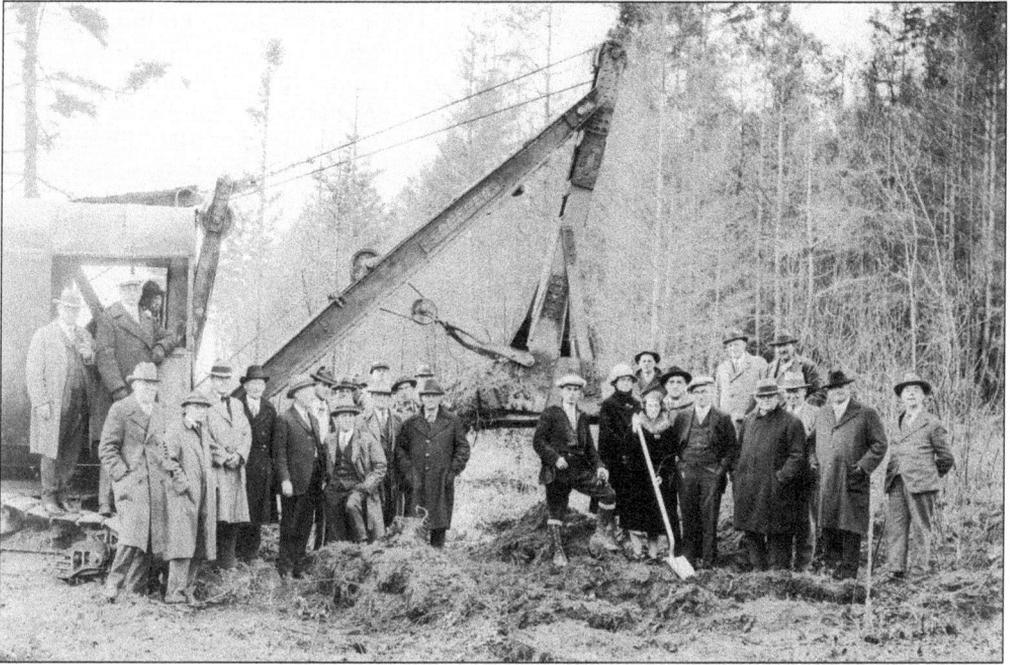

BREAKING GROUND ON THE NEW WATER SYSTEM. As a side benefit of the new paper mill that was built in 1827–1828, the city gained a new, reliable water supply to sustain the production of paper and an increase in the town's population. The Big Quilcene Water Extension Project began in September 1927.

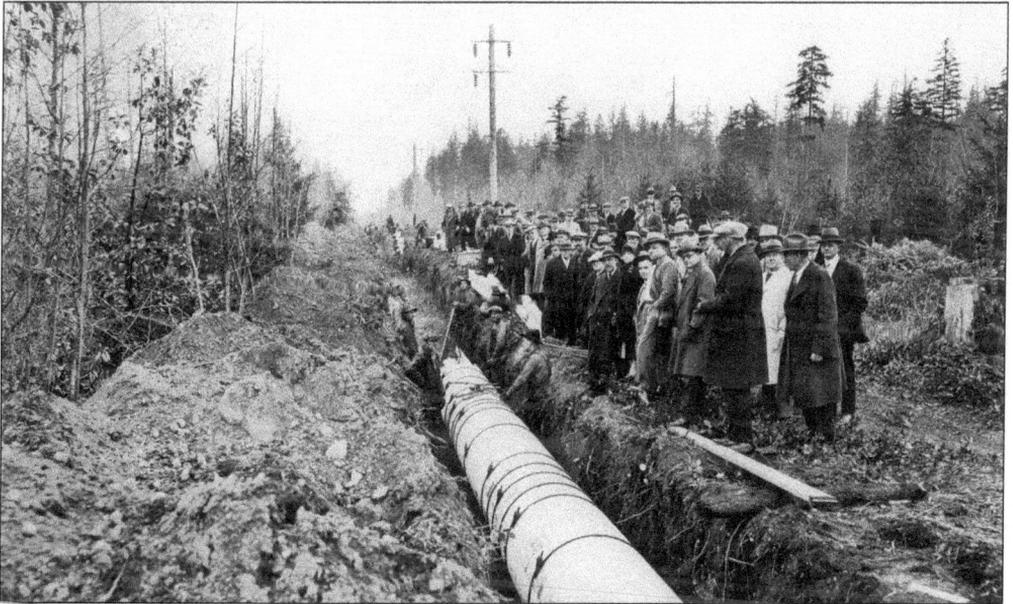

NEW WATER SYSTEM, 1928. The first wooden pipe of the new water system is laid on February 20, 1928. The city voted to issue $800,000 in municipal bonds to build the system. The Zellerbach Corporation agreed to pay $200,000 in advance royalties and $10,000 per year to lease the water system from Port Townsend for 30 years and to operate and provide all the maintenance on the pipeline.

GEORGE BANGERTER. George Bangerter works on a pipe for the Big Quilcene Water Project in 1928. The new dam and pipeline was capable of bringing 14 million gallons of fresh water per day from the Big Quilcene River, more than 30 miles away.

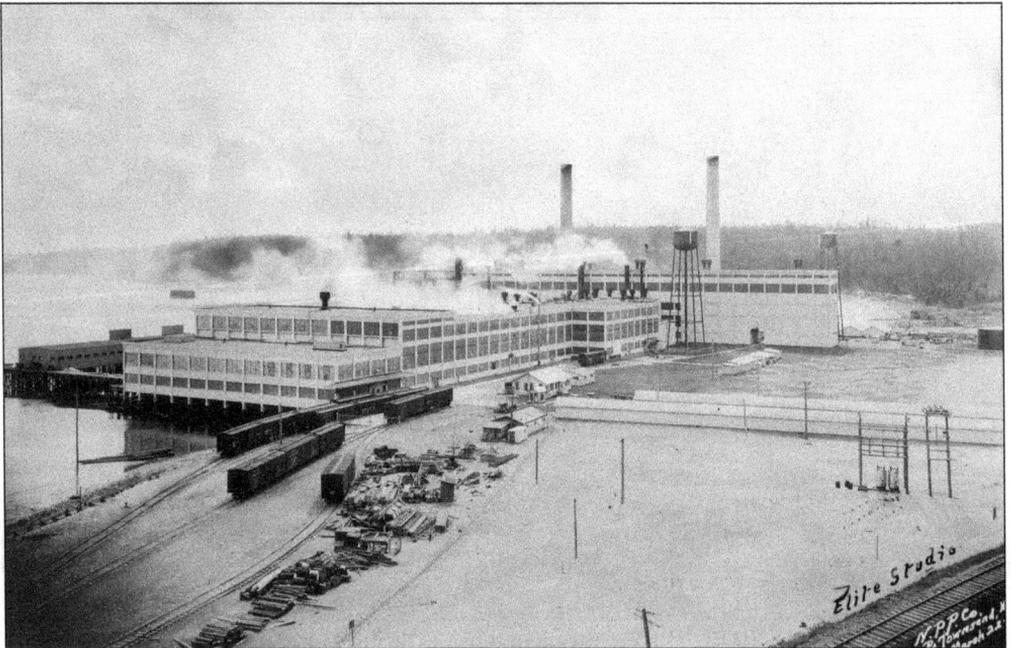

NATIONAL PAPER PRODUCTS COMPANY. On Monday, October 6, 1928, the new Crown Zellerbach kraft paper mill, doing business as the National Paper Products Company, started operation. The mill infused new life into the languishing city and immediately became the backbone of Port Townsend's economy.

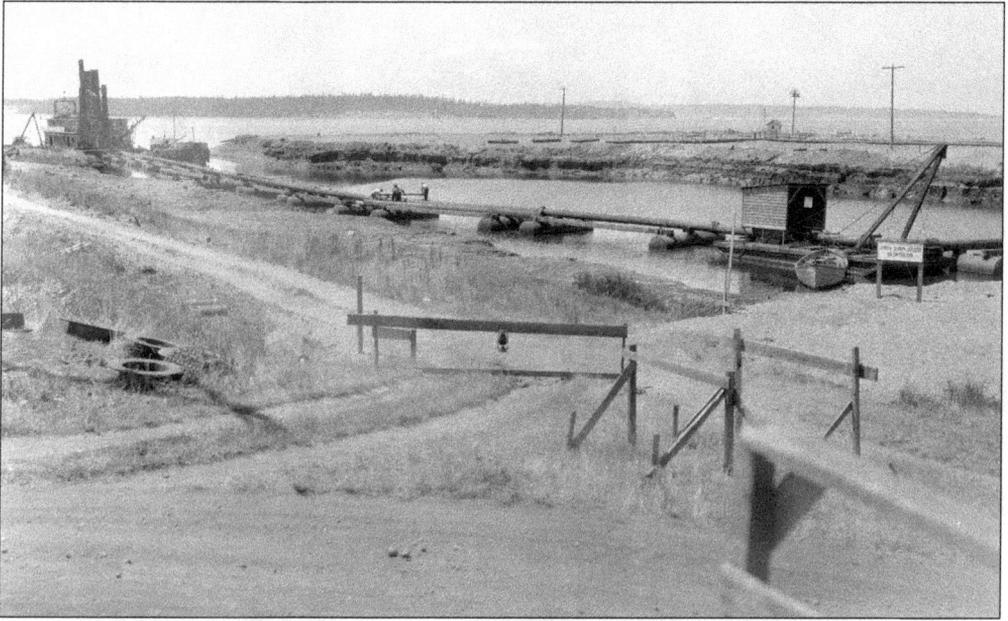

DREDGING POINT HUDSON. This view of dredging operations at Point Hudson was taken looking toward the harbor mouth on July 3, 1934. Out of the former millpond at the end of town, the Puget Sound Bridge and Dredging Company filled in land and dug a small harbor that could be used as a marina. Hudson Point was first used as a replacement to the aging U.S. Quarantine Station at Port Discovery, then as a Coast Guard training facility.

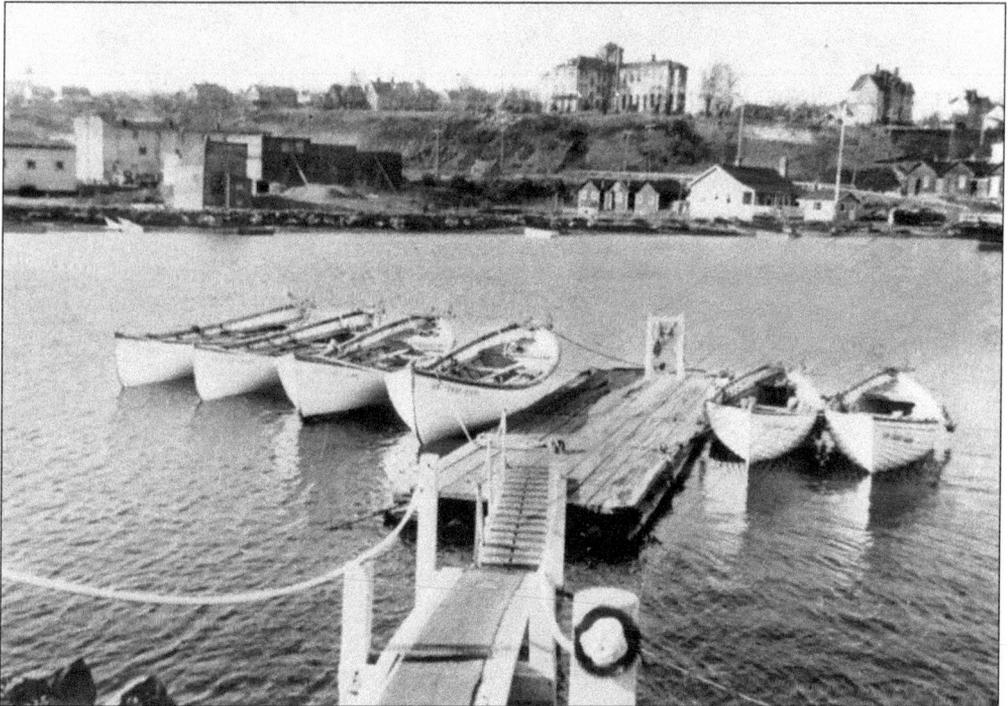

POINT HUDSON. This 1939 view of Point Hudson shows six dinghies tied up at the Coast Guard training station. The Marine Hospital is seen on the bluff in the background.

CENTENNIAL PARADE. Harry Hanson, pictured here, is driving the front carriage in the Port Townsend Centennial Parade on May 19, 1951. The four-day celebration included the official opening of the Jefferson County Historical Society Museum in the city hall building, multiple parades, a cavalcade, banquets, log rolling, horse shows, sailboat races, contests of many kinds, band concerts, and a golf tournament.

Nine

RENAISSANCE

Because of its swift and complete reversal of fortunes, most of Port Townsend's grand Victorian buildings and homes were never torn down and built over. They just waited—some incomplete, some boarded up, and many divided into apartments and rooming houses. Meanwhile, a new architectural style, known as craftsman, came into vogue. It made the Victorian buildings look fussy and old-fashioned.

In the 1950s and 1960s, Port Townsend saw glimmers of what would become its next major economic force: tourism. The beautiful site, easier access by cars, and a few visionary citizens were sparks for rekindled ambitions. The arrival of Mary Johnson from Tacoma in 1958 and her establishment of the Summer School of the Arts in 1961 were the beginnings of the Centrum Foundation, Port Townsend's nationally renowned arts education center. The Johnsons also became a lightning rod for historic preservation when, in 1958, they began the restoration of the Bartlett House and encouraged others to follow suit.

The first Wooden Boat Festival was held in September 1977. It has since been joined by almost weekly festivals and events throughout all but the winter months. On February 21, 1979, ferry service returned to Port Townsend after a 40-year absence. The previous Edmonds-Port Townsend run had ended on April 30, 1939, when the Puget Sound Navigation Company ceased operation because the run was unprofitable. By 1979, tourists wishing to travel to the Olympic Peninsula made the route a necessity for Washington State Ferries.

Many homes and buildings remained uninhabited until the 1970s, when cheap real estate and the splendid scenery were discovered by artists and writers seeking a creative atmosphere and retirees who could live somewhere beautiful without worrying about finding a job. They joined the paper mill workers and increasingly unemployed loggers and fishermen in an unlikely fusion. Since then, small business owners, persons of independent means, telecommuters, and government and hospital employees have added to the mix, making for a lively, often contentious, but never boring political and cultural scene.

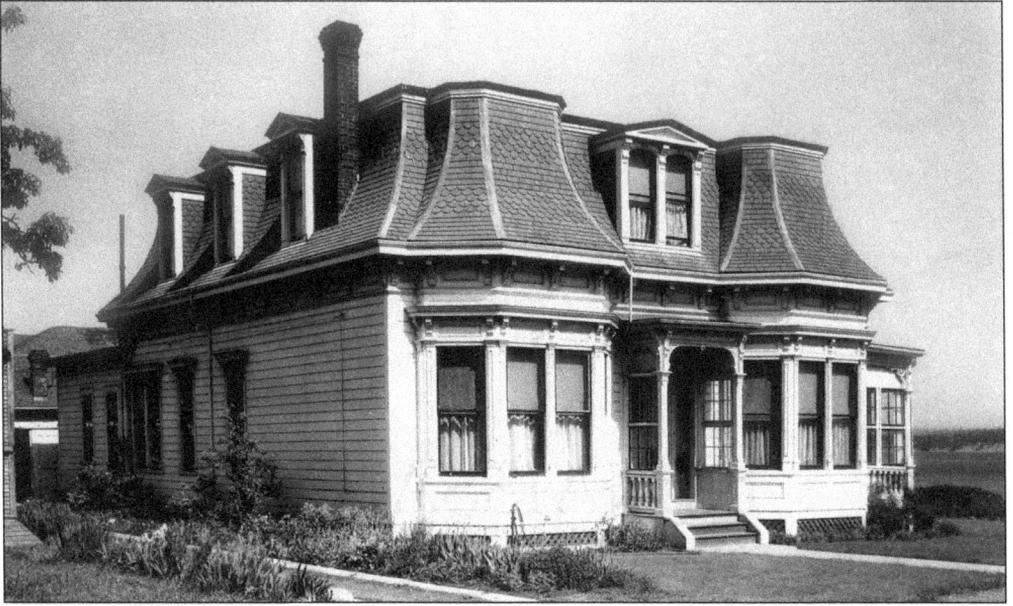

BARTLETT HOUSE. Frank A. Bartlett built the Bartlett House, which sits on the bluff overlooking downtown and Port Townsend Bay at 314 Polk Street. Bartlett, son of merchant Charles C. Bartlett, was president of the short-lived Port Townsend Steel, Wire, and Nail Company. Restored by Harry E. and Mary P. Johnson in the late 1950s, the Bartlett House was among the first Port Townsend residences to be placed on the National Register of Historic Places.

SUMMER SCHOOL OF THE ARTS. Mary Johnson is seen here with Washington State governor Albert Rossellini at a reception for the Port Townsend Summer School of the Arts in 1964. The Johnsons turned the Bartlett House into a Victorian showplace, opening their doors for arts and educational events and inspiring others to restore Port Townsend's homes and commercial buildings. They entertained thousands of people during their years at the Bartlett House and were instrumental in the development of the Port Townsend Summer School of the Arts, the forerunner to the Centrum Foundation.

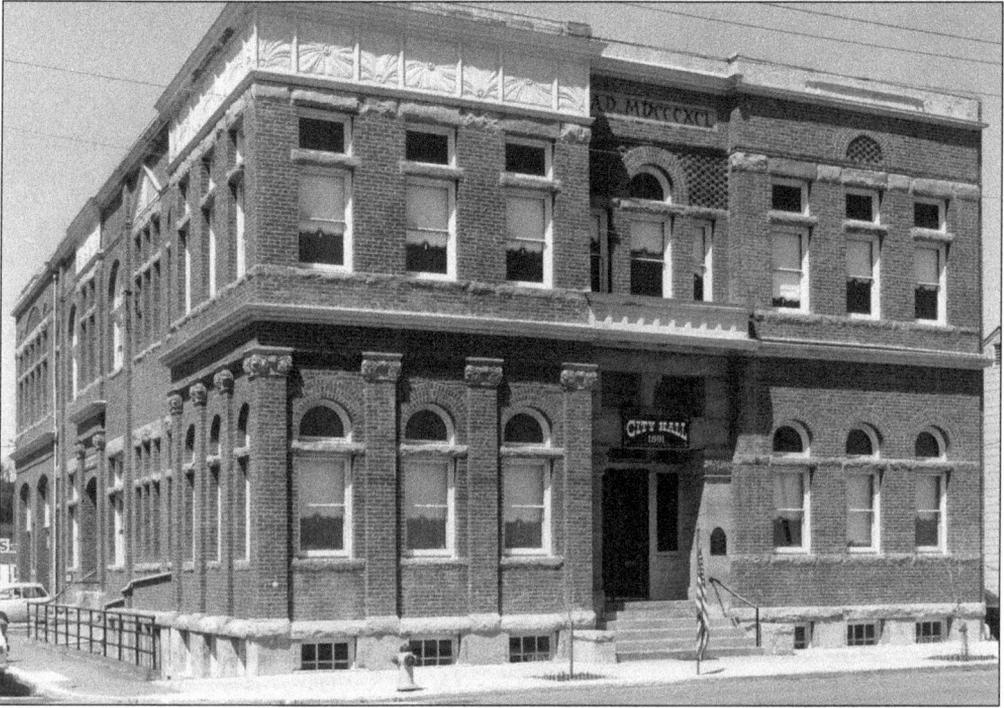

CITY HALL, 1978. After decades of deferred maintenance, federal funds arrived in 1972 to provide basic restoration work to the building.

NATIONAL HISTORIC LANDMARK. Mayor Joe Steve is seen here with the National Register of Historic Places plaque for city hall on May 14, 1971. In 1975, the National Trust for Historic Preservation undertook an architectural survey and inventory of Port Townsend's central business district. The district was listed on the National Register of Historic Places on May 17, 1976, and granted National Landmark status on May 5, 1977. The National Parks Service describes National Historic Landmarks as "exceptional places that form a common bond between all Americans. While there are many historic places across the nation, only a small number have meaning to all Americans—these we call our National Historic Landmarks." The district is roughly bounded by Scott, Blaine, Walker, and Taft Streets and the waterfront.

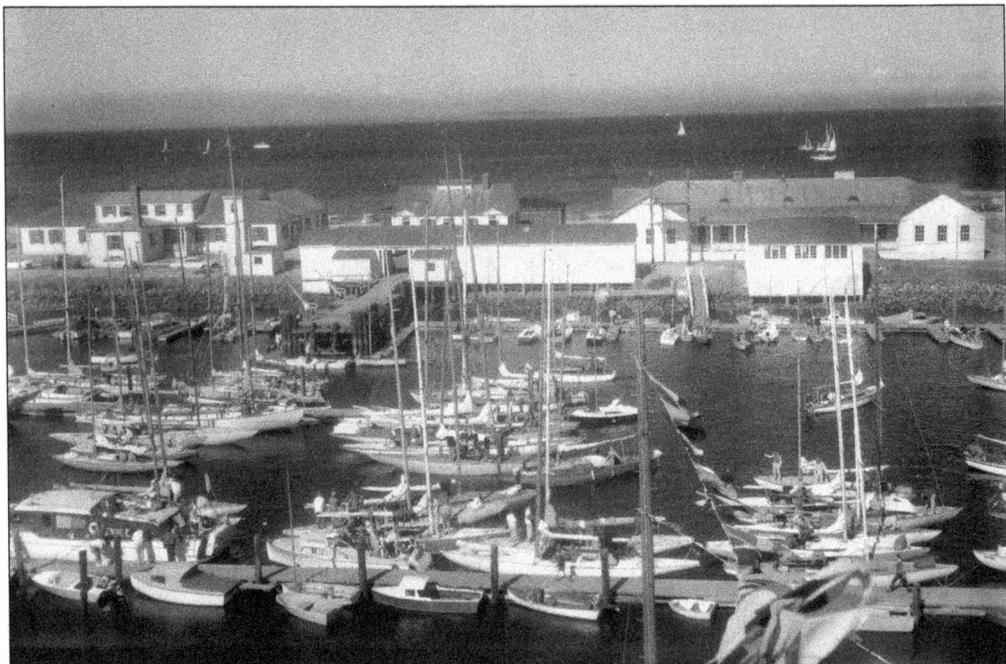

YACHT RACES. This is Point Hudson Marina during the six-meter yacht races in 1966. The first set of Port Townsend Yacht Club bylaws was adopted on February 11, 1947. Members continue to cruise to surrounding bays, inlets, and islands and teach local youngsters about sailing. The bay has seen many a spirited race.

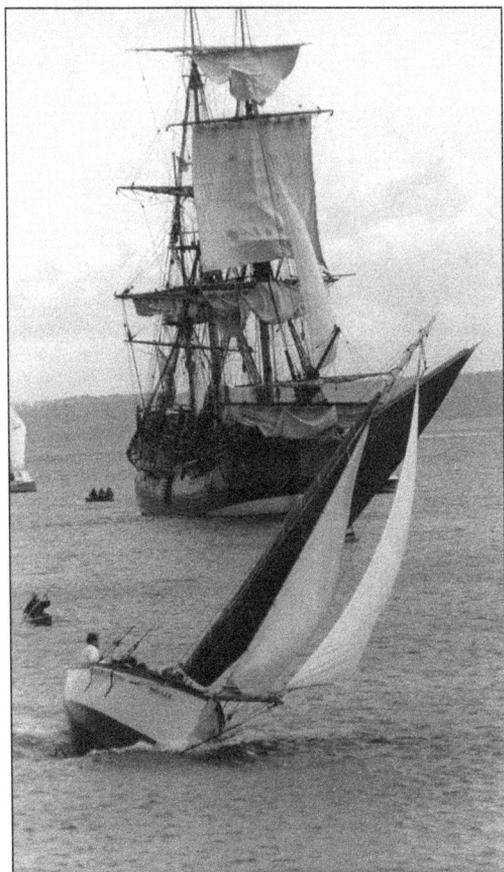

HMS ENDEAVOR. The HMS *Endeavor*, an Australian replica of Captain Cook's ship, is pictured here during the Wooden Boat Festival in Port Townsend Harbor in September 1999, with a sailboat in foreground. The annual Wooden Boat Festival brings boats, both large and small, to Port Townsend as well as more than 25,000 visitors.

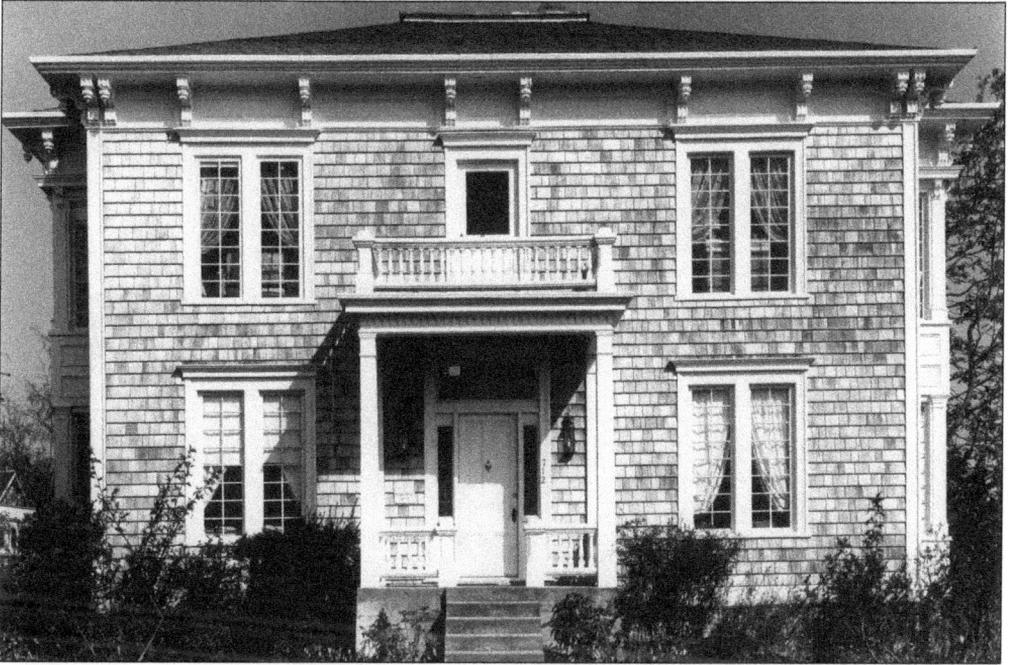

CAPT. RUDOLPHO DELION HOUSE. The Capt. Rudolpho DeLion House was built in 1883 at 712 Clay Street. Captain DeLion was a pilot and early investor in the Port Hadlock dry dock. The home, the first in Port Townsend with central heating, was little more than a shell before it was restored in the 1970s.

JAMES HOUSE DURING THE 1979 RESTORATION. The James House became the first bed and breakfast in the Northwest, the first of many in Port Townsend. Francis Wilcox James built the house in 1889. The site on the bluff at 1238 Washington Street gave him a clear view of Port Townsend and shipping in the bay. His wife, Mary, died seven weeks after moving into the house. In 1909, he married his housekeeper. He was 77 and she was 24. The marriage ended in divorce, and James died in 1920. The house originally cost $10,000 to build and is a fine example of Queen Anne architecture. The complex roof and chimney were considered modern at the time it was built.

SANBORN FIRE MAP. This section of the Sanborn fire map shows the block where Port Townsend's city hall was built in 1891. The site at Water and Madison Streets was chosen despite a petition signed by prominent citizens objecting to building city hall adjacent to a "low resort;" female boardinghouses were brothels. Sanborn maps were originally created for assessing fire insurance liability in urbanized areas in the United States.

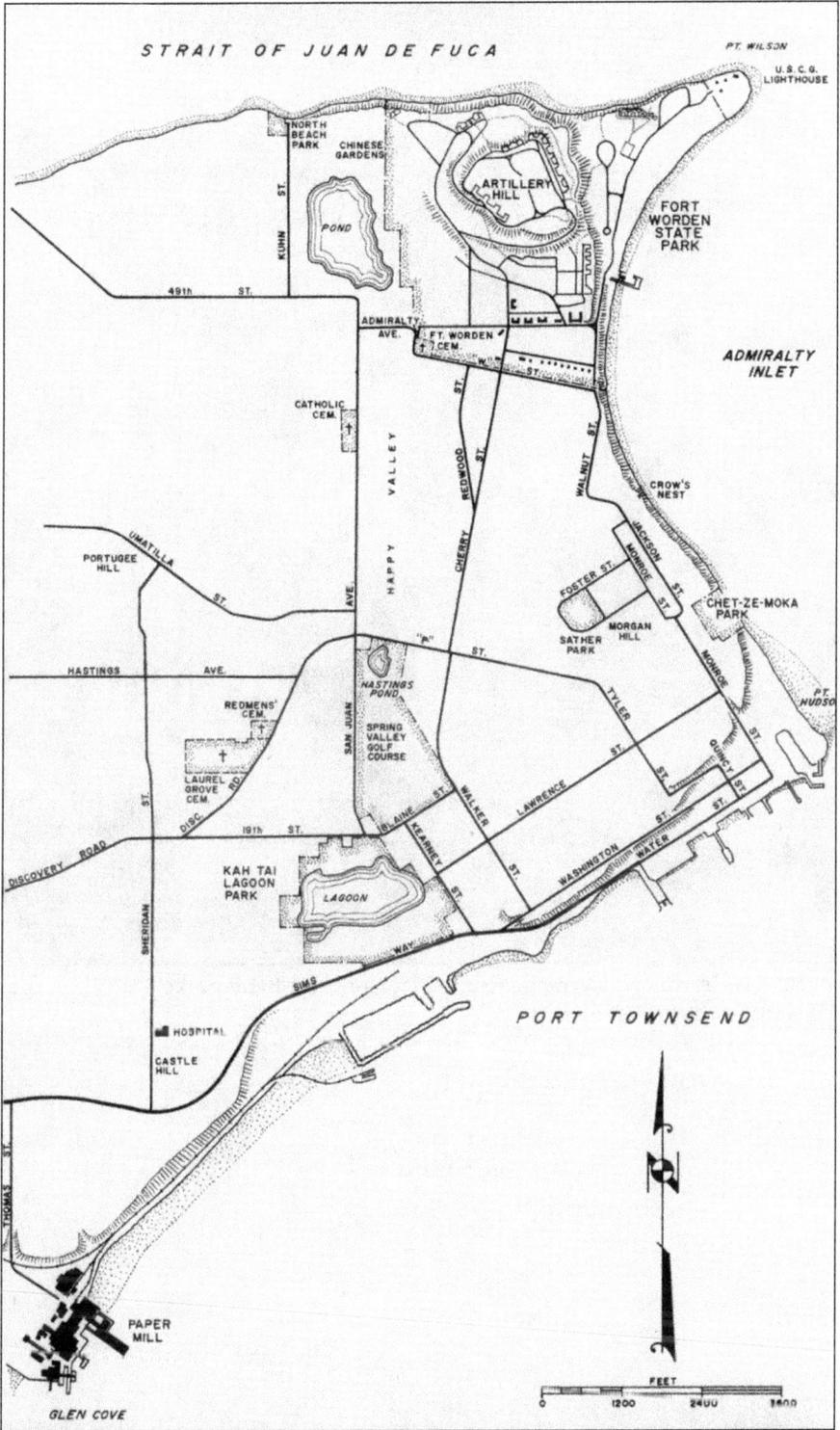

PORT TOWNSEND MAP. This map of Port Townsend is from the book *City of Dreams: A Guide to Port Townsend.*

ON THE BEACH. In this photograph, Annie McCurdy and Jumbo take a stroll on the beach. Note the bluffs in the background.

BIBLIOGRAPHY

Calkins, Kenneth L. *Name on the Schoolhouse, An Anecdotal List of Some Historic Names of Schools in Washington State.* Olympia, WA: Washington State Retired Teachers Association, 1991.

Camfield, Thomas W. *Port Townsend: An Illustrated History of Shanghaiing, Shipwrecks, Soiled Doves and Sundry Souls.* Port Townsend, WA: Ah Tom Publishing, Inc., 2000.

———. *Port Townsend: The City That Whiskey Built.* Port Townsend, WA: Ah Tom Publishing, Inc., 2002.

Clise, Pam McCollum. *Past and Present: Articles Written by James Hermanson for Publication in the Jefferson County/Port Townsend Leader 1992–1999.* Port Townsend, WA: self-published, 1999.

Denison, Allen T. and Wallace K. Hunington. *Victorian Architecture of Port Townsend Washington.* Seattle: Hancock House Publishes, Inc., 1978.

Hermanson, James. *Port Townsend Memories.* Port Townsend, WA: self-published, 2001.

Jefferson County Historical Society. *With Pride in Heritage: History of Jefferson County.* Portland: Professional Publishing Printing, Inc.: 1966.

McClary, Daryl C. *Jefferson County, Thumbnail History.* HistoryLink.org, Essay 7472, September 26, 2005.

McCurdy, James G. *By Juan de Fuca's Strait: Pioneering Along the Northwestern Edge of the Continent.* Portland: Binford and Mort Publishers, 1937.

Morgan, Murray. *The Last Wilderness.* New York: Viking Press, 1955.

Simpson, Peter. *City of Dreams: A Guide to Port Townsend.* Port Townsend, WA: Bay Press, 1986.

——— and James Hermanson. *Port Townsend: Years that are Gone—an Illustrated History.* Port Townsend, WA: Quimper Press, 1979.

Visit us at
arcadiapublishing.com